Only in America

Pierre Rosenberg

Only in America

One Hundred Paintings in American Museums
Unmatched in European Collections

SKIRA

Design
Marcello Francone

Editing
Maria Conconi

Layout
Paola Pellegatta

Iconographical Research
Maria Conconi
Paola Lamanna

Translation
Susan Wise

First published in Italy in 2006 by
Skira Editore S.p.A.
Palazzo Casati Stampa
via Torino 61
20123 Milano
Italy
www.skira.net

Printed and bound in Italy. First edition

ISBN-13: 978-88-7624-662-3
ISBN-10: 88-7624-662-2

Distributed in North America by Rizzoli
International Publications, Inc., 300 Park Avenue
South, New York, NY 10010, USA.
Distributed elsewhere in the world by Thames and
Hudson Ltd., 181A High Holborn, London
WC1V 7QX, United Kingdom.

Table of Contents

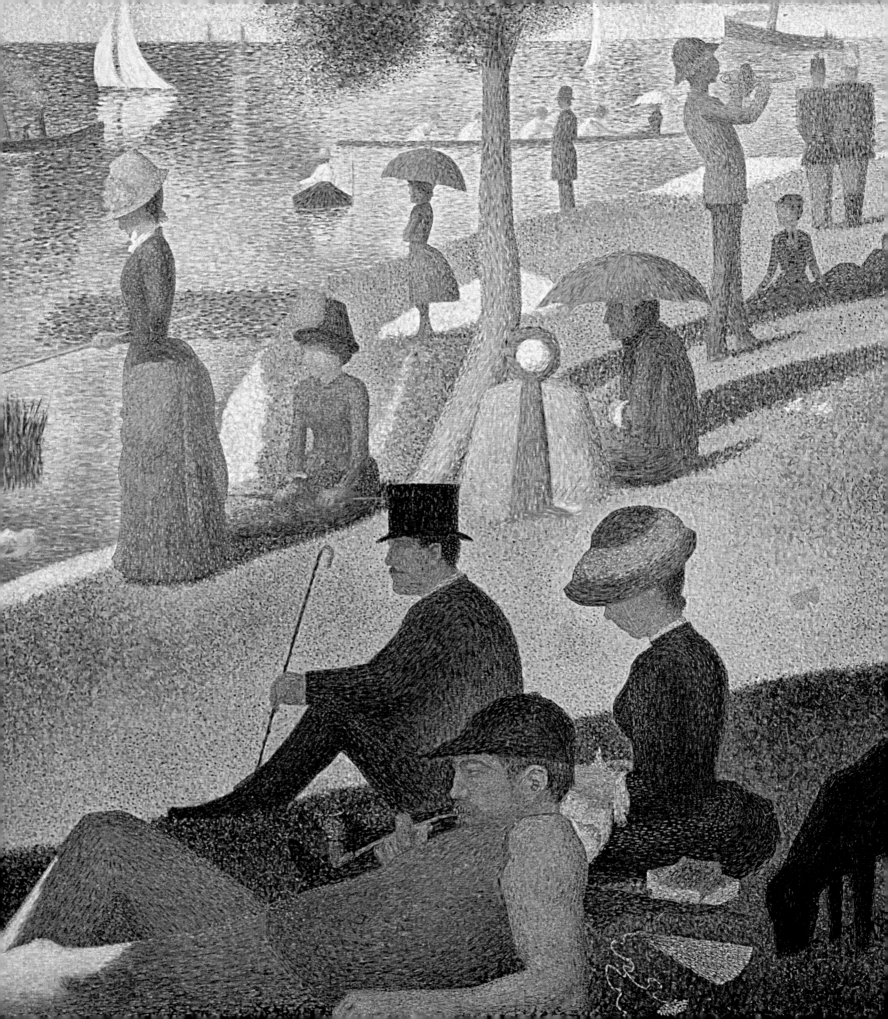

Why this book?

American museums were a revelation for Europe after the Second World War and everyone admires them. Yet visitors from the Old Continent are torn between two emotions, troubled by two complexes: inferiority on seeing what has been achieved—the splendor of the collections and the quality of their venues—and superiority because, after all, very often these museums celebrate the artists of Old Europe.

The purpose of this book is not to draw up the inventory of the rich holdings of American museums[1]. Nor does it intend to tell the long history of these museums and their directors and curators, nor the one, extensive as well, of American collecting, from Thomas Jefferson and Thomas Jefferson Bryan to Dominique de Ménil and Jayne Wrightsman, not to mention the names Mellon, Rockefeller, Frick, Kress, and so many other legendary ones. Others have already and often brilliantly dealt with the subject.

I first discovered these museums in 1962 while attending Yale University with a Focillon scholarship. The grant gave me the freedom to visit a great many of them, traveling by Greyhound bus from one city to another. Since then not a year has gone by without my visiting New York or some museum in the Middle West or in California. If I had to mount an exhibition, Poussin or Watteau, Fragonard or Chardin, I went to see or revisit this or that painting. Or when I wanted to study the French paintings in San Francisco for their catalog I published with Marion C. Stewart in 1987. At one time I needed to examine the collections of French drawings held in more or less important American museums to prepare the exhibition I devoted to them in 1972–73. Or else there were the Mellon Lectures I held at the National Gallery in Washington in 1996. And then I would visit curator friends. I always appreciated their warm welcome and frequently took advantage of their generosity for my

exhibitions. It would be pretentious to claim I know every museum in America. Yet the list of the ones I have not visited—Buffalo, San Simeon, Denver, Seattle…—is not very long, and I still hope to have the opportunity to discover them.

Naturally during these trips I looked mostly at paintings (and drawings), sacrificing among other things Asia and Pre-Columbian America, Africa, and Oceania, I ruefully confess out of lack of interest and lack of time. My personal taste led me to concentrate on seventeenth- and eighteenth-century Italian and French painting, along with the drawings of those same countries and periods. I dare hope the selection of works in the present book will not overly reflect such deplorable partiality.

So why this book? It groups a hundred paintings (actually ninety-eight and two pastels) of every school from the fifteenth century to 1912. Why the fifteenth century? Why 1912? The oldest painting in our book is well known. It is *The Annunciation with Saint Joseph and a Couple of Donors*, or *The Mérode Triptych* at the Cloisters in New York (p. 27). It dates to circa 1425–30. We should admit that in American museums we rarely find earlier works, either Italian, French, Spanish, or Nordic, which are unmatched in Europe. The reasons are simple: the artists of those centuries, especially in Italy, worked mainly in fresco, unmovable by definition. And then a great many masterpieces of that time are still preserved today in the places for which they were designed.

1912 is an arbitrary date. After first planning to limit our choice to the works of dead (European) artists, we then decided to retain only works anterior to 1945. Finally 1912 seemed a wiser choice: American collections hold so many great works by so many leading twentieth-century artists that to select the greatest was all but impossible. 1912, the year of the *Nude Descending a Staircase n. 2* by Marcel Duchamp (p. 225 [Duchamp

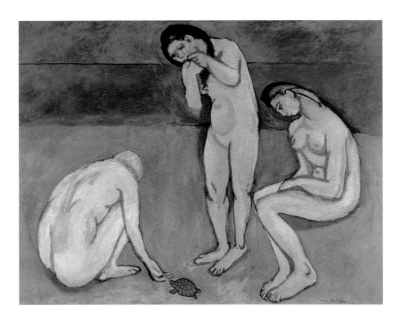

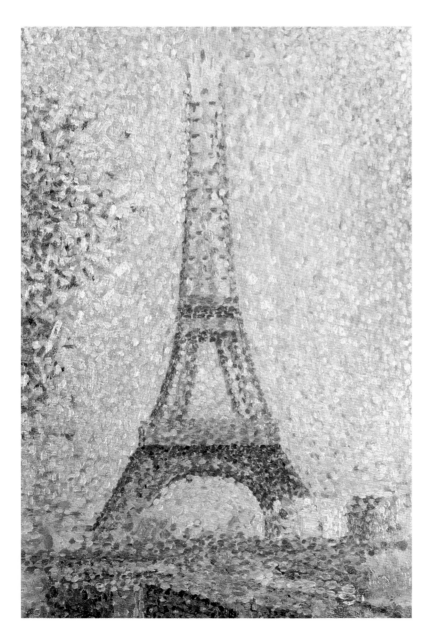

did not become an American citizen until 1955]), a year signaling a profound break, radical mutations: it seemed the symbolic date *par excellence*, an exemplary date to conclude our book.

Before going any further, I ought to justify the subtitle of the book[2]. First of all I admit that a word is missing: "one hundred *European* paintings." Indeed my selection does not include a single American painter, either eighteenth- or twentieth-century, of North America (neither Peale nor Basquiat, Bingham nor Hopper, Eakins nor Rothko, B. West nor W. Homer, Charles Morrice nor Riopelle), of Latin America (Frida Kahlo, Siqueiros, Wilfredo Lam, Diego Rivera, Matta), not a single painter from Asia (Foujita) or Africa.

One hundred: arbitrary. I first thought of saying: *The* hundred. Then I thought I might say: *My* hundred. I finally chose if not objectivity, a completely relative objectivity I admit, simplicity. My principle was to retain only one work per artist. Two hundred would have been easier and for a few artists I could have chosen two paintings (*La Grande Jatte* [p. 191] and *The Models* [p. 190] for Seurat, and maybe even the small *Eiffel Tower* in San Francisco [fig. 2], for Bellini *Saint Francis of Assisi in Ecstasy* [p. 47] and *The Feast of the Gods* [p. 46], and for Matisse *The Bathers with a Turtle* [fig. 1] and *The Happiness of Life* [p. 211]).

Paintings: no sculptures, no drawings (however two pastels as I said, Maurice Quentin de La Tour and Bracquemond! [pp. 131 and 175]).

Paintings, not masterpieces: I am not aware there is a definition of the word *masterpiece* that cannot be challenged. The notion has always varied and will always vary from one century to the next, one country to the next, one person to the next. I shall not attempt to suggest a definition, and when I have to use the word it will always be in a relative sense. I shall soon give an example.

Fig. 3
Gustav Klimt,
Portrait of Adele Bloch-Bauer,
New York, Neue Galerie

Fig. 4
Gustav Klimt, *Hope I*,
Ottawa, National Gallery
of Canada

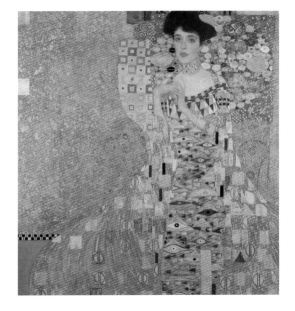

Museums: not a single work from private collections or art dealers. Why? Because as a rule—we are in the United States—the pictures seen in museums belong to them permanently—they are their property and for the most part inalienable—, whereas nothing allows us to claim that works in private collections or *a fortiori* those held by art dealers are certain to end up in a public American collection.

American: it would have been more accurate to say "in the United States." I felt very sorry to exclude Canada (the Chardin or the Klimt in Ottawa[3] [fig. 5 and 4], the *Portrait of Isaak Abrahamz. Massa* by F. Hals in Toronto [fig. 8], the Sablet in Montreal [fig. 9]). I have never been to either Central or South America (neither São Paulo nor Rio de Janeiro nor Buenos Aires), nor to Africa (Algiers, Cairo, nor Johannesburg), scarcely to Asia (Japan), not to Australia (*Blue Poles: Number 11* by Jackson Pollock in Canberra, true, he is an American painter) nor New Zealand.

Unmatched: we can explain by giving a few examples. Noël-Nicolas Coypel died young. His paintings are but few and he is the least famous of the artists of the Coypel dynasty. His *Rape of Europa* in the Philadelphia museum (p. 123) does not have a counterpart in any European collection. That one picture earns him a mention in any history of eighteenth-century French painting. Cagnacci is neither Guido Reni nor Guercino. His voluptuous *Cleopatra* at the Kunsthistorisches Museum in Vienna (p. 114) made schoolboys dream and hearts beat, captured many eyes. However, *Martha Rebukes her Sister Mary for her Vanity* at the Norton Museum in Pasadena (p. 115) ranks Cagnacci among the finest seventeenth-century Italian masters (there is nothing comparable at the Pinacoteca Nazionale in Bologna). Indeed Noël-Nicolas Coypel and Cagnacci are what we usually call "minor masters" (I am not at all sure what that expression means) and I felt choosing them for my book—a personal choice, I insist—was essential.

Fig. 5
Jean-Siméon Chardin,
The Governess, Ottawa,
National Gallery of Canada

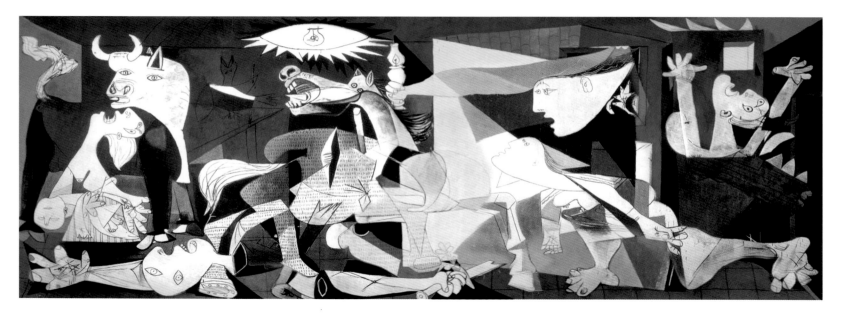

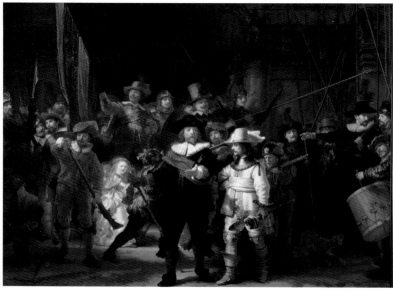

Fig. 6
Pablo Picasso,
Guernica, Madrid, Museo Nacional
Centro de Arte Reina Sofía

Fig. 7
Rembrandt,
The Night Watch, Amsterdam,
Rijksmuseum

But what about the "geniuses," the "giants of painting," the "luminaries of art history?" Well, here again in some cases it was easy to choose, I simply could not hesitate (*Les Demoiselles d'Avignon* [p. 213], *Christ's Entry into Brussels* [p. 195], a panel of the series of the *"Progress of Love"* by Fragonard [p. 149]). Those works are truly unrivaled in Europe, even if some may prefer *Guernica* (fig. 6) to the *Demoiselles d'Avignon*, or *The Fair at Saint-Cloud* (to quote the traditional title) to the *"Progress of Love."* But what about Rembrandt (*The Night Watch* [fig. 7]) or Velázquez (*Las Meninas* [fig. 10], the Rockeby *Venus*), or even more so for Giotto (Padua), van Eyck (Ghent) or Piero della Francesca (Arezzo) or again Caravaggio (San Luigi dei Francesi)? Just speaking of French painting, why include Poussin, La Tour, Fragonard, David, and Ingres, and exclude Le Nain, Claude Lorrain, Watteau, Chardin, and Delacroix? To do so I was forced to make concessions.

Recently I was in Saint Louis. For the present book I chose two works from its museum collections, the still life by Susi (p. 81) and Derain's *Ball at Suresnes* (p. 207). Each is unique in its own way (Beckmann would have been included in my selection had it not ended in 1912. I again had qualms about *Camaret. Moonlight and Fishing-Boats* by Maximilien Luce [fig. 11] and the large study for a ceiling by Corrado Giaquinto, even though I know it is not unique [p. 80]). Certainly, the admirable *Bathers with a Turtle* (1908) by Matisse (fig. 1) surpasses in importance (and in beauty) the two pictures I selected, but how could I not give precedence to the *Happiness of Life* at the Barnes Foundation (p. 211)?

Just how did I proceed? I tried to think of the most beautiful painting by Rubens or Vermeer, Tiepolo or Delacroix, Ingres or Turner held in the United States, the most remarkable, the

Fig. 8
Frans Hals,
*Portrait of Isaak Abrahamz.
Massa*, Toronto, Art Gallery
of Ontario

most extraordinary in the literal sense of the word, out of the ordinary. Toledo? The Met? The Frick? Baltimore? The Lehman Collection? Philadelphia...? Was that painting *exemplary*? What about a Van Gogh? There are many in the United States, yet *Rain* (p. 197) is unmatched in Europe. A Manet? America has an impressive number of them and of the greatest quality. However, his *Christ with Angels* (p. 177) is one of the handsomest religious paintings of the entire nineteenth century (with, I agree, the Chicago *Mocking of Christ* [p. 176]). In both cases they are magnificent pictures, but they are not the "absolute masterpieces" of those artists. They are exceptional, but it would be a mistake to see them as rarities, curiosities, sorts of *rara avis*. They are perfect, *unique* works. Each in its own way enriches the idea we have of those artists. Those two examples explain and justify our approach. Was the picture irreplaceable? If so, I put it on my list. My decisions will be judged. Doubtless they sometimes (often) will be deemed arbitrary. By no means do they mean to be imperative, authoritative. In matters of taste no one can claim to possess the absolute truth.

To make these choices I called upon recollections of my travels, books, and museum and exhibition catalogs. But I did not make my way alone. I wrote to a great many museum curators and art historians, American and European. I wish to express my gratitude to all those who were willing to answer me, sometimes at length: the list of them is below. I want them to know I paid a great deal of attention to their suggestions, and that my choices were never made light-heartedly.

I should first recall six of my correspondents who, alas, passed away, Kirk Varnedoe, Leonard J. Slatkes (he persuaded me to choose the painting by Paulus Bor in the Metropolitan Museum [p. 103]), Adriano Mariuz (I owe him, if I may say, the Boston Canaletto [p. 129] I might not have thought of without

Fig. 9
Jacques Sablet,
Family Group before a Seaport,
Montreal, The Montreal Museum
of Fine Arts

Fig. 10
Diego Velázquez,
Las Meninas, Madrid,
Museo Nacional del Prado

13

his letter), my old friend Donald Posner, John Hayes, indispensable for English painting, and then John Shearman. I should like to quote the last paragraph of his letter of April 7, 2003: "If I am allowed 'out of my field': some years ago the Museum of Fine Arts in Boston was under renovation and had to put its best pictures in one room. I thought (to my surprise) that the outstanding picture was Turner's *Slave Ship*." On his suggestion, I retained that picture (p. 169) instead of *The Burning of the Houses of Lords and Commons, 16 October 1834* in Philadelphia (fig. 12) and Cleveland (p. 168), both admirable but perhaps less unique.

Choosing my correspondents came about naturally. I appealed to the experts of an artist (for example Seymour Slive for Frans Hals, Denis Mahon for Guercino, Robert Herbert for Millet), without of course discouraging them from calling to my attention another painter or painting in this or that museum in the United States. Moreover, I turned to museum curators, preferably American but European as well. So I owe to John Leighton the suggestion of Van Gogh's *Rain* (p. 197) and to Edgar Munhall that of the Liotard in the Frick Collection (p. 147). Experts of a particular school or century (Italian Primitives, Everett Fahy; French sixteenth century, Sylvie Béguin…) or of American collections (Burton B. Fredericksen, Eric Zafran) were also called upon.

Which paintings did my correspondents name most often? The answer will come as a surprise: first of all, *Saint Sebastian Tended by Irene and a Companion*, by Ter Brugghen at the Allen Memorial in Oberlin (p. 83). I chose that picture, but, to be candid, I hesitated to include it in my book because like Leonard J. Slakes I feel that the *Crucifixion* ("self-consciously archaic") by the same artist (and of the same date) in the Metropolitan Museum (p. 82) is not as appreciated as it deserves to be.

And then we have (of course this is not an honors list): the Bellini and the Fragonard in the Frick Collection (pp. 47 and 149), the Chicago Seurat (p. 191), the Tanzio da Varallo in Tulsa (p. 89), the Renoir in the Phillips Collection (p. 185), Titian's *Europa* in the Gardner Collection in Boston (p. 67), the *Demoiselles d'Avignon* in the Museum of Modern Art of New York (p. 213), and last Pontormo's *Halberdier* (p. 59) at the Getty (ranking equal with the *Christ's Entry in Brussels* by Ensor in the same museum [p. 195]). I leave it up to my readers to draw their conclusions from this list.

At this point in my introduction, I thought I might give a random list of artists and works which at one time or another drew my attention: a Florentine (?) polyptych painted circa 1300 held in San Diego, and the small Vallotton *Street Corner* in the Lehman Collection. And then Domenico Veneziano, the anonymous *Martyrdom of Saint Hippolytus* in Boston, Bronzino, Pensionante del Saraceni, Rombouts, Drouais, Berthe Morisot, Kandinsky, without forgetting Marco Angelo del Moro, Nicolaes van Galen (?), Simon Verelst, Alonso Cano, Rubens' *Martyrdom of Saint Catherine* in Toledo, *Hagar and Ishmael in the Desert* by Karel Dujardin in Sarasota, *Stoke-by-Nayland* by Constable in Chicago, and how many others? I had to give up the idea because so many of those paintings were indispensable and so many of my choices seemed difficult to justify. A comment by Philippe Bordes that I chanced upon just as my manuscript was about to be sent to the publisher recalled me to order (and to modesty): "Of all the paintings in public collections, the most important is the uncompleted *grisaille* by François Gérard for the scene of *The 10ᵗʰ of August 1792* (fig. 13), a composition awarded the first prize in the competition of Year II. Purchased three years ago by the Los Angeles County Museum of Art, thereby becoming the most significant work of the revolutionary

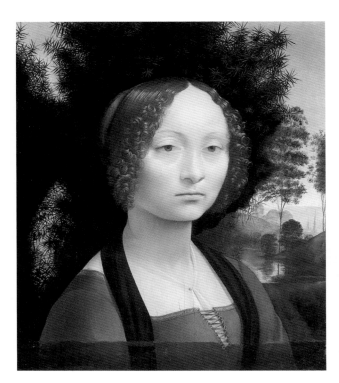

Fig. 14
Leonardo da Vinci,
Ginevra de' Benci, Washington,
National Gallery of Art

Fig. 15
Diego Velázquez,
Portrait of Juan de Pareja,
New York, The Metropolitan
Museum of Art

Fig. 16
Raphael, *Portrait of Bindo
Altoviti*, Washington,
National Gallery of Art

Fig. 17
Sebastiano del Piombo,
*Portrait of Anton Francesco
degli Albrizzi*, Houston,
Museum of Fine Arts

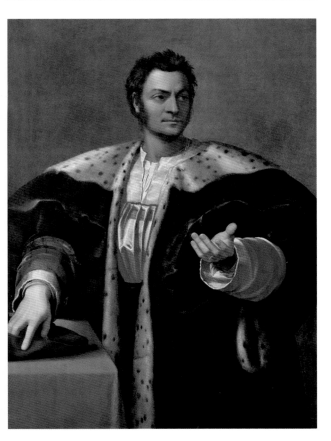

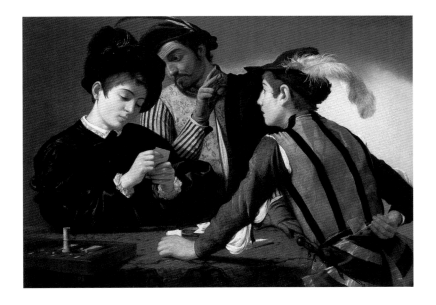

Fig. 18
Caravaggio,
The Cardsharps,
Fort Worth, Kimbell Art
Museum

period in a North American collection."[4] I must confess it had not occurred to me to include that work in my selection, and I was probably wrong.

A few additional remarks, rather words in defense of some of my choices. I already explained the reasons that led me to exclude several giants of painting, Leonardo da Vinci (*Ginevra de' Benci* at the National Gallery in Washington [fig. 14]), Raphael (the *Alba Madonna* and the marvelous *Portrait of Bindo Altoviti,* at the Munich Pinakothek until the 1930s, in the same museum [fig. 16]), Caravaggio (*The Cardsharps* at Fort Worth [fig. 18]), Velázquez (*Portrait of Juan de Pareja* in the Metropolitan Museum [fig. 15]), Boucher (the set of four paintings at Fort Worth) … just to mention a few. If I regretfully sacrificed those masterpieces, it is because, in my opinion, they have counterparts in Europe.

I often followed the advice of my correspondents (La Hyre in Chicago [p. 95; Erich Schleier], Murillo in Washington [p. 109; Alfonso E. Pérez Sánchez. Generally speaking the "Hispanists," William B. Jordan, Jonathan Brown, proved to be particularly attentive and conscientious interlocutors]; Hogarth at Buffalo [p. 139; John Hayes]), but in some instances I held my stand and even resisted the most emphatic arguments. Thus, against the opinion of most, I preferred the Los Angeles Rosso (p. 61) to the one in Boston (p. 60). I opted for the *Portrait of Antoine-Laurent Lavoisier and his Wife* (p. 157) rather than the *Death of Socrates* (p. 156) by David (Keith Christiansen, Joseph Baillio). And after some thought, I removed from the list Ruisdael's *Jewish Cemetery* (Detroit) and, by Sebastiano del Piombo, the *Portrait of a Man* in Hartford (David Alan Brown, Jean K. Cadogan), as well as the *Portrait of Anton Francesco degli Albrizzi* (fig. 17) in Houston (Philippe Costamagna, Burton B. Fredericksen, Anna Ottani Cavina). Even worse, I gave preference to Caillebotte's *Nude* in Minneapolis (p. 187) over his more famous and often cited *Paris Street: A Rainy Day* in Chicago (p. 186). I could multiply the examples (and publish all of the some one hundred letters I received), expand on the reasons that led me, finally, to not retain Rembrandt's (?) *Landscape with a Mill* (fig. 19) at the Washington National Gallery (its departure from England marked an epoch) and follow Maria van Berge-Gerbaud's suggestion and prefer the Frick Collection *Self Portrait* (p. 111)… I shall merely say that, thanks to the abundant mail I received and the generosity of the authors of these letters, I learned a great deal.

Another remark. The further we progress in time and approach 1912, the date we chose, the greater the number of capital works held in American museums. Hence a new quandary: which Monet, which Renoir, which Cézanne should we pick? Once again I followed my taste and sick at heart had to give up so many superb, exceptional paintings, wonderful works that would be the pride of the most glorious European institutions. Too many riches on the one hand (for the Impressionists [there are supposedly almost as many pictures by Monet in Chicago as at the Musée d'Orsay!], the painters of the late nineteenth-century and those of the early twentieth century), and on the other, lacunae and lacks (the well-known "lacks" in collections, to use museum professionals' doleful expression): writing this book, it should be obvious by now, has been excruciating!

I may not have been clear enough on an issue I feel is important. It has to do with the word *Europe.* Sometimes (often) American museums preserve a work that does not have its equivalent in a European museum, except in the native country of its author. Masaccio is absent from the Louvre collections. The Getty *Saint Andrew* (fig. 20) would be its pride and joy, but it falls short—*pace* the Getty!—when compared to the frescoes

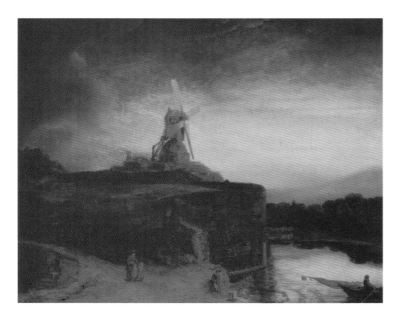

of the Brancacci chapel in Santa Maria del Carmine in Florence or even the Masaccio in the London National Gallery. Another example, Puvis de Chavannes. We know the admirable cycle of frescoes (actually the works are *a tempera*) in the Boston Public Library. In Europe there is nothing to match them. Except in France: the mural ensembles of the Sorbonne, the Pantheon, or again the museums of Amiens, Marseille, or Rouen are no less admirable.

Once again, by Europe I mean all of Europe, from the Atlantic to the Ural, from Lisbon to Saint Petersburg, from Philip II to the Great Catherine, from the Gulbenkian Collection to the Shchukin and Morosov Collections.

And another thing: as I said, I visited a great many American museums for the first time forty years ago. At that time would I have written this same book? Of course not, and for several reasons, the first being evident: since then American museums have considerably increased their number of works. But especially, and this reason prevails over the first, generally speaking taste, and naturally mine, has changed and taken into account movements, schools (the Italian Baroque, the Nazarene painters, the pre-Raphaelites [Lord Leighton's *Flaming June* at Ponce or *Miss May Sartoris* by the same painter at Fort Worth (fig. 21), the series of Burne Jones at Ponce], the academic artists of the second half of the nineteenth century), or neglected artists (G. de La Tour, C.D. Friedrich). Certainly this evolution is far from coming to an end, to state the obvious. New generations of curators, dealers, collectors, and *connoisseurs* will (re)discover artists who once had their hour of glory before being forgotten. They will promote artists we consider secondary. They will condemn others we extol. Many "absolute masterpieces"—the *Polish Rider* by Rembrandt (?) at the Frick (fig. 22), Goya's (?) *Majas on a Balcony* (fig. 23) in the Metropolitan Mu-

seum, the *Landscape with a Mill* by Rembrandt (?) at the National Gallery in Washington (fig. 19)—have been or will be demoted and banished to the museum deposits. This book would also like to recall us all to modesty.

Here is an example. The catalog of the recent (2004) exhibition around Seurat's *Grande Jatte* and notably the essays by Neil Harris give the detailed history of the entry in 1926 in the Chicago museum of that work considered an absolute masterpiece (p. 191). If today the work is generally viewed as "the single most important gift in the museum's history," that has not always been the case. In 1933, shortly after the opening of the exhibition *A Century of Progress*, attended by some 600.000 visitors (and to which the Louvre loaned Whistler's *Mother*), the *Chicago Daily News* reported that the *Song of the Lark* (fig. 25) by Jules Breton (1827–1906) had been taken off the museum wall. The newspaper expressed outrage and launched a survey to select "the most popular picture in America," a survey in which the Art Institute, with some dismay, accepted to collaborate. The list, the outcome of a compromise between the museum director Robert Harshe (1879–1938) and the newspaper management, confirmed the triumph of Jules Breton's painting. On July 10, 1934 Eleanor Roosevelt, the President's wife, during her visit to the Chicago exhibition, unveiled the painting. It is still shown there.

In the entries of each of the hundred selected paintings I endeavored to explain my choices. In a first part (pp. 26 to 225), I commented each of the selected paintings. I cited the name of the artist, the title of the work, its dimensions, and the date of its execution. The second part (pp. 228 to 236) features one or two fundamental bibliographical references. I sought to take a look at the provenance of each work and the conditions

of its acquisition and entry in the respective museum. When did the work leave Europe and how? How did it arrive in the museum that holds it now, at what price and thanks to which art dealers, connoisseurs, collectors, patrons? I could not always answer those questions. But there is another one, a crucial one: what is it about the work that makes it, in my opinion, worth figuring in our book?

I trust I may be allowed a digression. Recently I visited the Virginia Fine Arts Museum in Richmond. Not one of its works is listed here. Was I wrong? Should I have included Salvator Rosa's *Death of Regulus*, the *Allegory of Marital Fidelity* by J.M. Molenaer (fig. 24), the *Laocoon* by Hubert Robert, the *Judgment of Paris* by François-Xavier Fabre, the delightful Van Dongen of the Paul Mellon Collection? We must agree that none of these pictures are unmatched in Europe. Yet the Richmond museum is amazingly endowed. With its Indian sculpture, English silverware, African collections, British sporting art, exceptional Art Deco ensembles, waxes by Degas, without overlooking the French nineteenth century and contemporary art, it is an encyclopedic museum with an astonishing variety. This diversity constitutes its originality. You can spend a delightful day there. Which European museum can compare to it? Now just what is the point of this aside? First to insist on the number and quality of American museums and urge European visitors fond of painting to venture off the beaten track. Of course New York, Washington, Chicago, Philadelphia, the Getty, Cleveland, Detroit, but why overlook the Hill-Stead Museum in Farmington (Manet, Monet, Degas [fig. 28]) to mention just one example among a hundred others (Shelburne, San Simeon…). Besides the example of Richmond raises the question: just what is the ambition of that museum? Is it comparable to that of a European museum?

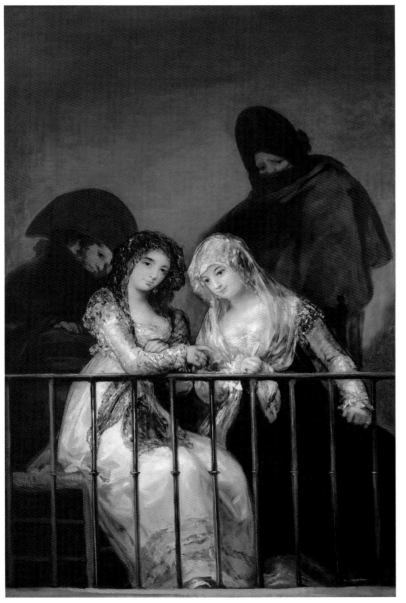

Moreover we should point out that American museums concede far less space to European art that those on the Old Continent, which is only to be expected. As a matter of fact, less and less space. American art in the broadest sense of the word— pre-Columbian, Mexican, South American, nineteenth-century and contemporary American—occupies a considerable number of rooms, which is not surprising. But Eastern and African arts as well, and photography and popular art, modern and contemporary above all. The composition and formation of American museum collections, and this is especially true in medium-size American museums, follow rules which are not those of European museums. This evolution of American museums deserves further examination.

As we said before, this book does not intend to tell the already long history of American museums. Two of the works of our selection have been in America for over two centuries, the *Still Life with Quince, Cabbage, Melon, and Cucumber*, by Sánchez Cotán (p. 75) and *The Rape of Europa* (p. 123) by Noël-Nicolas Coypel from Joseph Bonaparte's collection. *A Hare in the Forest* by Hans Hoffmann (p. 69) was purchased by the Getty museum in 2001. To the small *Madonna and Child* by Duccio that entered the Metropolitan Museum in 2005 [fig. 27], I dare prefer the *Raising of Lazarus* by the same artist in Fort Worth [fig. 26]. These achievements are owed to exceptional museum directors and curators—how could I name them all? —, great art historians, brilliant art dealers, patrons. Despite the temptation to do so, we shall decline to mention some rather than others.

Over and above a selection that can be challenged, this book would like to be a source of reflection for all those whom the air of museums intoxicates, those, above all, who believe and

Fig. 24
Jan Miense Molenaer,
Allegory of Marital Fidelity,
Richmond, Virginia Museum
of Fine Arts

Fig. 25
Jules Breton,
The Song of the Lark,
Chicago, The Art Institute

have always believed and believe more than ever in the twofold educational and contemplative vocation of this admirable institution we inherited from the nineteenth century. We tend to forget that if today museums are popular, it has not always been the case, and that if we are not careful, since events and temporary exhibitions are a threat to what is permanent, it might no longer be true tomorrow.

Up to now, at least I liked to think so, I had a good reputation in the United States. It is compromised and may not outlive this book. I shall be criticized for preferring this museum to that one, which henceforth will shut the door on me. I shall be called upon to justify the absence on my list of the museums of Fort Worth, of Toledo (Larry Nichols loyally tried to make me change my mind…), of Williamstown…, admirable museums with exceptional collections. I shall be reproached for privileging this or that school, and be accused of partiality, nationalism, chauvinism, or sectarianism, for giving my preference to this or that century or again this or that artist. Several omissions (and doubtless with good reason) will be emphasized.

This book reflects moods, maybe even whims. In some cases I wished to underscore what is already consecrated and universally famous, in others I sought to focus attention on an outstanding work by an artist who was not so. I insist: it mirrors my *personal choice*, subjective, impassioned, and I grant, arbitrary.

I should like to bring up a sensitive issue: some will accuse me of stoking the anti-American controversy and nurturing an argument unfortunately in vogue. Others will reproach me for being blithely pro-American. Nothing could be further from my intentions. Tolerance is one of my favorite words. In my choices there is not a hint of resentment, no mental reservation, no counter one-upmanship, no acrimony. Only a love for museums and painting.

After passing over those accusations which I dismiss beforehand, I still have much to regret and criticize. I should have liked to cite a greater number of "small" museums and do justice to more "minor masters" (I am sorry not to have been more daring with respect to nineteenth-century academic painting, Meissonier, Gérôme, Bouguereau, the *Joan of Arc* by Bastien-Lepage in the Metropolitan Museum [fig. 29], the *"Hail Mary"* by Luc-Olivier Merson in Atlanta, Gleyre in Norfolk [fig. 30], Cabanel at Charlottesville, and naturally the Maurice Boutet de Monvel at the Corcoran Gallery in Washington). I should have liked to create more surprises and share with the reader more rarities and "unknown masterpieces"… I shall be found guilty for this or that choice, for not picking this or that artist, even among the most glorious. I urge those who would like to suggest another selection to pass it on to me. I shall take it into consideration, and thanks to them, I feel certain a second edition of this book, perfect this time, will appear.

[1] It has already been done, notably as regards Italian painting by Federico Zeri and Burton B. Fredericksen (*Census of pre-nineteenth-century Italian paintings in North American public collections*, Cambridge, Mass., 1972), Flanders, Holland, England, and seventeenth-century France by Guy C. Bauman and Walter A. Liedtke (*Flemish paintings in America: a survey of early Netherlandish and Flemish paintings in the public collections of North America*, Antwerp, 1992), by Peter C. Sutton in 1986 (*A guide to Dutch art in America*, Washington; consult on the same subject, *Great Dutch paintings from America*, exhib. cat. edited by Ben Broos, The Hague and San Francisco, 1990-91), by Malcolm Warner and Robyn Asleson (exhib. cat. *Great British paintings from American collections: Holbein to Hockney*, New Haven and San Marino, 2001-02) and by us in 1982 (exhib. cat. *La peinture française du XVIIe siècle dans les collections américaines*, Paris, New York, and Chicago); we should not forget Hans Tietze (*Masterpieces of European painting in America*, New York, 1939 [German ed. 1935]), nor Fiske Kimball and Lionello Venturi (*Great paintings in America; one hundred and one masterpieces*, New York, 1948), nor John D. Morse (*Old master paintings in North America*, New York, 1979 [First ed., 1955]) among many others.

[2] I owe the English title to Carl Strehlke, whom I thank for his wonderful suggestion.

[3] Ronald Lauder just purchased for his Neue Galerie in New York the *Portrait of Adele Bloch-Bauer*, by Gustav Klimt (fig. 3), for 135 million dollars.

[4] Philippe Bordes, "La recherche sur l'art de la Révolution française: le tournant du bicentenaire," in *La Révolution à l'œuvre. Perspectives actuelles dans l'histoire de la Révolution française*, Rennes, 2005, p. 263.

Fig. 29
Jules Bastien-Lepage,
Joan of Arc, The Metropolitan
Museum of Art

Fig. 30
Charles Gleyre,
The Bath, Norfolk,
The Chrysler Museum of Art

The list of dealers, collectors, curators, colleagues, friends of every country, of course mainly the United States, whom I questioned, is very long. To them I owe suggestions, which I did not all follow, but that always stimulated me. They helped me in making difficult decisions. I wish to cordially thank them and apologize to those I may have forgotten to name.

Mr. and Ms. Dawn Ades, Katherine Baetjer, Colin B. Bailey, Joseph Baillio, Jean-Luc Baroni, Sylvie Béguin, Sylvain Bellenger, Luciano Bellosi, Shelley Bennett, Maria van Berge-Gerbaud, Jonathan Bober, Piero Boccardo, Olivier Bonfait, Philippe Bordes, Miklós Boskovits, Emily Braun, Richard R. Bretell, David Alan Brown, Jonathan Brown, Jean K. Cadogan, Karen Chastagnol, Bruno Chenique, Keith Christiansen, Guy Cogeval, Isabelle Compin, Maria Conconi, Philip Conisbee, Dominique Cordellier, Philippe Costamagna, Delphine de Crépy, James Cuno, Thomas DaCosta Kaufmann, Jacques Dupin, Everett Fahy, Burton B. Fredericksen, Dominique Fourcade, Thomas Gaehtgens, Mina Gregori, † John Hayes, Robert L. Herbert, William B. Jordan, Ian Kennedy, Michel Laclotte, Alastair Laing, Paola Lamanna, Sylvain Laveissière, Claudine Lebrun, Ellen W. Lee, John Leighton, Serge Lemoine, Karen Lerheim, Cristophe Leribault, Walter A. Liedtke, Giovanni Lista, Kurt Löcher, Glenn D. Lowry, Henri Loyrette, Sir Denis Mahon, Judith Mann, Jean-Patrice Marandel, † Adriano Mariuz, François-René Martin, Olivier Meslay, Philippe de Montebello, Edgar Munhall, Larry Nichols, Patrick Noon, Nancy Norwood, Anna Ottani Cavina, Suzanne Pagé, Alfonso E. Pérez Sánchez, Edmund P. Pillsbury, Vincent Pomarède, † Donald Posner, Joseph J. Rishel, Marcel Roethlisberger, Robert Rosenblum, Angelica Zander Rudenstine, Marie-Catherine Sahut, Xavier Salmon, Cécile Scailliérez, Scott Schaefer, Erich Schleier, Pierre Schneider, Nicholas Serota, † John Shearman, † Leonard J. Slatkes, Seymour Slive, Werner Spies, Nicola Spinosa, Carl Strehkle, Werner Sumowski, Ann Sutherland Harris, Peter C. Sutton, Erika TenEyck, Antoine Terrasse, Dominique Thiébaut, Carol Togneri, Lilian Tone, † Kirk Varnedoe, Horst Vey, Mary Webster, Arthur K. Wheelock Jr., Nicole Willk-Brocard, Susan Wise, Eric Zafran, Martin Zimet, Armin Zweite.

Without Eileen Romano this book would never have appeared.

My special thanks to Benjamin Peronnet who accompanied me in writing this book. It is greatly indebted to him.

Only in America

Robert Campin, known as the Master of Flémalle

Valenciennes or Tournai (?), c. 1375/1379 – Tournai, 1444

The Annunciation with Saint Joseph and Couple of Donors,
or *The Mérode Triptych*

Wood
Central panel: H. 64.1; W. 63.2
Wings: H. 64.5; W. 27.3
C. 1425–30

New York, The Metropolitan Museum of Art,
The Cloisters Collection (inv. 1956 56.70)
[See Provenance and Reference p. 228]

At page 24
Vincent van Gogh,
Rain (detail), Philadelphia,
Philadelphia Museum of Art

Robert Campin,
The Annunciation (detail),
New York, The Metropolitan
Museum of Art

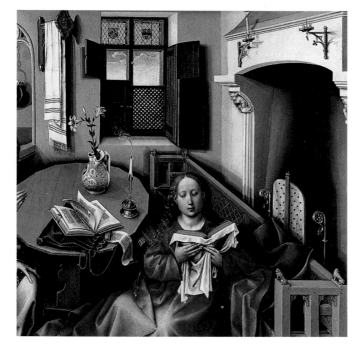

Who is Robert Campin? Today scholars concur in identifying him with the Master of Flémalle: that conventional name encompasses a group of works including two wings of a triptych presently held at the Städelsches Kunstinstitut in Frankfort and coming from the castle of Flémalle near Liège. Controversy between Flemish and Walloons raged at length, sometimes going beyond the context of art history. Actually Robert Campin worked at Tournai, a French-speaking city, whereas supposedly the "Flemish primitives" all spoke Netherlandish.

The Mérode altarpiece, named after the Belgian family who owned it in the nineteenth century and sold it to the Metropolitan Museum in 1956, is one of the most significant, appealing works of this artist, even if today wide agreement has been reached on two scores: the date of the wings is later than that of the central *Annunciation* (1425–30) and the participation of Rogier van der Weyden (Roger de La Pasture, c. 1399–1464), Campin's principal pupil and collaborator in Tournai, is certain.

Campin did not set his *Annunciation* in a church but in a bourgeois interior. The lily alludes to Mary's virginity. A number of details baffled scholars, notably the mousetraps on Joseph's table and the window ledge. Saint Augustine likened this kind of trap to the Crucifixion: "the Lord's Cross was the devil's mousetrap, the lure that helped catch him is Our Lord's death."

Campin enjoyed describing reality (the window overlooking a city plaza, in the right wing) and delighted in accumulating details (often with a symbolic import), conferring on them intense suggestiveness and an unforgettable poetic flavour.

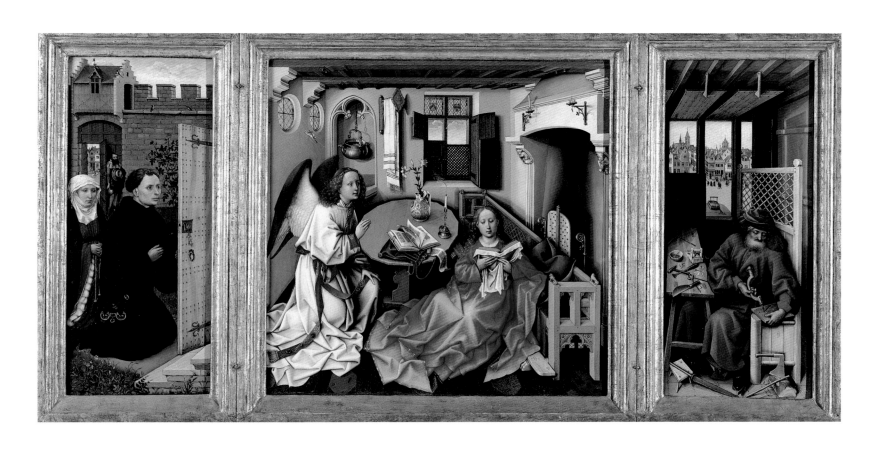

Bernat Martorell

Cited in Barcelona between 1427 and 1452

Saint George Killing the Dragon

Wood
H. 142; W. 96.5
Before 1435

Chicago, The Art Institute (inv. 1933.786)
[See Provenance and Reference p. 233]

The central panel of an altarpiece—its wings are pre-served in the Louvre—, the Chicago *Saint George Killing the Dragon* is unquestionably one of the most enchanting images left us by fifteenth-century Catalan painting. The Saint's spear crosses the entire composition while the Princess, kneeling in the middle distance as in prayer, modestly lowers her eyes.

In the foreground bones of humans and animals are scattered over the ground. The black monster with outspread wings and the white horse grapple, while a throng of onlookers sheltered behind the fortifications of the castle observe the battle.

The charm of the work—a perfect image of medieval chivalry—is owed to the great number of details treated with an apparent naïveté. Martorell dismissed perspective and the recent achievements of painting, remaining faithful to the tenets of International Gothic. Above all he wanted to tell a story, as the painters of illuminated manuscripts of the previous generation had done before him. For sure Crivelli (see p. 41), a generation later, would adopt an equally narrative approach, but there is an appealing rusticity in the Catalan painter's rendering of the legendary character of the episode, enhanced by the presence of the Princess of Trebizond.

Bernat Martorell, *Judgement of Saint George*, Paris, Musée du Louvre

Bernat Martorell, *Saint George dragged through the City*, Paris, Musée du Louvre

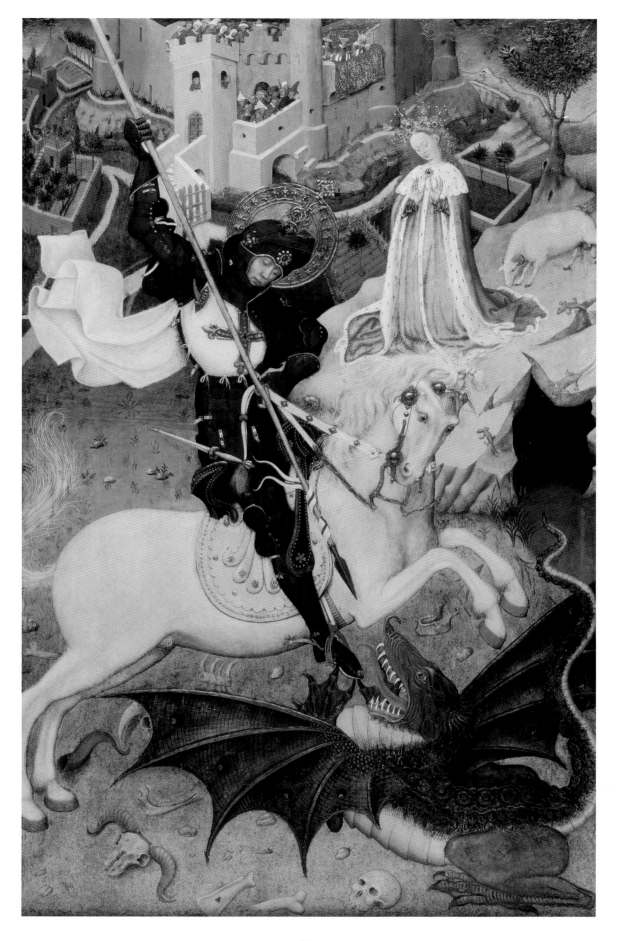

School of the Van Eyck brothers Jan and Hubert

Maaseik, c. 1366 – Ghent, 1426 (Hubert);

Maaseik, c. 1390 – Bruges, 1441 (Jan)

The Annunciation

Wood
H. 77.5; W. 64.4
C. 1450

New York, The Metropolitan Museum of Art
(The Friedsam Collection, Bequest of Michael Friedsam, 1931,
inv. 32.100.35)
[See Provenance and Reference p. 235]

The most famous scholars of the Netherlandish primitives long disagreed over the attribution of this painting, the "Master of the Friedsam Annunciation," Jan van Eyck, Hubert van Eyck (Panofsky), Petrus Christus (Friedländer). Today that last name seems to widely prevail and meet with the approval of the majority. The date, circa 1450, as well as the fragmentary state of the work, are equally agreed on.

The inspiration of the work is still strongly influenced by the Van Eycks. The realistic taste for details, the accuracy of the rendering (in the enclosed garden—*hortus conclusus*—twelve plants, all with symbolic meanings, have been identified: thus on the right, the purple orchid [*orchis mascula*] alludes to fertility), and the crystal-clear light reveal the fundamental allegiance of the young Petrus Christus (for a painting that is definitely his, see here p. 35) to the world of the master of the Ghent polyptych.

The surprising perspective from above (or maybe we should say the lack of true perspective) and multiple points of view, but above all the enchanting composition, are extremely appealing. The Virgin, on the threshold of a church which she personifies, together Romanesque and Gothic, receives the divine message.

A detail often pointed out: the empty niche above the Virgin. It awaits the statue of the Saviour.

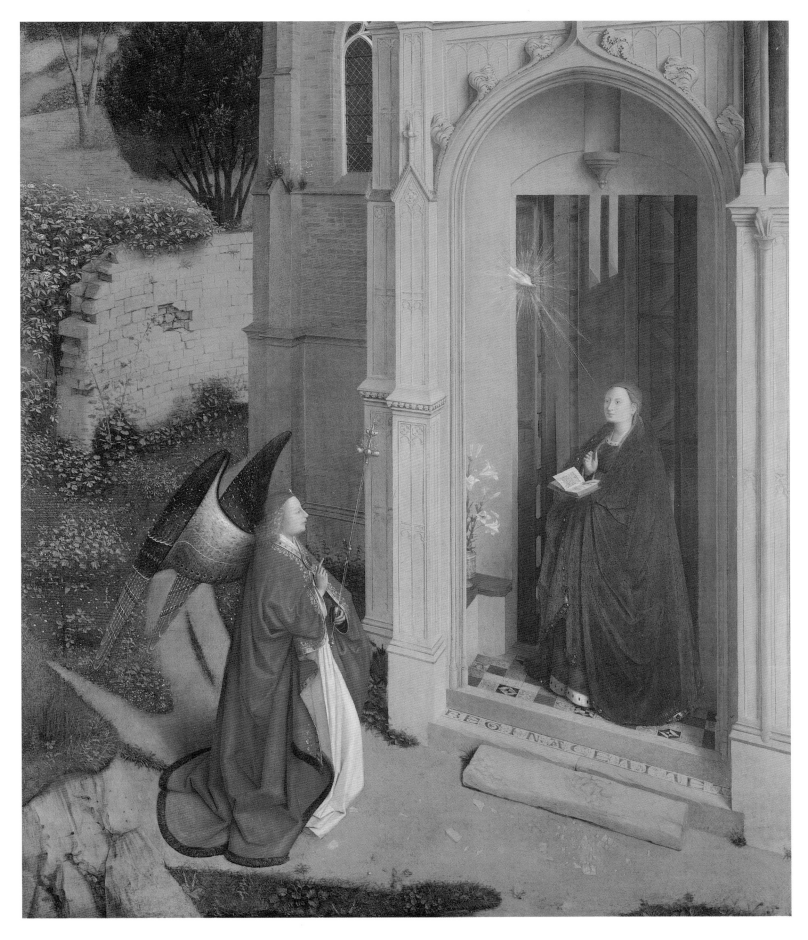

Giovanni di Paolo

Siena, 1395/1399 – Siena, 1482

The Creation and the Expulsion of Adam and Eve from Paradise

Wood
H. 46.5; W. 52
1445

New York, The Metropolitan Museum of Art
(Robert Lehman Collection, inv. 1975.1.31)
[See Provenance and Reference p. 230–31]

On the right, a nude angel drives Adam and Eve from Paradise (this group derives from a carved motif of the "Fonte Gaia" by Jacopo della Quercia on the Piazza del Campo in Siena). The four rivers of Genesis, the Pison, the Gihon, the Tigris, and the Euphrates lie at their feet.

At the center of the globe of the earth, these same rivers appear at the top of the map of the world with Europe in lower right. The colors of each of the twelve circles surrounding the earth symbolize the elements, green for water, blue for air, red for fire and the planets. God, accompanied by throngs of cherubim, creates the Earth and the Heavens. For the details of his painting Giovanni di Paolo's direct source was the text of Dante's *Divine Comedy* that he transposed with great narrative accuracy. The rabbits symbolize lasciviousness and Man's fall while also referring to his innocence.

Giovanni di Paolo is particularly well represented in American collections (aside from New York, we should mention the museums of Chicago, Minneapolis, Detroit, Pasadena [Norton Simon], Boston, Cleveland…).

Giovanni di Paolo,
Paradise, New York,
The Metropolitan Museum
of Art

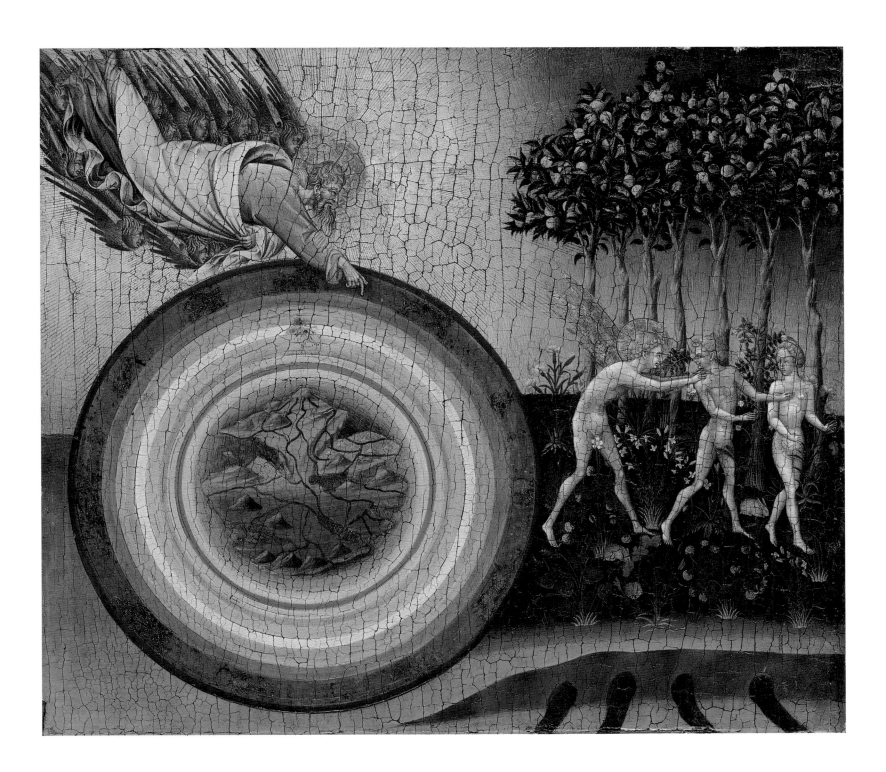

Petrus Christus

Mentioned in Bruges after 1444 and died in that city
in 1475/1476

A Goldsmith in his Shop, possibly Saint Eloi

Wood
H. 98; W. 85
Signed and dated *1449* below (signature impossible to copy)

New York, The Metropolitan Museum of Art
(Robert Lehman Collection, inv. 1975.1.110)
[See Provenance and Reference p. 229]

When selecting a Petrus Christus for this book, we hesi-
tated: our heart leaned toward the *Portrait of a Carthusian*
(1446) in the same Metropolitan Museum, but the *Portrait of
a Young Woman*, held at the Gemäldegalerie in Berlin, is the
artist's masterwork. And then our desire to pay tribute to the
generous collectors Philip and Robert Lehman prompted us to
pick *Saint Eloi,* the artist's most popular work, according to
M. Ainsworth, the author of the catalog of the *Petrus Christus*
exhibition in 1994.

Petrus Christus,
Portrait of a Carthusian,
New York, The Metropolitan
Museum of Art

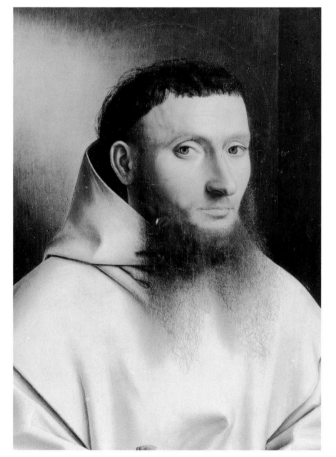

A young couple, in lavish apparel, is
choosing wedding rings at a goldsmith's,
symbolized by Saint Eloi: such appears to be
the subject of the New York picture. Articles
of all kinds arrayed on the shelves of the
richly stocked jeweler's shop, the convex
mirror reflecting the two men, one of whom
is holding a falcon, and the betrothal belt on
the table are so many details that Petrus
Christus delighted in painting, carefully sep-
arating them one from another. Attention
has been drawn to the shifting gaze of the
jeweler, questioningly turned toward the fi-
ancée, as the fiancé lovingly holds his be-
trothed by the shoulder, while carefully
watching the beams of the jeweler's scales…
The work is one of the most important fif-
teenth-century secular compositions.

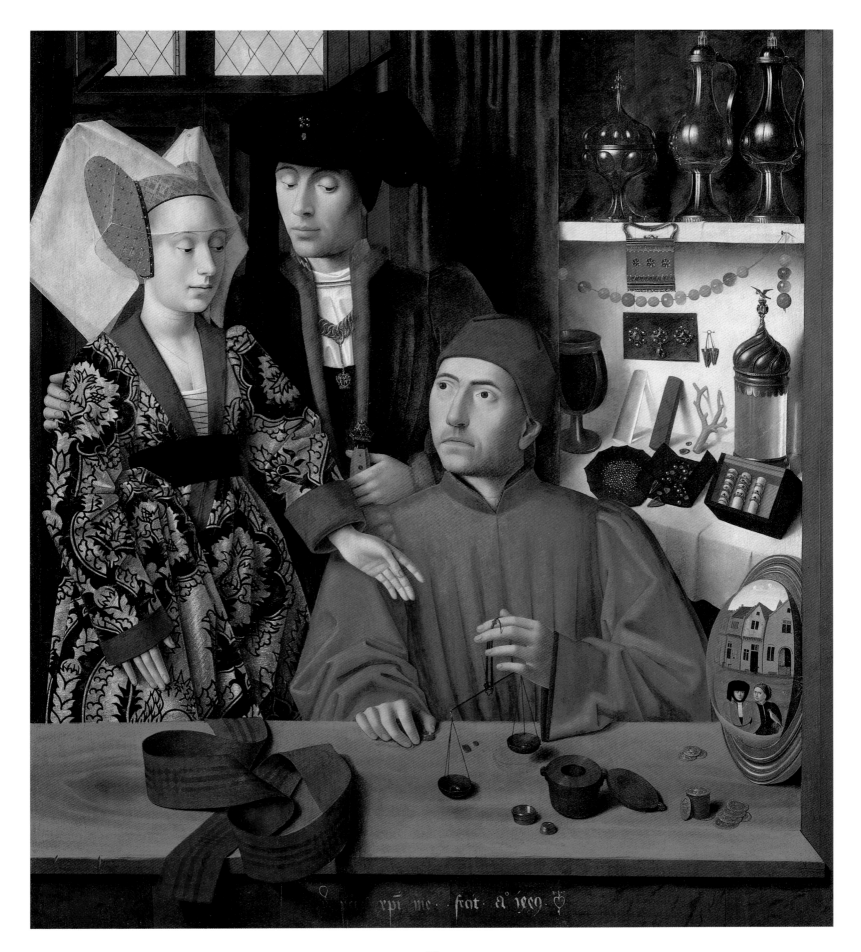

Giovanni di Ser Giovanni di Simone,
known as Lo Scheggia

San Giovanni Valdarno, 1406 – Florence, 1486

The Triumph of Fame

Wood with gold and silver heightening
(in its original frame)
Ø 92.7 (62.5 without the frame)
1449

New York, The Metropolitan Museum of Art
(inv. 1995.7)
[See Provenance and Reference p. 234–35]

In Florence in the fifteenth century it was customary at the birth of a child to have made a *desco da parto* (birth tray or salvar). The loveliest of all those hitherto come down to us is the one in New York owed to Lo Scheggia, the younger brother of the great Masaccio (1401–1428). It celebrates the birth, on the first of January 1449, of Lorenzo de' Medici (later known as Il Magnifico, died in 1492), son of Piero de' Medici, known as Il Gottoso (1416–1469), and Lucrezia Tornabuoni (their arms appear on the reverse of the *desco da parto*). Inspired by Boccaccio (*L'Amorosa Visione*) and by Petrarch's *Trionfi*, it displays the winged figure of Fame holding a sword and a Cupid—they symbolize victory by arms and by love—, with at his feet a throng of knights swearing loyalty to him.

The work was in Florence until 1801 when it was purchased by A.-F. Artaud de Montor (1772–1849), one of the first French *connoisseurs* of the Italian Primitives. When it was sold in Paris in 1851 (under the name of Giotto), it was purchased by Thomas Jefferson Bryan (1802–1870), the first New York collector of early Italian painting. In 1867 he offered it to the New York Historical Society before the Metropolitan Museum bought it in 1995.

The rim, an integral part of this unique work, is ornamented with twelve ostrich plumes, a heraldic device of Lorenzo's father.

Reverse of the panel,
*Impresa of the Medici Family
and Arms of the Medici and
Tornabuoni Families*,
New York, The Metropolitan
Museum of Art

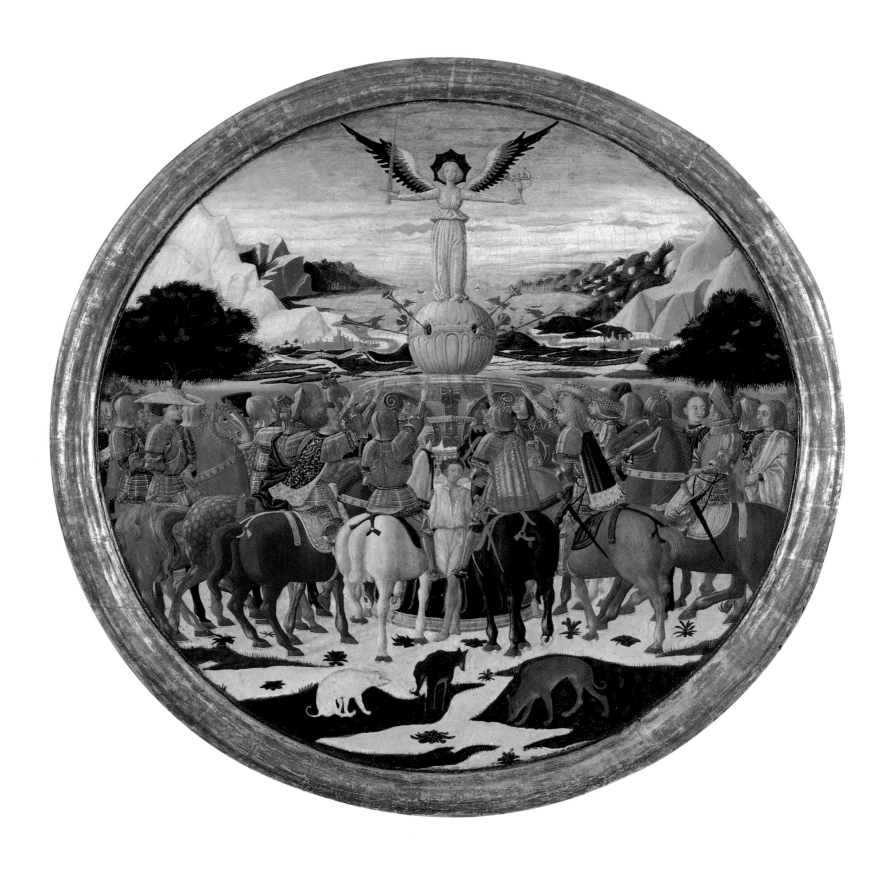

Bartolomeo di Giovanni Corradini, known as Fra Carnevale

Urbino, 1420/1425 – Urbino, 1484

The Presentation of the Virgin at the Temple (?)

Wood
H. 146.5; W. 96.5
C. 1466

Boston, Museum of Fine Arts
(Charles Potter Kling Fund, inv. 37.108)
[See Provenance and Reference p. 228]

The Metropolitan Museum holds the *pendant* of the Boston picture: a *Birth of the Virgin*. These extravagant compositions, which remained together until 1934, were reunited in Milan and in New York seventy years later on the occasion of the memorable *Fra Carnevale* exhibition.

Countless art historians have endeavored to penetrate the mystery of their subjects, their author, his relationship with Piero della Francesca, Alberti, and the world of architects, as well as with contemporary Florentine culture. Federico Zeri proposed identifying the painter in the Master of the Barberini Panels, Giovanni Angelo d'Antonio da Camerino. But today scholars agree on the name of Fra Carnevale, the leading figure in fifteenth-century Marchigian painting, as well as on the original collocation and the dating (c. 1466) of the two works. On the other hand, the identification of the subject of the Boston panel (is it, as it would seem at a glance, the *Presentation of the Virgin at the Temple*?) and the eventual existence of other panels are still being discussed.

The overall unity of the composition is assured by the complex architecture, the object of the painter's utmost care. The greyhound, seen in profile in the foreground, the three nude beggars, the bedecked apparel of the young women and the adolescents, their heavy chatoyant draperies, and other fascinating and puzzling details explain the popularity of these two admirable compositions among which the reader may choose according to taste.

Fra Carnevale,
The Birth of the Virgin,
New York, The Metropolitan
Museum of Art

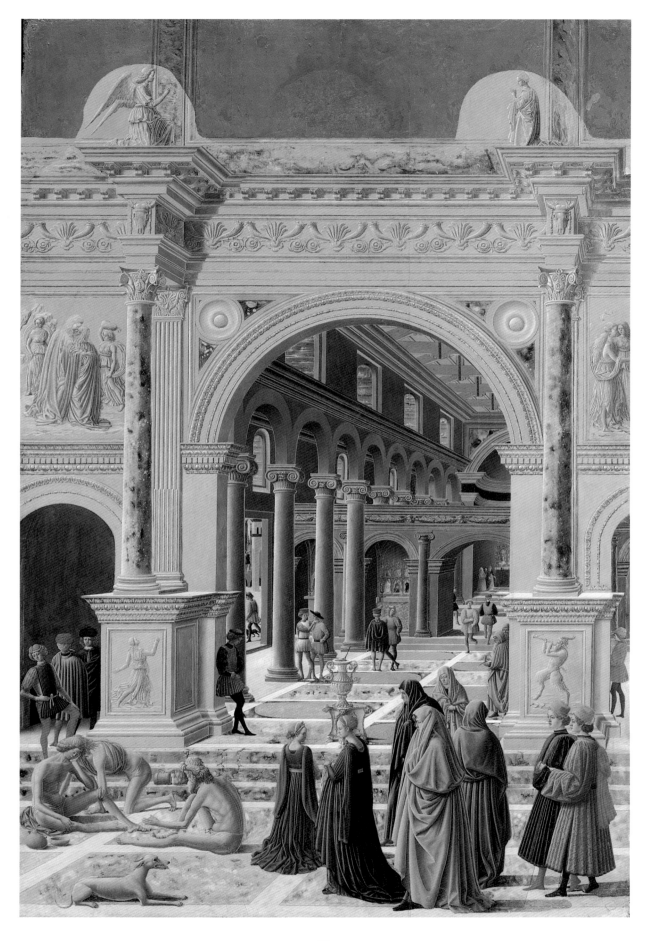

Carlo Crivelli

Venice, c. 1430/1435 – Camerino, in the Marches,
c. 1494/1495

Saint George and the Dragon

Wood
H. 90; W. c. 46 (uneven)
1470

Boston, Isabella Stewart Gardner Museum
(inv. P16e13)
[See Provenance and Reference p. 229]

The right wing of a multi-paneled altarpiece, now dismembered (and divided between London, Washington, Detroit, Tulsa, and Cracovy), painted by Crivelli in 1470. We recognize on the left, in the upper part of the panel, the thirteenth-century fortress of Porto San Giorgio, near Fermo.

While Crivelli remained true to the gold ground he adopted throughout his career, in his *Saint George*, the patron saint of the assumed commissioner of the work as well as of the church and the Marchigian town which initially held the polyptych, he introduced a rather uncharacteristic movement. The rearing charger, the gesture of the saint, an adolescent, wielding his sword in both hands, who is about to slay the long-tailed dragon, give this panel an unusual vitality. We are enthralled by the ornamental sumptuosity, the imagination, the rich details (the broken lance on the ground, the light striking the horse's breast), the inventive coloring in which the reds of the horse's trappings predominate.

May we be forgiven a heresy? Of course, the dismembering of the altarpiece is regrettable. But did not the *Saint George*, a separate element of the polyptych, actually gain by it?

For the painting by Martorell on the same subject, see p. 29.

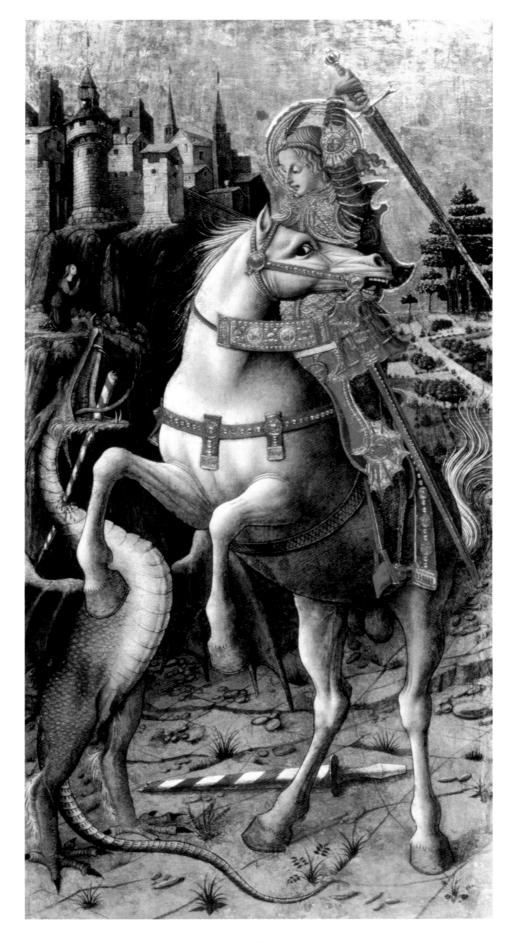

Nicola di Maestro Antonio d'Ancona

Born in Ancona; active in the Marches in the 1470s
and up to c. 1511

*Madonna and Child Enthroned with Saints Leonard, Jerome,
John the Baptist, and Francis*

Wood
H. 153; W. 199.4
Signed and dated on the step of the throne: *OPVS . NICOLAI .
M . ANTONII . DE . ANCONA . M . CCCCLXXII*

Pittsburgh, The Carnegie Museum of Art
(Howard A. Noble Collection, inv. 71.4)
[See Provenance and Reference p. 233]

This work is unquestionably one of the most important creations of Marchigian painting in the second half of the fifteenth century. Signed and dated, it enabled B. Berenson ("Nicola di Maestro Antonio d'Ancona," *Rassegna d'Arte,* II, 1915, pp. 165–74) and then F. Zeri ("Qualcosa su Nicola di Maestro Antonio," *Paragone,* IX, 1958, n.107, pp. 34–41) not only to reconstitute the production of this forceful artist, but to restore to that long-neglected school its place in Renaissance Italy.

Nicola di Maestro Antonio d'Ancona was fond of multiplying the "mineral" folds of his saints' garb, giving them a metallic appearance. The twisted, knotty hands and the expressive realism of the faces characterize his manner of painting.

Observe Jerome with the tiny donor at its feet, the lion, the bouquet of flowers, and especially the lovely landscape unfolding in the background on the right, contrasting with the closed, clearly archaistic aspect of the work.

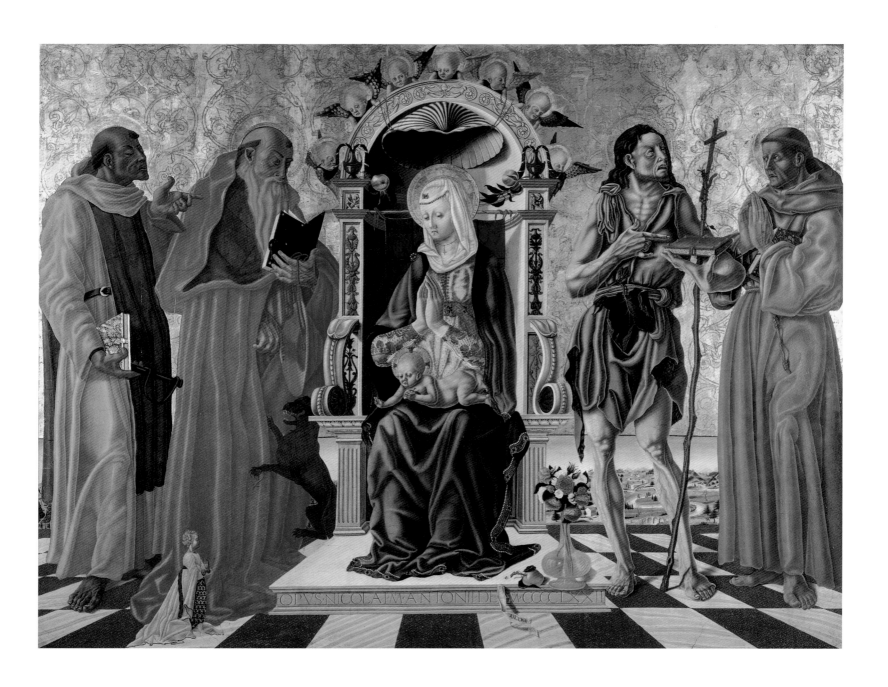

Bartolomé Bermejo

Cordoba, c. 1440 – Barcelona, after 1495

Santa Engracia

Wood
H. 163; W. 72
1474–78

Boston, Isabella Stewart Gardner Museum
(inv. P19e25)
[See Provenance and Reference p. 228]

The central panel of an altarpiece painted circa 1474–78 by Bermejo for the church of Daroca near Saragossa, and certainly the artist's masterwork. Engracia, a saint of Portuguese birth, was martyred in Saragossa under the emperor Diocletian in 304. In 1468 the King of Aragon John II (1398–1479) claimed to be healed of cataracts through contact with a nail, the instrument of the saint's martyrdom: in the Gardner Museum painting she is delicately holding it in her left hand. To tell the truth, the sovereign proved himself ungrateful toward the Arab physicians who successfully treated him.

The painting was auctioned in Brussels in 1904 as the work of an "Unknown Master." Mrs. Gardner (1840–1924) outbid the museums of Brussels and Budapest. That same year Sir Claude Phillips was the first, in the *Daily Telegraph*, to publish it under its correct attribution (hitherto it was believed to be Netherlandish).

We cannot fail to compare the painting to the *Saint George and the Dragon* by Crivelli (see p. 41) of almost the same date, two works revelatory of Mrs. Gardner's taste.

Bartolomé Bermejo,
Reconstruction of the altarpiece

Giovanni Bellini

Venice, c. 1430 – Venice, 1516

Saint Francis of Assisi in Ecstasy

Wood
H. 124.4; W. 141.9
Signed lower left on a *cartellino* attached to a shrub:
IOANNES BELLINVS
1485–90

New York, The Frick Collection (inv. 15.1.3)
[See Provenance and Reference p. 228]

Which is the most beautiful painting in America, the one that is absolutely unmatched in Europe? To that question, art historians, whether they be American or European, almost unanimously reply either *La Grande Jatte* (see p. 191), or the Frick Collection Bellini (in 1912 Berenson failed to persuade Mrs. Gardner to buy it).

In 1525 Marcantonio Michiel saw the painting in Venice at the home of Taddeo Contarini. Circa 1845 it arrived in England. It was sold at Christie's, 19 June 1852 (n. 48), for 735 pounds, a considerable amount. In 1915 it was purchased by Henry Clay Frick (1849–1919) for 170.000 dollars.

Today the attribution of the painting is unanimously accepted, but that has not always been the case. Even the great "B.B.", Bernard Berenson (1865–1959), in 1916 continued to hesitate until he fully rehabilitated it some time later. The date of the work is still under discussion, between 1475 and 1490. Its subject as well was recently the object of numerous and divergent iconographic interpretations (see p. 228, our bibliographical references). Giovanni Bellini shows us Saint Francis of Assisi (1181/1182–1226), the saint of the humble, so sweet, so cheerful, the friend of nature, receiving the stigmata of the Passion on Mount Alverne (1224). One detail among others, the ass. It is the one Saint Francis took to go up to Alverne, and it is the one of Christ's entry in Jerusalem as well.

In a radiant, sun-lit landscape Bellini introduced countless details, all alluding to the Franciscan legend. But it is above all the crystal-clear light, at once natural and steeped in the divine, that gives the work its unity, its poetry, its emotion.

The United States possesses a second absolute masterpiece by Bellini: the much later *Feast of the Gods* at the National Gallery in Washington.

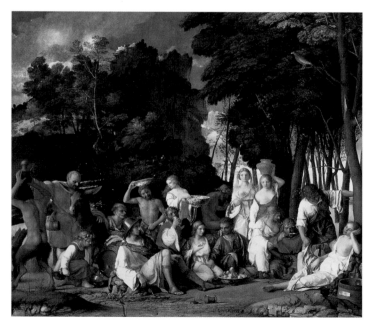

Giovanni Bellini and Titien,
The Feast of the Gods,
Washington, National Gallery of Art

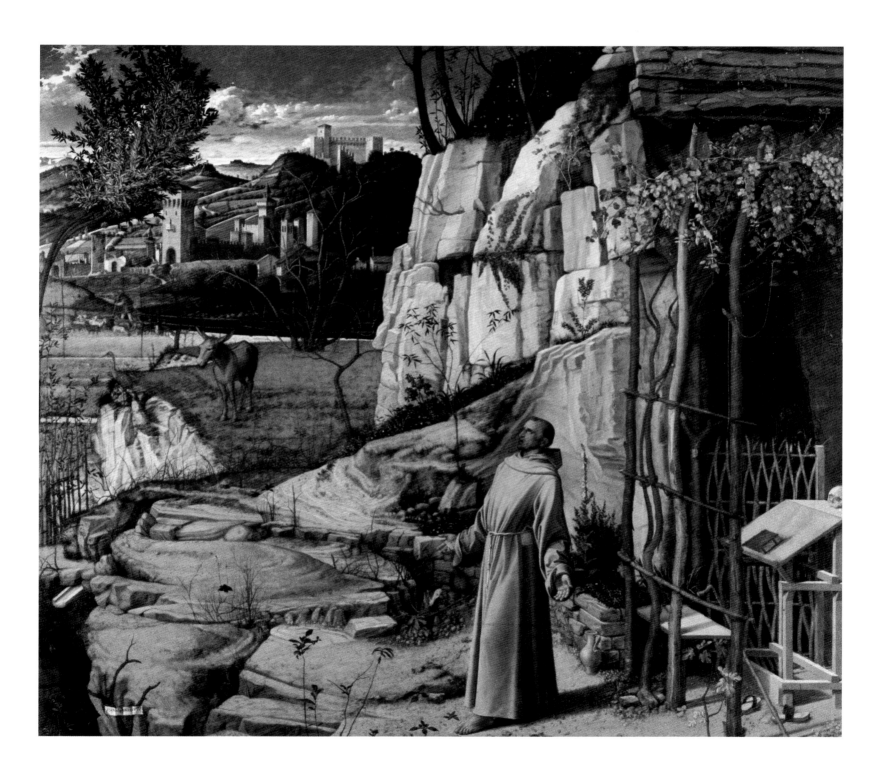

Neroccio de' Landi

Siena, 1447 – Siena, 1500

Portrait of a Young Girl

Wood
H. 47; W. 30.5 (61.8; 45.6 with its original frame)
Signed left and right of the *cartellino*: *OP/ NER*
C. 1485–90

Washington, National Gallery of Art
(Widener Collection, inv. 1942.9.47)
[See Provenance and Reference p. 233]

The Latin inscription we read on the painting can be translated in these words: *Wonderful as my art is in achieving what is possible to man, as negligible am I, mere mortal, compared to the gods.* It may allude to the beauty of the sitter, identified today by general consensus (and confirmed by the family crest on the frame) as one of the three Bandini daughters, among the richest families in Siena. We know for certain the portrait is of a young girl: the model wears her hair loose, whereas married women in Renaissance Italy dressed it in a chignon.

The work probably dates to the years 1485–90. The sitter's spectacular blonde hair, the exquisiteness of her features, her smiling grace, her dreamy, almost absent expression have a great deal to do with the popularity of the painting (its state of conservation leaves greatly to be desired). The young girl's head dress, her gown and opulent jewelry enhance the charm of the work, as does the delicate landscape.

If Neroccio de' Landi, who is considered today a "minor master," retained the memory of bygone elegance, such as that of Simone Martini for example, we remark that in the second half of the fifteenth century Siena had some reservations toward the Tuscan Renaissance and its bold innovations.

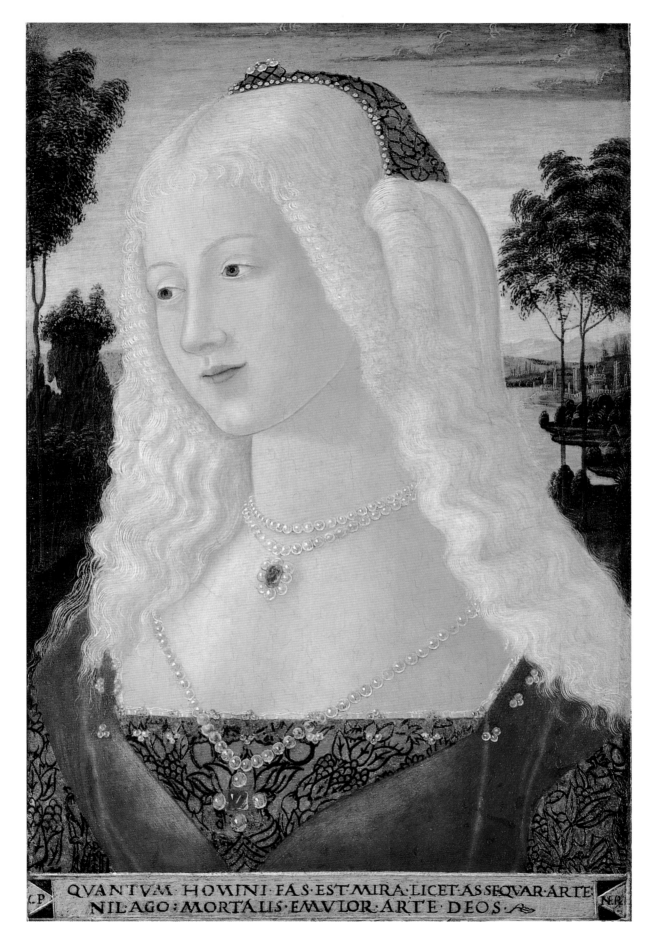

QVANTVM·HOMINI·FAS·EST·MIRA·LICET·ASSEQVAR·ARTE
NIL·AGO·MORTALIS·EMVLOR·ARTE·DEOS

Vittore Carpaccio

Venice, c. 1460/1465 – Venice, c. 1525/1526

The Cormorant Hunt, or *Hunting on the Lagoon*
(reverse: *Trompe-l'œil with Letter Rack*)

Wood
H. 75.4; W. 63.8
1493–95

Los Angeles, The J. Paul Getty Museum
(inv. 79.PB.72)
[See Provenance and Reference p. 229]

It is only very recently that we were able to definitively establish the status of one of the most fascinating works of Venetian painting. *Hunting on the Lagoon* formed the upper section of one of the icons of Italian painting, the so-called *Courtesans* at the Museo Correr in Venice, for Ruskin "the best picture in the world." Proof, among other things, is the lily in the foreground of the Getty picture: its stem immersed in a vase continues in the painting of Museo Correr.

The *Cormorant Hunt*—the work is dated to c. 1493–95—describes the lagoon of Venice steeped in serenity and silence. The hunters bearing bows, standing on boats called "fisolere" or "fisoli," are about to shoot their arrows at some cormorants, piscivorous water fowl. In the sky, a flight of wild geese.

The trompe-l'œil on the reverse, letters attached to a wall on a string, is one of the oldest still lifes in Italian painting.

Vittore Carpaccio,
The Cormorant Hunt, or
Hunting on the Lagoon,
Los Angeles, The J. Paul
Getty Museum

Vittore Carpaccio,
reverse of *The Cormorant Hunt,*
Los Angeles, The J. Paul
Getty Museum

Vittore Carpaccio,
"The Courtesans,"
Venice, Museo Correr

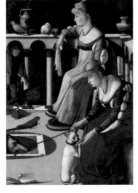

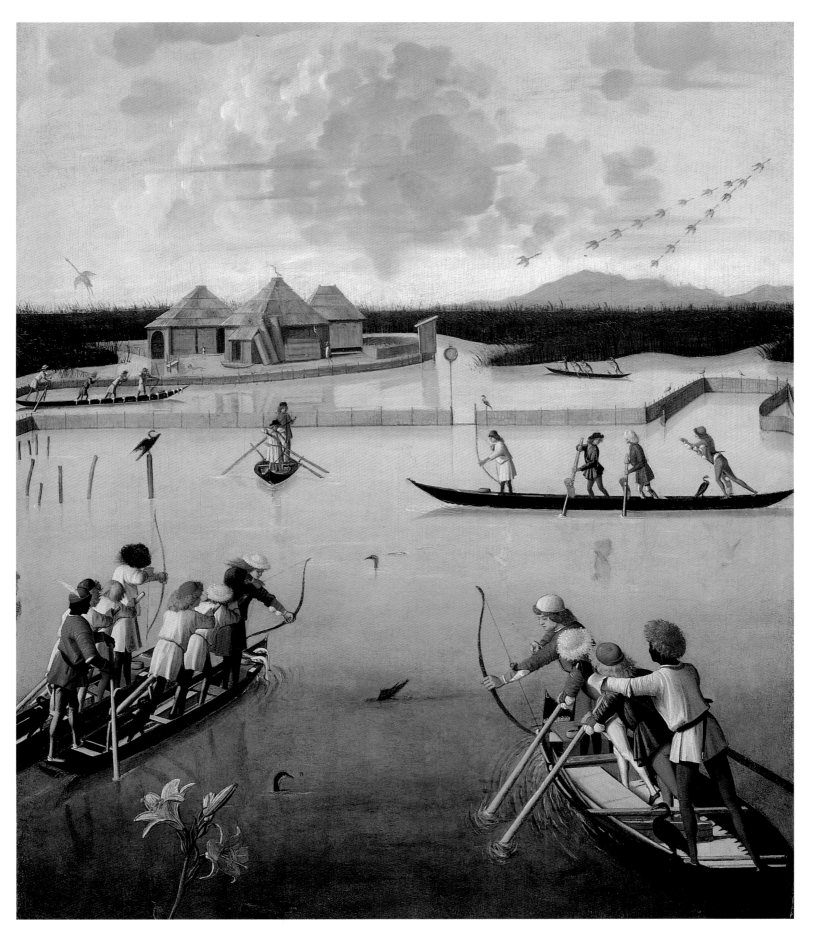

Matthias Gothardt Nithardt, known as Matthias Grünewald

Probably Wurzburg, c. 1475/1480 – Halle, 1528

The Small Crucifixion

Wood
H. 61.6; W. 46
Inscription of the painter's initials at the top of the Cross: *mg*
Doubtless c. 1516

Washington, National Gallery of Art
(Samuel H. Kress Collection, inv. 1961.9.19)
[See Provenance and Reference p. 231]

Why did we choose for our book this *Small Crucifixion* by Grünewald, in all likelihood painted in the 1510s for the canon Caspar Schantz at Aschaffenbourg and engraved in 1605 by Raphael Sadeler? The Isenheim altarpiece in the Colmar museum (its central panel also features a *Crucifixion*) is unquestionably of far greater importance. Of course the work is the only one by this painter in the United States, of course we should once again admire Samuel H. Kress' courage in making this purchase in 1953, two years before passing away. But the main reason is that it is a unique masterpiece, outside of time and of every pictorial tradition, like every true masterpiece.

Grünewald chose the moment when, at the death of Christ, the sun disappeared and the sky darkened. The Cross is bent under the weight of the Christ's body. The wild violence of the attitudes and expressions, the bold coloring, make this small picture blending mysticism and realism an unforgettable work.

Matthias Grünewald,
Crucifixion, Colmar,
Unterlinden Museum

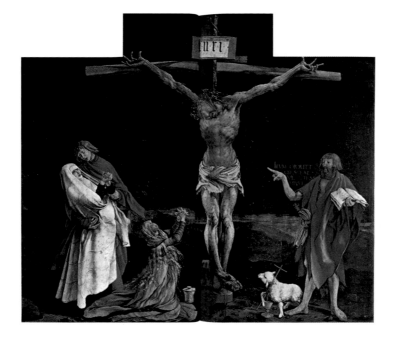

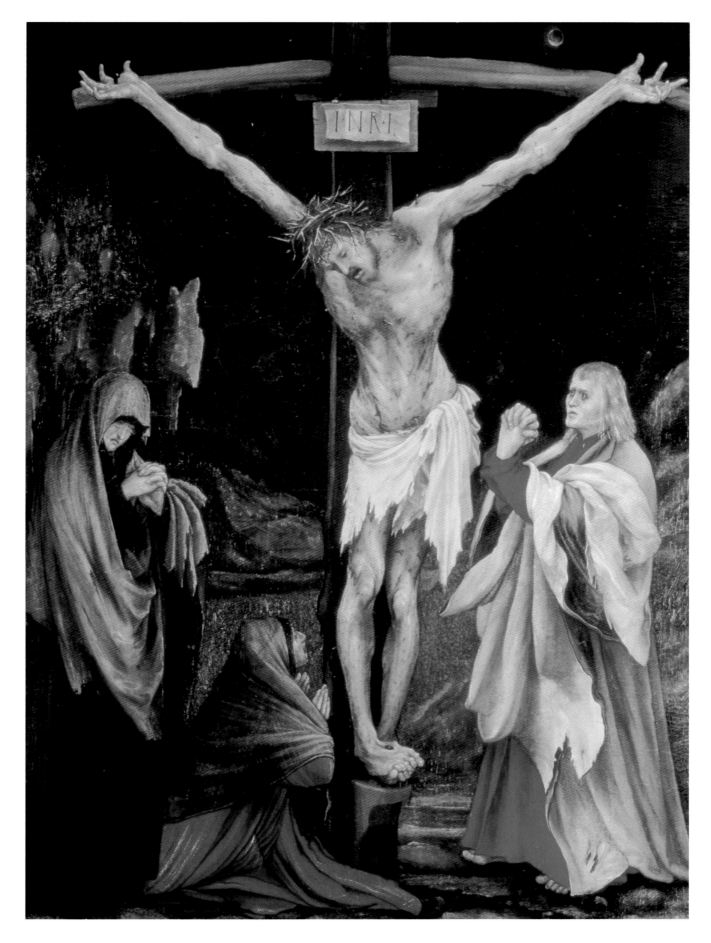

Pietro di Lorenzo, known as Piero di Cosimo

Florence, 1461/1462 – Florence, 1521 (?)

The Building of a Palace

Wood
H. 77.5 (excluding the 5 cm added at the top); W. 197
C. 1515–20

Sarasota, The John and Mable Ringling Museum of Art
(inv. SN 22)
[See Provenance and Reference p. 234]

The attribution of the panel, a *spalliera*, decorative panel for the ornamentation of Florentine patrician residences, is not certain (Federico Zeri thought of the Master of Serumido, perhaps Aristotile da Sangallo), nor is its date (generally 1515–20). But the work, for good reasons, drew the attention of architecture historians (notably Martin Kemp). It shows a palace with two strictly symmetrical porticoed buildings connected to one another by a wide balustrade graced with sculptures. The edifice is under construction and the various craftsmen working on it (architects and sculptors, stone cutters, sawyers, carpenters, engineers…) are moving about. The work is at once a fascinating document on building techniques in Florence in the early sixteenth century, an era of great architectural blossoming, and a reflection on the application of the architectural theories of Vitruvius and Leon Battista Alberti, widely discussed at the time.

In an image ruled by perspective, Piero di Cosimo created an ideal assembly of practicians and theoreticians, in keeping with the principles prized by the Humanists of the Florentine Renaissance.

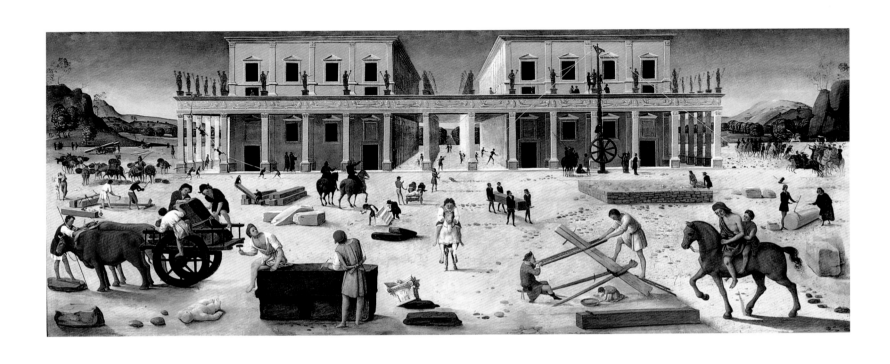

Lorenzo Lotto

Venice, c. 1480 – Loreto, 1556/1557

Venus and Eros

Canvas
H. 92.4; W. 111.4
Signed at the bottom of the tree trunk, lower right: *Laurent. Loto*
Probably c. 1525, toward the end of the artist's sojourn in Bergamo
or on his return to Venice

New York, The Metropolitan Museum of Art
(Purchase, Mrs. Charles Wrightsman Gift, in honor of Marietta Tree,
inv. 1986.138)
[See Provenance and Reference p. 232]

Why is Eros, a cupid, a winged Eros armed with his bow, but at the same time a four year-old little boy, pissing on Venus through a myrtle wreath she elegantly holds aloft at her finger tips? Everything in this saucy, light-hearted, high-spirited painting alludes to marriage. The shell above Venus' head, the rose petals scattered over her lap, the brazier burning incense suspended from the wreath are all matrimonial, sexual symbols, allusions to the couple's future fecundity. Note as well the ivy, signifying conjugal fidelity, on the tree trunk.

There were countless representations of the theme of *Venus and Eros*, from Giorgione to Titian, in sixteenth-century Venice. Lotto innovates and above all provokes. Lively Eros, like the goddess with her single earring staring at us, have the ambition of being portraits as well as allegorical figures. Venus smiles at us and unashamedly presents us her nude body, as she is about to offer it to her husband.

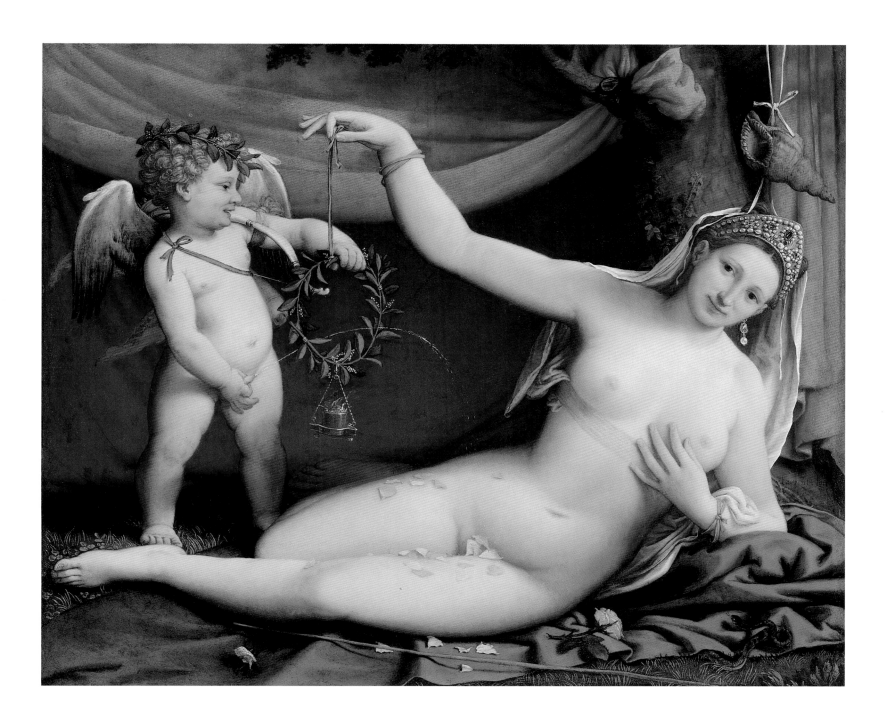

Jacopo Carucci, known as Pontormo

Pontorme, 1494 – Florence, 1556

Portrait of a Halberdier

Canvas (formerly wood)
H. 92; W. 72
1529–30

Los Angeles, The J. Paul Getty Museum
(inv. 89.PA.49)
[See Provenance and Reference p. 234]

The painting hung for so many years (1970–1989) on the walls of the Frick Collection that unobservant visitors thought it belonged to the famous New York museum whereas it was only on loan. In 1920 it had been definitively attributed to Pontormo. For the sitter's identity, probably Francesco Guardi (1514–1554) and not Cosimo I de' Medici, we are indebted to Elizabeth Cropper (1997), who dates the work to 1529–30.

The adolescent is staring at us. He holds a halberd in his right hand and his left hand is on his hip. Pontormo carefully describes his sitter's apparel, but it is his face, a combination of arrogance and anxiety, that focuses his attention. Notice the sword with its hilt standing out against the halberdier's red trousers, as well as the gilt medallion gracing his feathered cap, bright red as well, on which Pontormo depicted a scene that was popular in the Renaissance showing Hercules suffocating Antaeus.

Until Rubens' *Massacre of the Innocents* was sold at auction, 10 July 1992 (49.500.000 pounds), the *Portrait of a Halberdier* was constantly cited in the press as the "most expensive [Old Master painting] in the world" following itsa sale, 31 May 1989, in New York for 35.200.000 dollars.

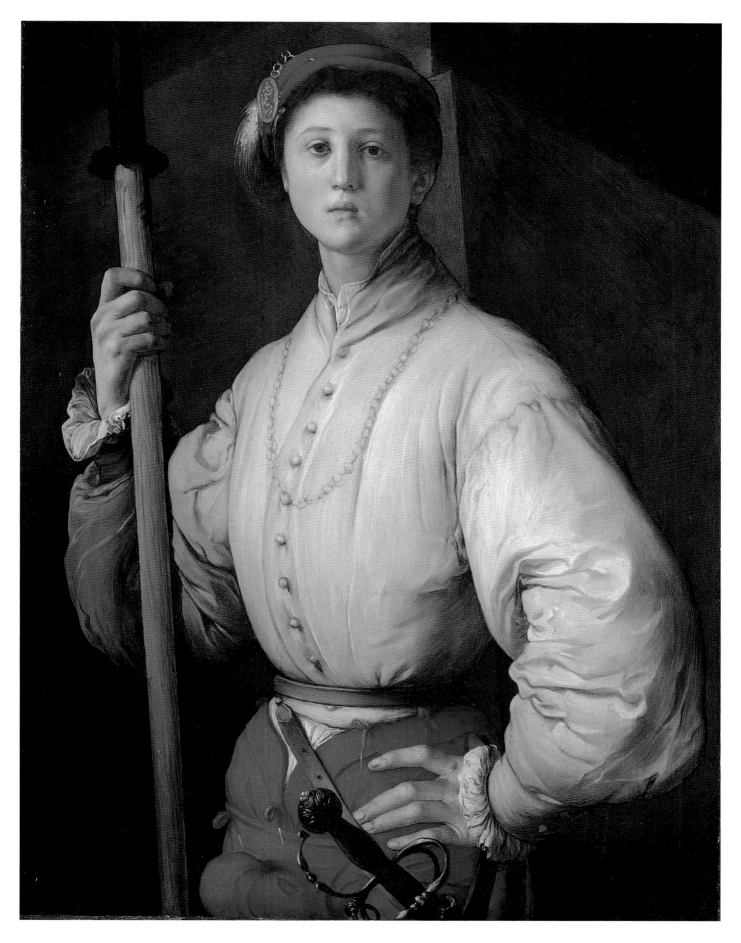

*Virgin and the Christ Child, Saint Elizabeth (or Saint Anne),
the Young Saint John the Baptist, and Two Angels*

Wood
H. 116; W. 117
Before 1532 or shortly before 1540

Los Angeles, Los Angeles County Museum of Art
(Gift of Dr. and Mrs. Herbert T. Kalmus, inv. 54.6)
[See Provenance and Reference p. 234]

Paintings by Rosso—his surname comes from the color of his hair—are extremely rare. The United States holds two absolute masterpieces by the artist: we hesitated at length between them. To the *Dead Christ Flanked by Angels* of Boston we finally preferred the fascinating Los Angeles picture.

There has not been a consensus to recognise in the figure of the old woman on the left of the composition, Saint Elizabeth, or Saint Anne according to some. The date of the work is also under discussion: Rosso's last years in Italy, therefore before 1532, for some (the support, cottonwood, is an argument in their favor), or his stay in France, for others (its unfinished aspect, comparison with several prints after the French-period Rosso, argue for them).

The composition is striking, almost a hallucination. The elongation of the fingers and the emaciated bodies, the hacked out folds, the expressive violence of the countenances, the dramatization of the scene, emphasized by the unfinished appearance of the work, fully justify the words of Roberto Longhi who described the panel as the "Holy Family in Hell."

Rosso Fiorentino,
Dead Christ Flanked by Angels,
Boston, Museum of Fine Arts

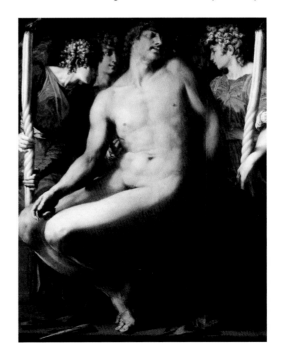

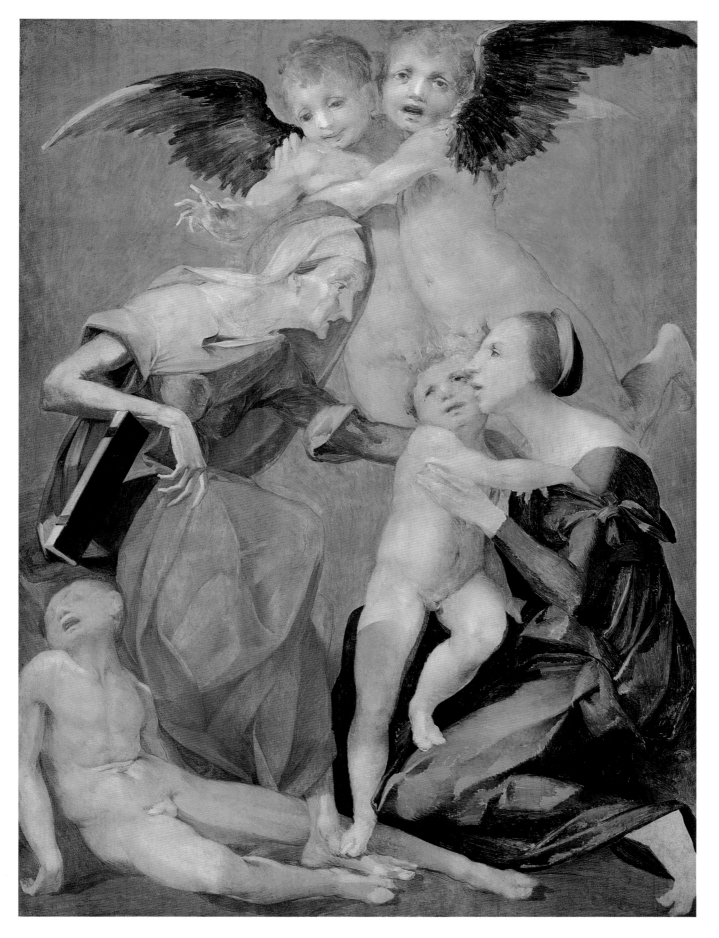

The Pseudo-Félix Chrestien,
known as the Master of the Dinteville Allegory

Active in the region of Auxerre between 1535 and 1537

Moses and Aaron before Pharaoh

Wood
H. 176; W. 192.7
Dated *1537*

New York, The Metropolitan Museum of Art
(Wentworth Fund, inv. 50.70)
[See Provenance and Reference p. 234]

The powerful Dinteville family, after falling out of grace in 1537, sought to vindicate its character. The Metropolitan Museum panel, at once biblical and allegorical, pleads its cause. To prove the Lord's almightiness, Aaron turned his staff into a serpent before Pharaoh. In the New York picture, Jean de Dinteville in the guise of Moses is accompanied by his three brothers François II, bishop of Auxerre, Guillaume, and Gaucher. On the left, we recognize the King of France François I identified with Pharaoh. Jean points at heaven with one hand and with the other at François II/ Aaron, as if to signify that he is the bishop chosen by the Lord and that the family is innocent of the accusations borne against it.

Just who might be the author of this impressive composition? After mistakenly suggesting the name of Félix Chrestien (ou Chrétien), scholars now lean toward a Netherlandish artist, still anonymous, active in the region of Auxerre after 1535 but doubtless even earlier (perhaps Bartholomaeus Pons; see Frédéric Elsig, "Un peintre de la Renaissance en Bourgogne, le Maître du triptyque d'Autun [Grégoire Guérard ?]," *Revue de l'Art*, n. 147, 2005, pp. 88 and 90 note 54).

We recall that at Polisy, in the Dinteville chateau, it was once possible to admire Holbein's *Ambassadors*, today at the National Gallery in London, painted in 1533 and scarcely larger than the New York picture. The two works were not separated until 1787 (at the Beaujon sale they were sold together for the paltry sum of 40 pounds).

Hans Holbein,
The Ambassadors,
London, The National Gallery

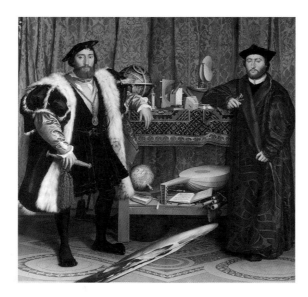

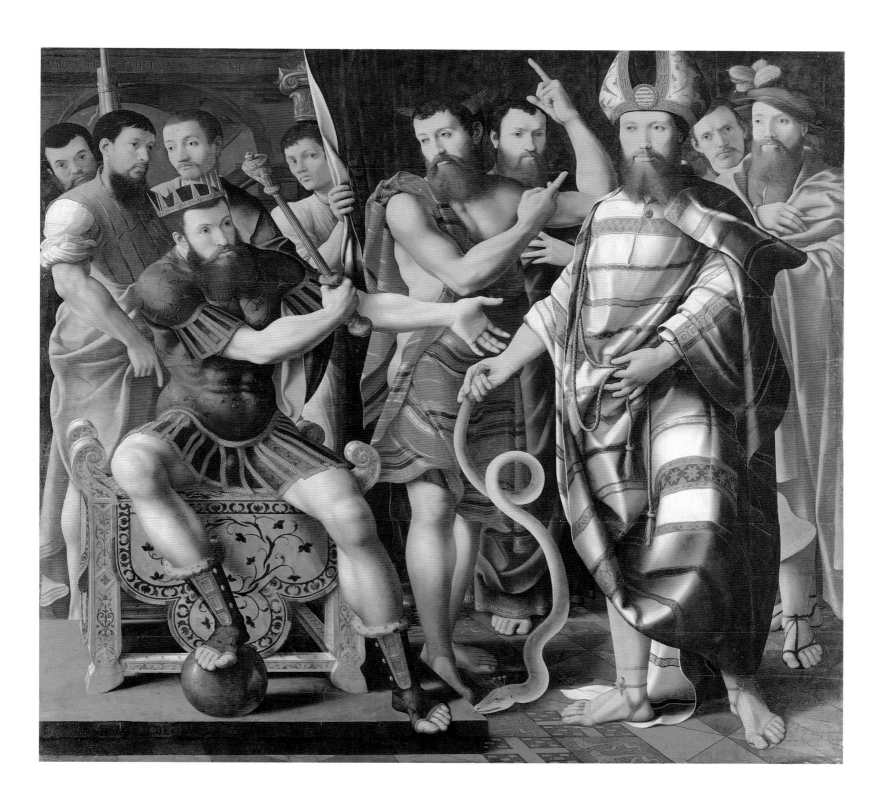

Jacopo da Ponte, known as Jacopo Bassano

Bassano, c. 1510/1515 – Bassano, 1592

The Flight into Egypt

Canvas
H. 119.4; W. 198.1
1544–45

Pasadena, Norton Simon Museum
(inv. M. 1969.35.P.)
[See Provenance and Reference p. 228]

In 1969, when Norton Simon purchased this picture for 655.000 dollars, which at the time seemed extravagant, everyone realized not only that the great collector's interest would no longer be limited to Impressionist canvases, but above all that the prices of high quality Old Master paintings, even by artists less famous than Raphael or Rembrandt, would never again be the same (at the same sale, the Getty bought its *Old Man in Military Costume* by Rembrandt for 756.000 dollars).

The Flight into Egypt by Bassano, which everyone agrees to date to c. 1544–45, renews one of the most popular themes in the history of painting. Unforgettable are the realistic morcels like the peasant in the foreground with his basket full of chickens, the movement given to the composition by the angel with its large, gaily colored outspread wings leading the caravan. The Norton Simon canvas can be compared to the one with the same subject, larger but more restrained, of the Toledo Museum of Art, slightly earlier.

Jacopo Bassano,
The Flight into Egypt,
Toledo, Toledo Museum of Art

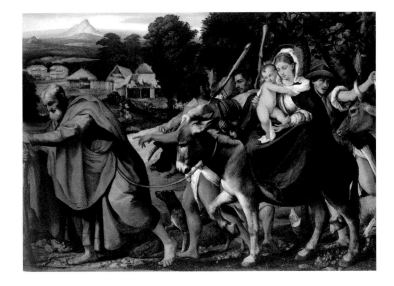

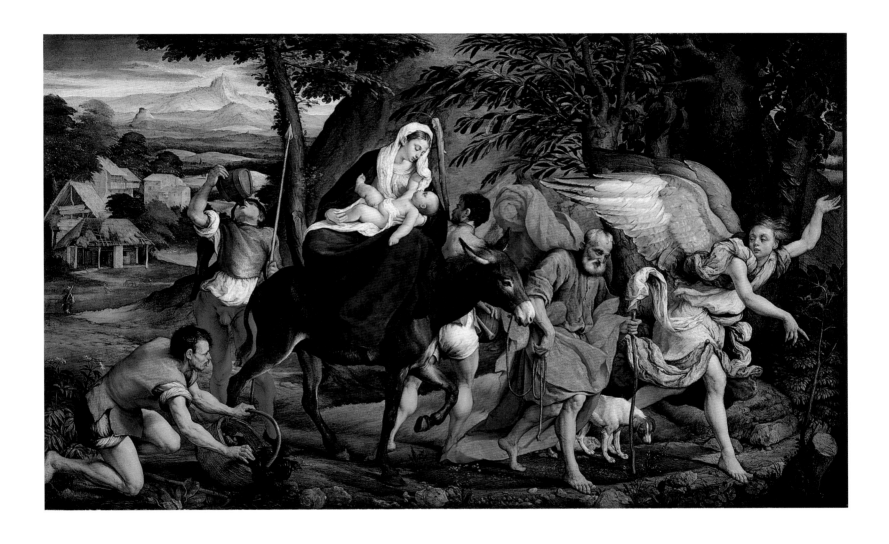

Tiziano Vecellio, known as Titian

Pieve di Cadore, 1484/1489 (?) – Venice, 1575

Europa

Canvas
H. 178; W. 205
Signed in capital letters lower right: *TITIANVS. P.*
1559–62

Boston, Isabella Stewart Gardner Museum
(inv. P26e1)
[See Provenance and Reference p. 235]

One of the six "poems," to quote Titian's word, painted by the artist on a commission by Philip II, King of Spain (the other compositions of the series are shown at the Prado, the National Gallery in Edinburgh [on loan from the Duke of Sutherland's collection], and the National Gallery in London), and one of the painter's most beautiful pictures. The Boston painting was executed at the same time as the *Diana and Actaeon* of the National Gallery in London.

The subject is borrowed from Ovid's *Metamorphoses*: before the very eyes of her handmaidens, Europa is ravished from the shores of her native Phoenicia by a bull. He carries her to Crete and discloses his identity: he is Jupiter, King of the Gods.

Even more than the landscape of sea and mountains, Europa's gesture of surprise strikes us as admirable. With her right arm she conceals her face that expresses dismay (before the growing maritime power of the Turks) and expectancy. Europa will give her name to a continent, to a Europe prevailingly Spanish at the time.

The freedom of its execution and inspiration as well as its sensuous poetry unquestionably rank the Boston canvas among Titian's masterpieces.

Titian, *Diana and Actaeon*, London, The National Gallery

Titian, *Portrait of Cardinal Filippo Archinto*, Philadelphia, Philadelphia Museum of Art

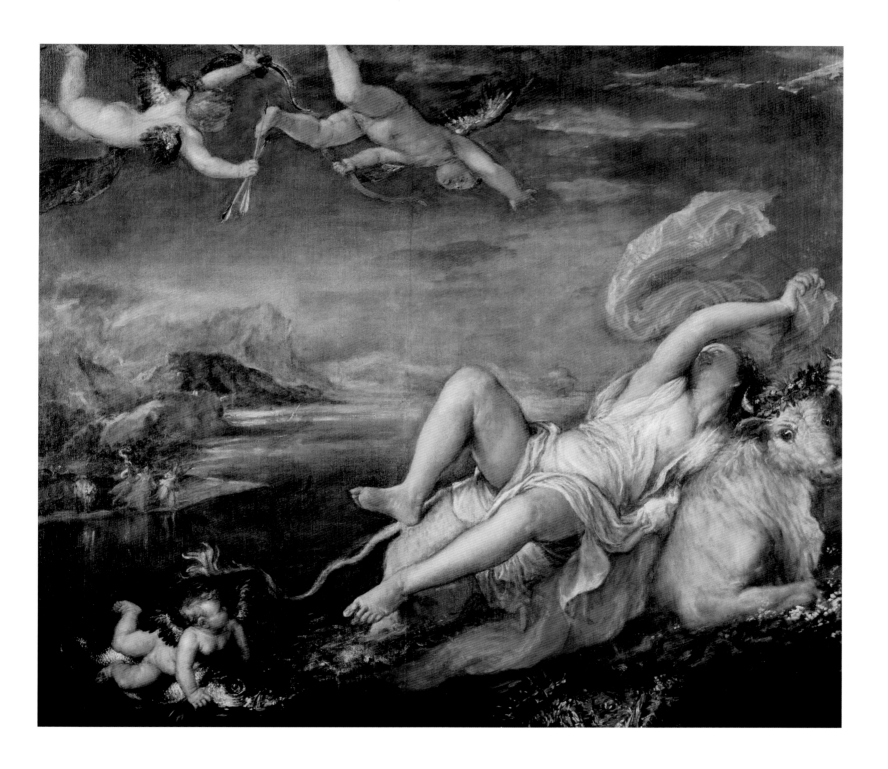

Hans Hoffmann

Nuremberg, c. 1530 – Prague, 1591/1592

A Hare in the Forest

Wood
H. 62; W. 78
1585

Los Angeles, The J. Paul Getty Museum
(inv. 2001.12)
[See Provenance and Reference p. 231]

The only oil painting with an animal subject by Hans Hoffmann hitherto known, the Getty *Hare* takes its source directly from Dürer's celebrated *Hare* (preserved at the Albertina in Vienna).

Hoffmann, who painted several hares on vellum, was fond of accumulating details: a lizard, butterflies, a grasshopper, flowers, and plants of all kinds (bluebell, thistle…). A robin, snails, a fly, a bee, are meticulously, faithfully reproduced. But what most of all catches our eye is the watchful big russet hare, nibbling on a leaf of Lady's Mantle.

The work, perfectly suited to the taste at the courts of Munich and Prague in the late sixteenth century when Dürer's work was in high favor, might be irksome with its concern for highly detailed observation, scientific in character. Yet it is appealing as much for its verist accuracy as for the sympathy with which Hoffmann described this shaded underwood and its fearful long-eared inhabitant.

Albrecht Dürer,
Hare, Vienna, Albertina

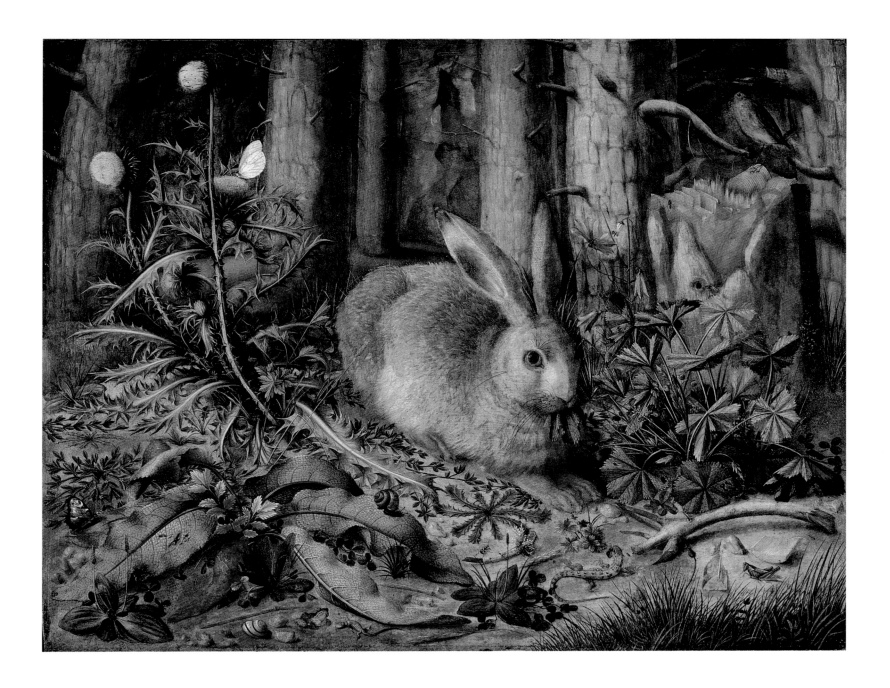

Dhomenikos Theotokópoulos, known as El Greco

Candia, in Crete, 1541 – Toledo, 1614

View of Toledo

Canvas
H. 121.3; W. 108.6
Signed lower right in Greek characters
Shortly before 1600

New York, The Metropolitan Museum of Art
(Bequest of Mrs. H.O. Havemeyer, inv. 29.100.6)
[See Provenance and Reference p. 231]

In this representation of Toledo seen from the north we recognize the Alcazar towering over the city, on its left the cathedral, lower down the Roman bridge of Alcántara, and on the far left of the composition the castle of San Servandos. This is not merely one of the only two views of Toledo by El Greco, but above all one of the most stunning cityscapes in the entire history of painting. Probably executed before 1600, in Spain until 1907, as soon as the picture entered the Havemeyer collection it largely contributed to El Greco's fame, deeply impressing the imagination of the painters of the first half of the twentieth century. The stormy sky accentuates its dramatic violence, its expressionist character. It is a unique work, by its composition as well as its bold coloring, freed from the rules of the Italian or Northern landscape. We have to wait for Van Gogh's landscapes of Provence to see nature approached with a comparable visionary boldness.

El Greco,
Laocoon, Washington,
National Gallery of Art

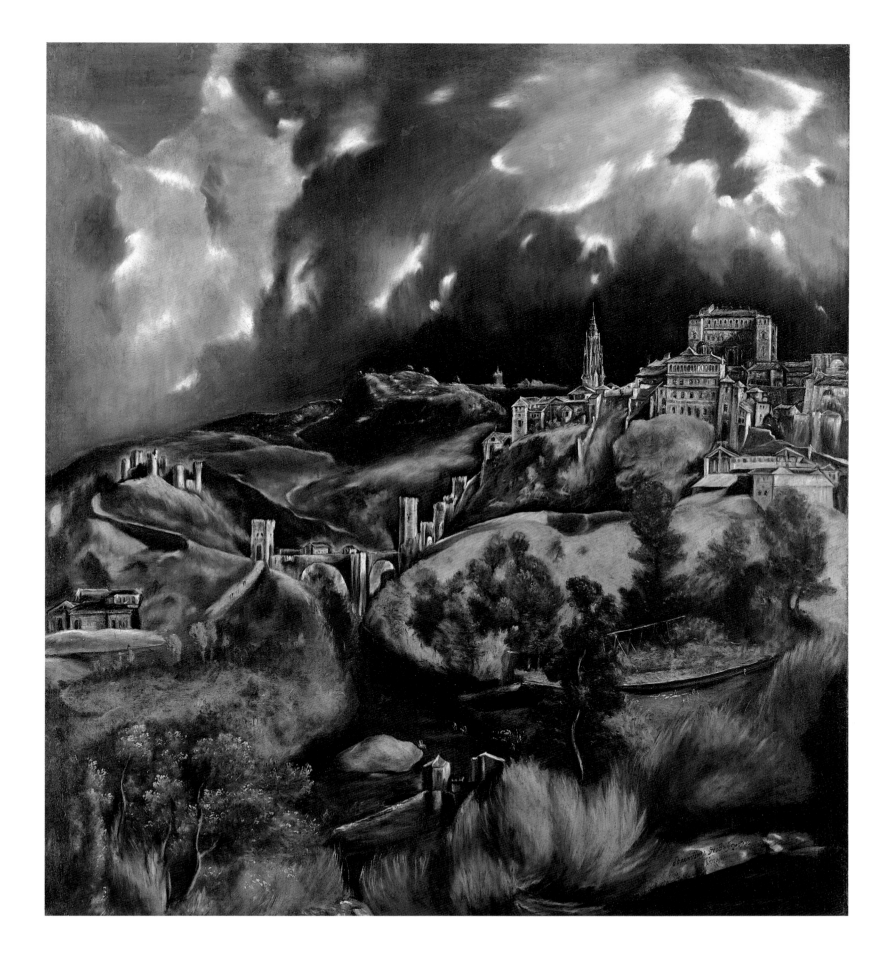

Hendrick Goltzius

Mühlbracht, 1558 – Haarlem, 1617

"Sine Cerere et Libero friget Venus"
Without Bacchus and Ceres, Venus Would Freeze

Canvas, pen and brown ink
H. 105; W. 80
Monogram *HG* with entwined capitals lower right
C. 1600–05

Philadelphia, Philadelphia Museum of Art
(inv. 1990.100.1)
[See Provenance and Reference p. 231]

Rather than the *Danae* (1603) of the Los Angeles County Museum by the same Goltzius, we chose the exceptional, enthralling Philadelphia composition. Exceptional by its technique: it is actually a large pen drawing on a canvas primed with blue-gray oil and featuring yellow, pink, and red highlights. Out of the three pen drawings on canvas cited in the early seventeenth century by Karel van Mander, the only one extant is at the Hermitage. And unlike the Philadelphia one it is not colored.

Exceptional as well by its artificial light. A torch kindles the faces and the nude breasts of Venus, graced with a pearl necklace. A horned satyr and a long-haired adolescent offer her fruit and grapes. The torch is held by a winged cupid, carrying his bow and his quiver, with a saucy expression, turned toward us as if vaunting the beauty of Venus and amorous pleasures.

Hendrick Goltzius,
Danae, Los Angeles,
Los Angeles County
Museum of Art

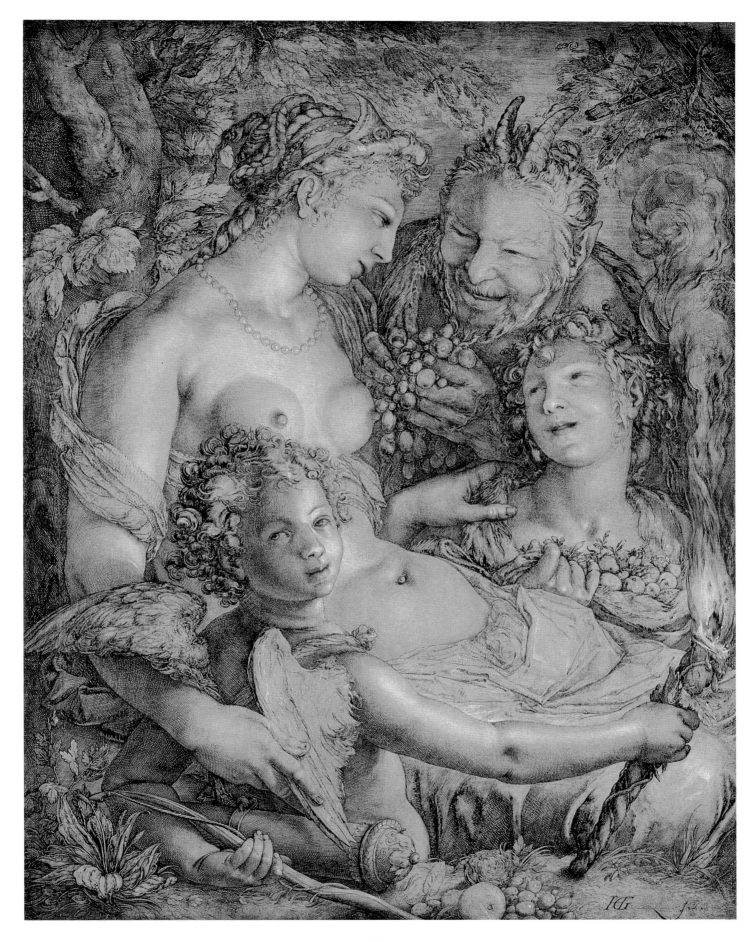

Juan Sánchez Cotán

Orgaz, 1560 – Granada, 1627

Still Life with Quince, Cabbage, Melon, and Cucumber

Canvas
H. 68.9; W. 84.5
Signed lower center: *Juᵉ Sáchez Cotán F.*
Before 1603

San Diego, San Diego Museum of Art
(Gift of Misses Anne R. and Amy Putnam, 1945)
[See Provenance and Reference p. 234]

One of the first major paintings to land in the United States, at the early date of 1815, Sánchez Cotán's picture is also one of the loveliest Spanish still lifes. It is impressive for the highly mathematical rigor of its composition, its austere coloring, its skilled spareness, and that quality of silence we so often find in Spanish still life paintings. Each fruit and vegetable, underscored by a strong light from the left, is observed with verist accuracy.

Its date, before 1603, makes it one of the oldest masterpieces of the seventeenth-century European still life. We now know more about the extraordinary adventure of the canvas. In all likelihood Joseph Bonaparte, Napoleon's older brother, King of Naples and then of Spain (1808), who loved painting, took it with him to the United States, to Point Breeze near Bordentown in New Jersey where, under the name of Comte de Survilliers, he sought refuge in 1815. Since then it never left America, even if when the Putnam sisters bought it in 1945 it moved to the other coast.

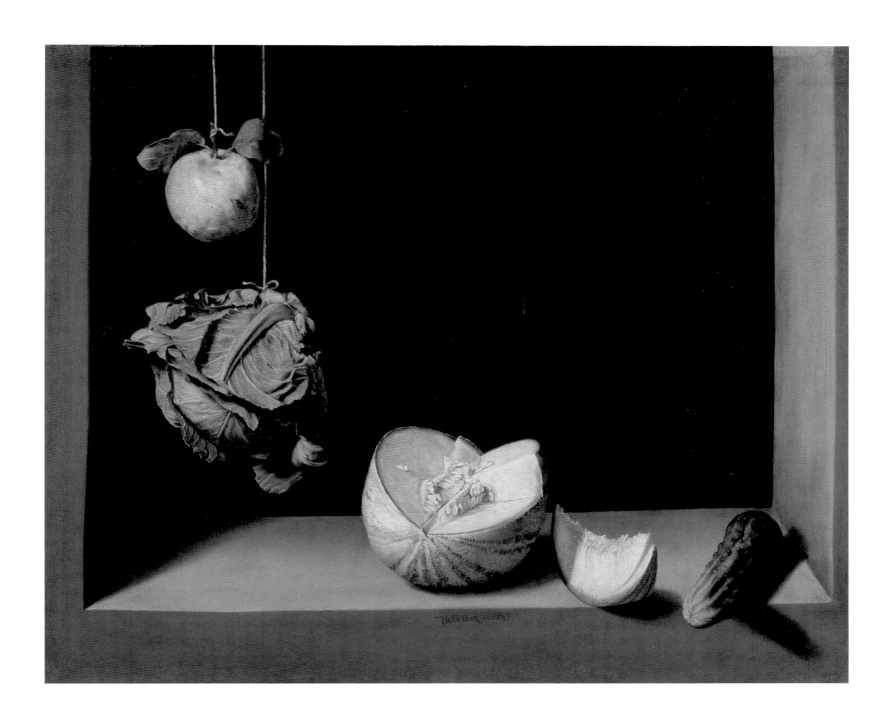

Orazio Gentileschi

Pisa, 1563 – London, 1639

The Lute Player

Canvas
H. 143; W. 128.8
1612–15

Washington, National Gallery of Art
(Ailsa Mellon Bruce Fund, inv. 1962.8.1)
[See Provenance and Reference p. 230]

If none of the Caravaggios held in the United States can compare to the masterpieces by that artist in Rome and Sicily, none of the Gentileschi works in European museums, not even the *Annunciation* at the Galleria Sabauda in Turin, have the exquisite poetry tinged with melancholy of the Washington canvas which for a long time, until 1922, passed for being by Caravaggio.

The beautiful musician is tuning her lute, listening to its sound. The elegant young lady is shown in three-quarters, turned slightly toward us, attentive and intent on her instrument. Did Gentileschi want to do the portrait of a musician or instead was he thinking of an allegorical representation of music? It is not easy to make up our mind.

Gentileschi takes as his source Caravaggio, his early works such as his *Rest during the Flight into Egypt* (Rome, Galleria Doria) rather than his *Musicians* (New York, The Metropolitan Museum). He offers us a delicate, aristocratic, and refined version of Caravaggism, more Venetian and Giorgionesque than realistic and popular.

The Liechtensteins, to whom the painting belonged and whose collection is now preserved in Vienna in the palace bearing their name, sold several masterpieces after the Second World War (Chardin to Ottawa [fig. 5], Frans Hals to Munich, and especially Leonardo da Vinci's *Ginevra de' Benci* to the same National Gallery in Washington [fig. 14]). But in recent years they have undertaken to enrich their collections (Badminton Cabinet, the Valentin of the Pommersfelden collection, a Frans Hals from the Vienna Rothschild collection...).

Orazio Gentileschi,
Annunciation,
Turin, Galleria Sabauda

76

Francesco Boneri, known as Cecco del Caravaggio

Born c. 1588/1589 and active in Rome between 1603 and 1620

The Resurrection

Canvas
H. 339; W. 199.5
1619–20

Chicago, The Art Institute
(Charles H. and Mary F.S. Worcester Collection, inv. 1934.390)
[See Provenance and Reference p. 229]

In most of your dictionaries of art you would waste your time looking for a biographical entry on Francesco Boneri. But you will find one under the name of Cecco del (or da) Caravaggio, an artist already cited in the seventeenth century, to whom a stylistically coherent group of works has been attributed. Now thanks to Gianni Papi, we know with near certainty the identity of Cecco del Caravaggio, Francesco Boneri, an artist born in Lombardy. The Chicago *Resurrection*, this masterpiece painted in 1619–20, is undoubtedly his.

Caravaggio's manner is carried to extremes: violent lighting, grimacing expressions, stiff, exaggerated attitudes, bright pure colors, but above all a hyperrealism that must have shocked and probably explains the commissioner's rejection of the canvas (see p. 229). The figure of the angel is unforgettable, with its huge white wings turned toward us in an inviting gesture as if to explain the miracle to us.

Lodewijk Susi (Ludovico de Susio)

Netherlandish artist settled in Amsterdam or Leyden in 1616.
In Turin and Rome in 1626

Still Life with Three Mice

Wood
H. 35; W. 46.5
Signed and dated lower right: L^D (letters entwined) *Susio.1619*

Saint Louis, Saint Louis Art Museum
(inv. 50:149)
[See Provenance and Reference p. 235]

Two mice nibble on an almond, a third sneaks onto a table laden with fruit (apple, lemon, Seville orange), walnuts, a Venetian-style glass of wine, and various pastries. On a pewter plate, half an apple, a knife, and some sweets. Why, in the Saint Louis museum that besides holds a unique series by Beckmann and a peerless Derain (see p. 207), a magnificent Luce (fig. 11), a splendid Corrado Giaquinto, an absolute masterpiece by Matisse (*Bathers with a Turtle*, fig. 1), did I select this attractive still life, at the cross-roads of the art of Flegel and Fede Galizia? To draw attention to a unique work, the only one we know by this mysterious artist, who appears to have been itinerant (thanks to a photograph, we have a recollection of a second still life by the artist).

In a view from above, Susi described with painstaking care each of the items represented. He endeavored to render textures, shadows, and reflections. Should we interpret this still life as a *memento mori*, as the three delightful gray mice animating the composition might lead us to think or, as we believe, did the artist merely wished to show off his skill?

Corrado Giacquinto,
Saint Helen and the Emperor Constantine Presented to the Holy Trinity by the Virgin Mary,
Saint Louis, Saint Louis Art Museum

Hendrick Ter Brugghen

Utrecht, 1588 – Utrecht, 1629

Saint Sebastian Tended by Irene and a Companion

Canvas
H. 150; W. 120 (cut on three sides)
Signed and dated upper left: *HTBrugghen fe 16*[25]

Oberlin, Allen Memorial Art Museum
(R.T. Miller Jr. Fund, inv. 53.256)
[See Provenance and Reference p. 235]

When we approached our American fellow art historians asking them to kindly tell us which works in American museums they felt were unmatched in European collections, the *Saint Sebastian* by Ter Brugghen in Oberlin was often cited, more often than any other painting. To this masterpiece, which was bought thanks to the sagacity of Wolfgang Stechow (1896–1974), we must confess we prefer the more archaizing Metropolitan Museum *Crucifixion* (it can be compared to the one by Grünewald, p. 53). However we yielded to the opinion of the majority.

Irene, a solemn Irene, donning a modish turban, delicately removes an arrow from Sebastian's side. Her companion frees his right arm. An intense light from the left strikes the bare, abandoned body as well as the faces of Irene and the saint, whom she will nurse and heal. The contemplative quality and the restraint of the close-cropped scene contribute to the pathos of the composition.

Hendrick Ter Brugghen,
The Crucifixion, New York,
The Metropolitan Museum
of Art

Giovanni Battista Barbieri, known as Guercino

Cento, 1591 – Bologna, 1666

Portrait of a Dog

Canvas
H. 111; W. 173
1625

Pasadena, Norton Simon Museum
(inv. F. 1984.2P.)
[See Provenance and Reference p. 231]

The picture, mentioned for the first time in 1957, is unique in the work of the great Emilian painter, without any sort of counterpart in European collections, as was kindly confirmed by Sir Denis Mahon to whom Guercino is greatly indebted (and who dates the work to c. 1625).

The dog—it is a brindle Great Dane—belonged, as the coat of arms we can see on the animal's collar tells us, to the Count Filippo Aldrovandi (who died in 1644). The picture is listed in the inventories of that family's collections in 1748 and 1764. This is not a dog just like any other, but a perfectly recognizable animal that must have meant a great deal to its master.

Guercino treated this portrait of a dog, doubtless a commission, with the same application, the same care, the same sincerity without the least intellectual pretense, as if it were the portrait of a Bolognese nobleman.

The mastiff stands out against a sun-lit landscape (notice the shadows of his paws), adorned with buildings, and with a massive column on the right. We can once again but admire the daring of Norton Simon, who had the courage to acquire this unusual work for a very high price.

Juan van der Hamen y León

Madrid, 1596 – Madrid, 1631

Still Life with Sweets and Pottery

Canvas
H. 84.2; W. 112.8
Signed and dated lower right:
Ju vander Hamen i Leonl fắ 1627

Washington, National Gallery of Art
(Samuel H. Kress Collection, inv. 1961.9.75)
[See Provenance and Reference p. 236]

We hesitated between the Washington still life and the Houston one, representing mostly fruit, dated to 1626, probably mistakenly held to be its *pendant*. Both published by Roberto Longhi in the first issue of *Paragone* (1950), they were purchased by Samuel H. Kress in 1955, the year of the great patron's death. We recall that Kress wished to leave the pictures from his collection to the cities where he had opened the Five-and-Dime Stores to which he owed his fortune.

The composition is arranged on several planes. At center, a brick-red pottery (Germanic?) is surrounded by a basket and a dish of delicacies, sweets of all sorts, jams and boxes of marzepan, little bowls of honey, attractively arrayed.

Van der Hamen delighted in rendering straw, terracotta, wood, pewter, crystal (an elegant finger-bowl with its reflections), in playing on the countless round forms that contrast with the straight lines of the stone structure.

With consummate art, the source of which should be sought in the still life of the Northern countries as well as of Italy, without overlooking Spain, Van der Hamen composed a wonderfully harmonious work.

Juan van der Hamen y León,
Still Life with Fruit and Glassware,
Houston, The Museum
of Fine Arts

Antonio d'Errico (Enrico), known as Tanzio da Varallo

Riale di Alagna, 1575/1580 – Varallo, 1635

Saint John the Baptist in the Wilderness

Canvas
H. 165; W. 114
1627–29

Tulsa, The Philbrook Museum of Art
(Gift of the Samuel H. Kress Foundation, inv. 1944.2)
[See Provenance and Reference p. 235]

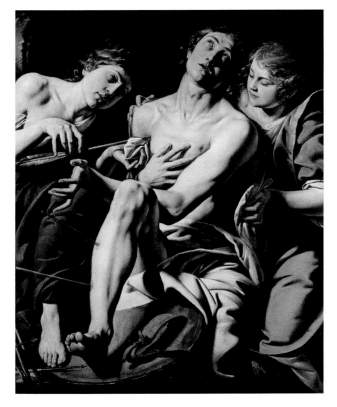

Tanzio da Varallo,
Saint Sebastian Tended by Irene,
Washington, National Gallery
of Art

A painter rarely found outside of his native Lombardy, yet Tanzio da Varallo is particularly well represented in American public collections (Cleveland, Houston, Kansas City, Los Angeles, Oberlin, Washington…). His forceful *Saint John the Baptist in the Desert,* which is somewhat indebted to the painting with the same subject by Caravaggio in Kansas City, is unquestionably one of his masterpieces.

In a verdant alpine landscape graced with pines—recalling Tanzio's native Alps—the Saint, a youthful saint with a head of unruly hair, his foot resting on a rock, raises his eyes heavenward and points his finger at the sacred lamb. The interpretation of the subject—the salvation of the world by Christ's sacrifice—cannot be mistaken.

The dramatic intensity of the composition, underscored by the light coming from the left, and its powerful suggestiveness are irresistible.

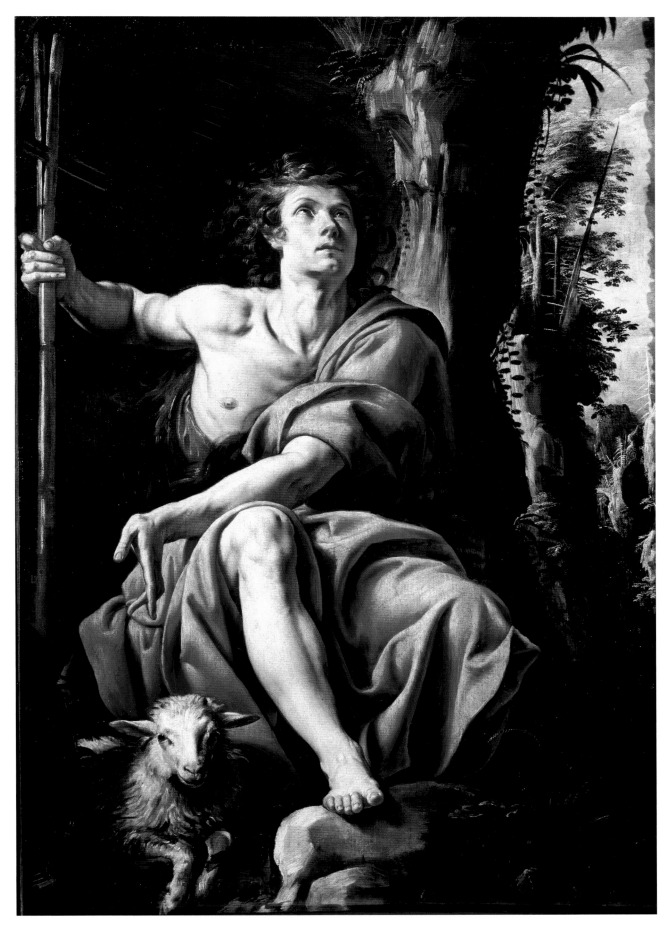

Antoon van Dyck

Antwerp, 1599 – London, 1641

Rinaldo and Armida

Canvas
H. 236.5; W. 224
1629

Baltimore, The Baltimore Museum of Art
(The Jacob Epstein Collection, inv. 1951.103)
[See Provenance and Reference p. 236]

Commissioned for Charles I shortly before Van Dyck settled in London in 1632, *Rinaldo and Armida* is probably the loveliest mythological composition left to us by the artist, the most seductive, the most sensual, executed under the twofold influence of Titian and Rubens. The subject, often treated by painters, derives from Tasso's *Jerusalem Delivered*. The magician Armida is determined to kill the Christian knight Rinaldo, but on discovering him sleeping, instantly enthralled by his beauty, she decides to carry him off to the Enchanted Isles. We see her here surrounding fast asleep Rinaldo with a wreath of flowers that will enable her to convey him.

The music score held by the beautiful nude nymph in the foreground of the picture has been researched: it might be Monteverdi's *Armida*, performed at Mantua in 1628 and that Van Dyck may have heard about through his friend Nicholas Lanier who stopped off in Antwerp on his way back to England.

The Baltimore painting can be compared to the slightly later version in the Louvre, in our opinion less poetic and less inspired.

Antoon van Dyck,
The Loves of Rinaldo and Armida,
Paris, Musée du Louvre

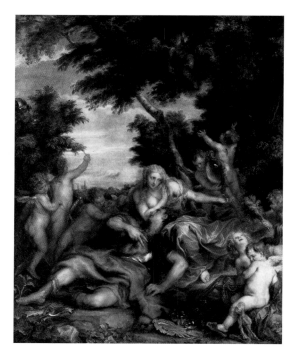

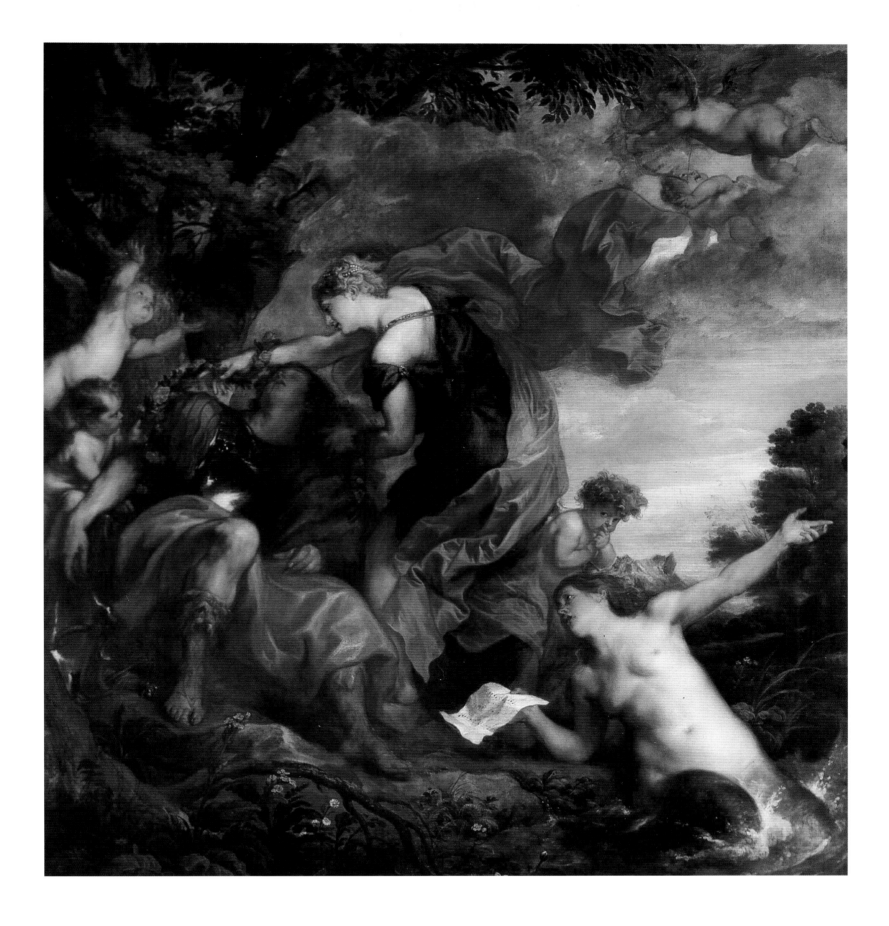

Francesco Furini

Florence, 1603 – Florence, 1646

Cephalus and Aurora

Canvas
H. 229; W. 189
Probably c. 1628

Ponce, Museo de Arte Fundación Luis A. Ferré
(inv. 58.0060)
[See Provenance and Reference p. 230]

Initially attributed to Jacopo Vignali (1592–1664), the Ponce picture was given back to Furini by Mina Gregori and Giuseppe Cantelli. It is one of the most attractive works of seventeenth-century Florentine painting (its *pendant* is in Budapest). The canvas shows us handsome Cephalus asleep, watched by Aurora. The goddess is in love with Cephalus and about to abduct him "against his will."

The work exemplifies the recently rediscovered seventeenth-century Florentine school, blending poetry and sensuality, and which art history brought back in vogue. There is another reason for our choice, and that is the personality of its purchaser. Luis A. Ferré (1904–2003), engineer, industrialist, and politician (he was governor of Puerto Rico from 1969 to 1973), in his native city of Ponce on the island of Puerto Rico formed a collection that went against the fashionable trends of the day. He courageously bought important pre-Raphaelite pictures (Dante Gabriel Rossetti, Frederick Lord Leighton, Burne Jones, the rare *Brittany Landscape* by Thomas Seddon...), as well as paintings discredited as "pompiers," despised at the time, after having been universally admired (Gérôme). He created one of the the most original and singular collections in America (we recall that Puerto Rico is an independent state associated with the United States). It is well worth the trip.

Francesco Furini,
The Death of Adonis,
Budapest, Fine Arts Museum

Thomas Seddon,
Brittany Landscape,
Ponce, Museo de Arte
Fundación Luis A. Ferré

Laurent de La Hyre

Paris, 1606 – Paris, 1656

Panthea, Cyrus, and Araspes

Canvas
H. 142; W. 102
C. 1631–34

Chicago, The Art Institute
(Major Acquisitions Centennial Endowment Fund, inv. 1976.292)
[See Provenance and Reference p. 232]

I trust we shall be forgiven for having retained among our hundred paintings, probably with excessive generosity, this elegant, picturesque composition: it illustrated the cover of the French edition of the catalog of our exhibition *France in the Golden Age. Seventeenth-century French Paintings in American Collections* (1982). We might just as well have chosen the painting in the Metropolitan Museum in New York reproduced below.

The story, in all likelihood derived from Xenophon's *Cyropaedia*, a book which was popular in the seventeenth century, is abstruse. Cyrus, King of Persia, victorious over Abradates, King of Susa, engages Araspes, his loyal servant, to select his booty. He chooses for his master the beautiful Panthea, Abradates' wife, with whom he will fall in love (the interpretation of the subject remains uncertain).

In dazzling colors, an entire range of enameled reds and yellows, and teal greens, the three heroes, steeped in the glow of the setting sun, stand out in front of an architectural background open onto a vast clouded sky and a military camp enhanced with white and pale pink flags. The gorgeous turbans of Cyrus and Araspes remind us we are in the Orient, while Panthea's bare bosom with her high, small round breasts adds a very attractive touch of sensuality to the work.

Laurent de La Hyre,
Allegory of Music,
New York, The Metropolitan
Museum of Art

Francisco de Zurbarán

Fuentes de Cantos, 1598 – Madrid, 1664

Lemons, oranges, and rose

Canvas
H. 62; L; 109.5
Signed and dated lower right: *Fran° de Zurbarán facieb¹ 1633*

Pasadena, The Norton Simon Museum
(inv. F.1972.6.P.)
[See Provenance and Reference p. 236]

The choice of this picture for our book was imperative: it is the most beautiful still life in all of Spanish painting and in all probability, with Caravaggio's *Basket of Fruit* of the Ambrosiana collections in Milan, the finest still life of the entire seventeenth century. The detail of the basket of oranges topped by orange flowers adorned the cover of the catalog of the still life exhibition in 1952, a milestone owed to Charles Sterling. He quotes Longhi: "The objects are not placed at random on a tavern table, but piously arranged, like flowers on an altar. Lined up side by side like litanies of the Virgin. Even if the huge citrons in the basket [sic], the rose on the dish may not be mystical allusions, does not the very perfection of this superb monastic garden produce symbolize a votive offering?"

We must once again pay tribute to Norton Simon who, despite the extravagance of the price (see p. 236), had the discernment in 1973 to acquire this masterpiece (admire the abstract black ground against which the fruit and dishes stand out). The realism of its execution is associated with absolute bareness and a poetry of supreme distinction.

Georges de La Tour

Vic-sur-Seille, 1593 – Lunéville, 1652

The Fortune-Teller

Canvas
H. 102; W. 123 (cut off on the left)
Signed upper right: *G. DeLaTour Fecit*
Lunevillae (*ae* entwined) *Lothar*
1632–35

New York, The Metropolitan Museum of Art
(inv. 60.30)
[See Provenance and Reference p. 232]

We hesitated between the *Fortune-Teller* and the magnificent version of *The Cardsharp* held at Fort Worth. Subsequent to Caravaggio (fig. 18), the theme of the *Fortune-Teller* tempted quite a few painters. A gorgeously attired youth, to whom an old gypsy foretells the future (to do so, she holds a coin marked with a cross, an indispensable accessory for prediction), is systematically robbed of his possessions by three attractive young ladies. One steals his purse and furtively slips it to her accomplice, another cuts his gold chain…

Notice some superb pieces of painting: the buff leather of the youth's doublet, the pink satin of his sleeves, the fancywork with motifs of facing birds and rabbits worn by the gypsy, the jade necklace… And do not overlook the play of hands and eyes, a ballet meant to mislead the innocent, nor the black-haired young woman whose profile is so pure, on the left of the composition.

Georges de La Tour,
The Cardsharp, Fort Worth,
Kimbell Art Museum

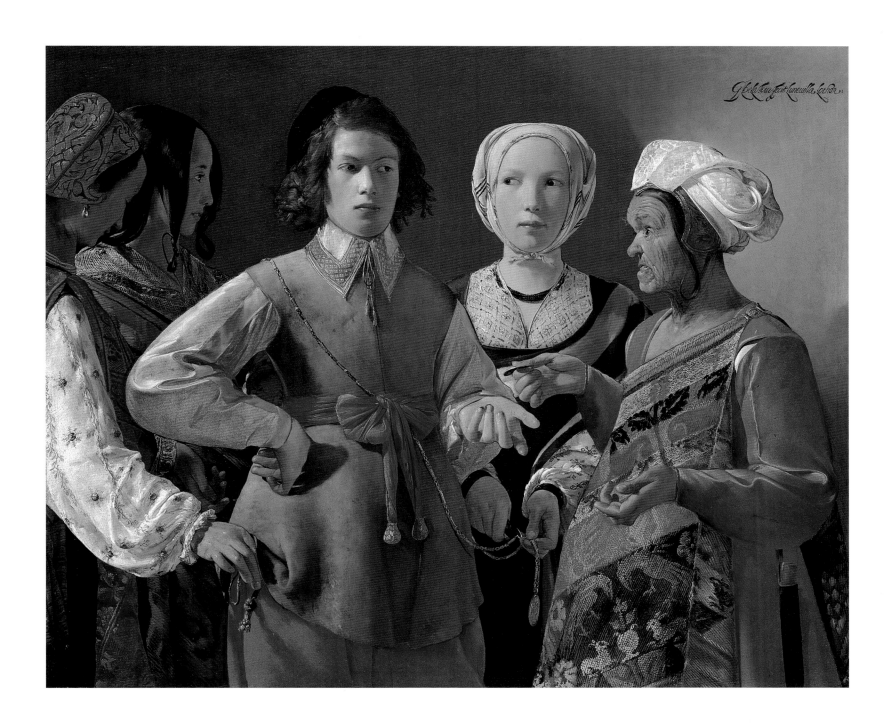

Francesco Cairo

Milan, 1607 – Milan, 1665

Judith with the Head of Holophernes

Canvas
H. 119; W. 94.3
C. 1635

Sarasota, The John and Mable Ringling Museum of Art
(inv. SN 798)
[See Provenance and Reference p. 228]

Usually dated c. 1635, the *Judith* by Francesco Cairo (or del Cairo) counts among the most original works, as well as the most characteristic, of this Lombard school, presently back in favor, which is inclined to combine pathos, theatricality, and the bizarre.

Impassive, Judith stares at us: she is holding, even conspicuously displaying, the sword with which she beheaded Holophernes, saving the Jewish people by her deed. A servant is about to wrap the head of the Assyrian enemy general in a linen cloth.

The paleness of Judith's perfectly oval face contrasts with her black dress that reminds us the beautiful heroine was a widow. Judith's expression, at once determined and remote, proud of her deed, is in unison with her pose and the provocative sensuality of her low neckline. The droll invention of the huge blue and gold turban comes to complete it.

The purchase of this painting by Sarasota was a must: John Ringling (1866–1936; see herein Piero di Cosimo, pp. 55 and 234), a king of the circus, assembled an exceptional group of baroque works at a time when the genre was not in vogue, and built the fascinating museum that bears his name at Sarasota in Florida. His action was pursued by A. Everett Austin Jr. (1900–1957), called "Chick," another personality with daring, pioneering tastes who, after running the Wadsworth Atheneum in Hartford, was appointed director of the Ringling Museum in 1946.

View of the Ringling Museum
of Art in Sarasota

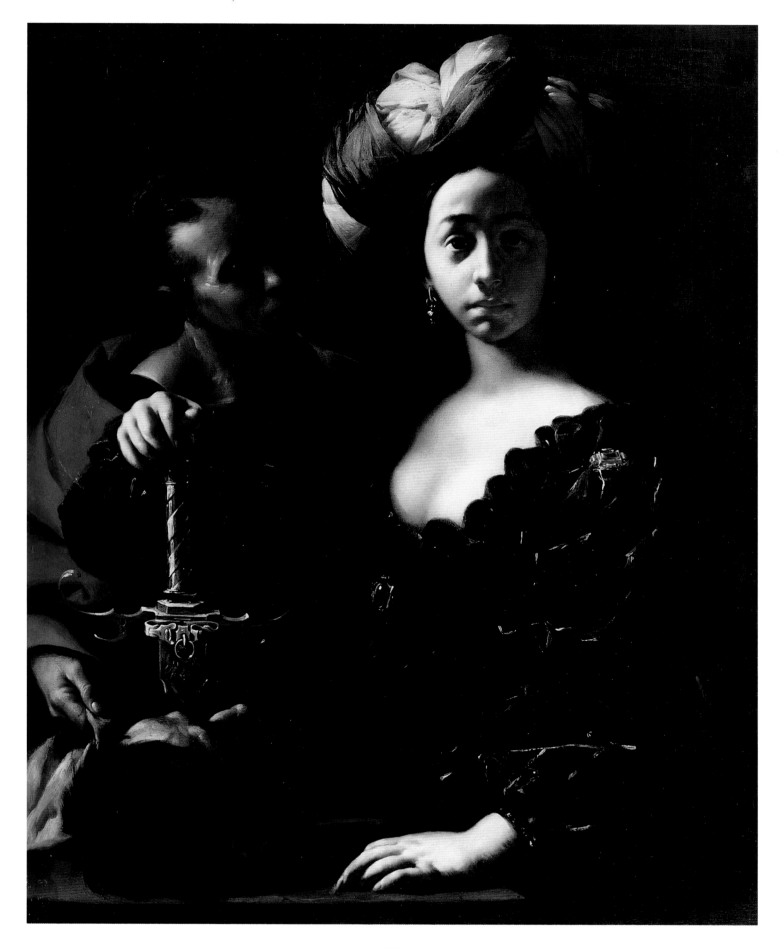

Paulus Bor

Amersfoort, c. 1601 – Amersfoort, 1669

Medea Betrayed

Canvas
H. 155.6; W. 112.4
C. 1640

New York, The Metropolitan Museum of Art
(inv. 1972.261)
[See Provenance and Reference p. 228]

All we know about Paulus Bor is that he was Catholic, from a well-to-do family native of Amersfoort, and that in Rome, where he is mentioned between 1623 and 1626, he was a member of the "bentvueghels," a jolly company of Northern artists. He was nicknamed "Orlando." Pictures by Bor are rare and the chronology of his work is still unclear.

The identification of the subject of the New York canvas, commonly known as *The Enchanteress,* is not certain. Nor do we know for sure whether *Cydippe and the Apple of Acontius* at the Rijksmuseum in Amsterdam is its *pendant.* Medea, abandoned by Jason, lets her hair down and bares her bosom.

Receptive to the Caravaggesque innovations as well as to Orazio Gentileschi's work, Bor, erudite in his iconography but slightly awkward in his handling, combined realism and poetry, surprising inventions and delicately refined colors. His uncanny, eccentric art has a definite appeal for our contemporaries.

Paulus Bor,
Cydippe and the Apple of Acontius, Amsterdam, Rijksmuseum

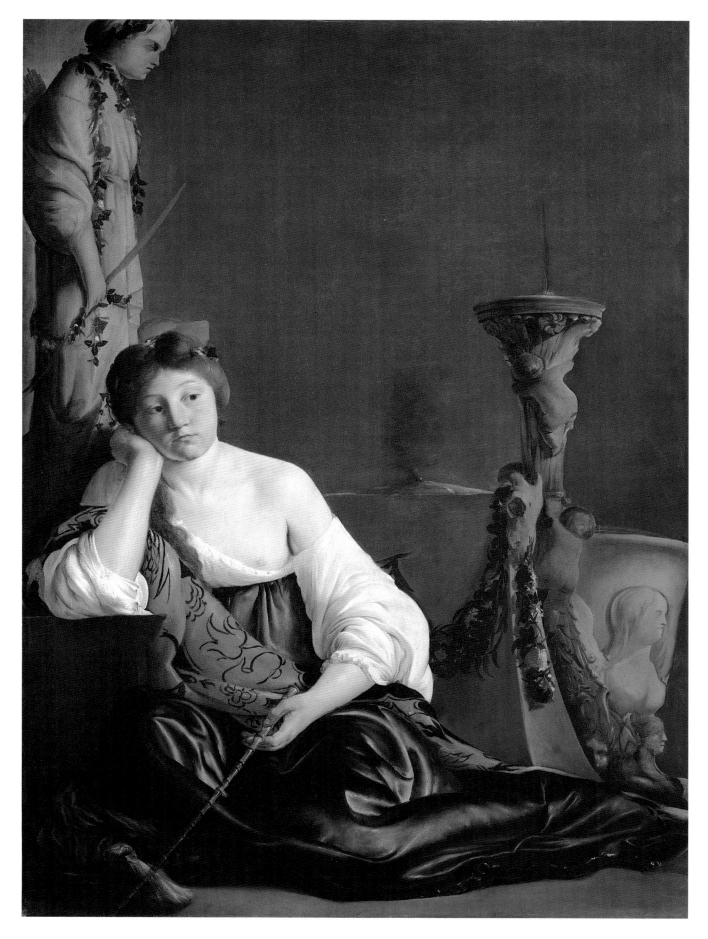

Michael Sweerts

Brussels, 1618 – Goa (the Indies), 1664

The Plague

Canvas
H. 119; W. 171.5
C.1650–54

Los Angeles, Los Angeles County Museum of Art
(Gift of the Ahmanson Foundation, inv. AC 1997.10.1)
[See Provenance and Reference p. 235]

The work is unquestionably the most ambitious left us by Sweerts (an artist furthermore particularly well represented in American collections, Detroit, Hartford, Getty Museum in Los Angeles, Metropolitan Museum in New York, Oberlin, San Francisco…).

It shows a plague scene in a cityscape with several dead bodies in the foreground. A mother, her child resting on her bare breast, is expiring. Actually Sweerts did not prevailingly draw his inspiration from the reality of those plagues which were still frequent in the seventeenth century (there was one in Rome in 1648–50; yet notice the figures holding their nose, an allusion to the stench of rotting corpses). He idealized the scene in the likeness of Raphael's *Plague in Phrygia* or Poussin's *Plague of Ashod* and several ancient texts in which the plague symbolizes the blindest and cruellest fate (on the theme of the plague and more especially on the painting by Sweerts, see the recent excellent catalog *Hope and Healing*, Worcester, Art Museum, n. 6, repr. and essay by Franco Mormando).

Sweerts had a hard time mastering the huge composition and was forced to call upon a specialized painter to treat the architectural background, but some parts, like the brightly-lit grieving old woman at the far left of the canvas, are unforgettable.

Michael Sweerts,
Self-Portrait, Oberlin,
Allen Memorial Art Museum

Massimo Stanzione

Orta di Atella, 1585 – Naples, 1656

Woman in Neapolitan Costume

Canvas
H. 118.5; W. 96.5
Signed center left:
EQ. (letters entwined)
MAX. (*MA* entwined)
C. 1650

San Francisco, The Fine Arts Museum
(Museum Purchase by Exchange, inv. 1997.32)
[See Provenance and Reference p. 235]

The model is wearing the typical seventeenth-century popular Neapolitan costume: the headdress called "magnosa," the heavy damask skirt, the vest enhanced with insertions, and especially the filigree necklace. But are we looking at a lady of the aristocracy coyly adopting the popular attire, or instead a richly dressed peasant, or else a woman selling chickens (!), or last a parodic picture in which the rooster replaces the pet dogs of Renaissance portraits (!)?

In any case the rooster, a superb piece of painting, is what gives Stanzione's picture, unique in the great Neapolitan artist's production, its unusual note and comic tone.

The painting belonged to the Hispanic Society of America, that loaned it and then sold it, in 1997, to the museum of San Francisco.

Bartolomé Esteban Murillo

Seville, 1617 – Seville, 1682

Two Women at a Window

Canvas
H. 125.1; W. 104.5
C. 1655–60

Washington, National Gallery of Art
(Widener Collection, inv. 1942.2.46)
[See Provenance and Reference p. 233]

Two women leaning out of a window are looking at us. The older one, standing, smiling, is hiding the lower part of her face with her veil, the younger one, resting her elbows on the window sill, smiles at us. Scholars are divided: a mere flirtation scene or a young prostitute with her procuress soliciting the customer? Conversely, there is no hesitation as to the undeniably erotic nature of the dialogue that is created between the two women and the beholder. They look at us, we look at them. The subtle low neckline, the window open onto a darkened room, the partly-drawn shutter, everything suggests an invitation, everything is made to kindle desire.

A far cry from the countless *Madonna and Child* pictures and somewhat sugary, mawkish religious compositions permanently associated with Murillo's name!

Rembrandt Harmenszoon van Rijn

Leyden, 1606 – Amsterdam, 1669

Self Portrait

Canvas
H. 133.7; W. 103.8
Signed and dated lower right,
under the arm of the chair: *Rembran.| f. 1658*

New York, Frick Collection
(inv. 06.1.97)
[See Provenance and Reference p. 234]

Rembrandt, *Lucretia dying*,
Minneapolis, The Minneapolis
Institute of Arts

It took us some time to make up our mind: why Rembrandt's admirable *Self Portrait* of 1658 and not the *Portrait of Juan de Pareja* by Velázquez at the Metropolitan Museum (fig. 15)? In both cases—the *Night Watch* (fig. 7), *Bathsheba*, the *Jewish Fiancée* for the former; *Las Meninas* (fig. 10), *Venus at her Mirror* for the latter—Europe offers its visitors works that are unique, unsurpassable. And then if Rembrandt, why the Frick *Self Portrait*, one of the sixty self portraits by the artist, rather than the *Lucretia dying* of Minneapolis (or the one in Washington) or the *Woman with a Pink* in the Metropolitan Museum (or *Aristotle with a Bust of Homer* in the same museum)?

Well, the author took a fancy to it. Now it is the reader's turn to wonder, suggest his choice, and justify it, stating his reasons. And yet, in matters of beauty, is it not always the inexplicable, the illogical, the irrational that takes the prize?

Rembrandt—he is fifty-two years-old—stares at us intently. In his left hand he holds a rattan cane with a silver knob and he is dressed in a lavish, fancy costume. The somptuous colouring, with its reds, yellows, and golds, the rich pictorial material, the careful study of the face, and the sitter's impressive authority are unforgettable.

Nicolas Poussin

Les Andelys, 1594 – Rome, 1665

Blind Orion Searching for the Rising Sun

Canvas
H. 119.1; W. 182.9
1658

New York, The Metropolitan Museum of Art
(Fletcher Fund, inv. 24.45.1)
[See Provenance and Reference p. 234]

Why Poussin, and why this Poussin when America, with the *Death of Germanicus* of the Minneapolis Institute of Arts, owns a unique work by the artist—whose importance we can never over-emphasize—and when the Louvre *Seasons*, scarcely posterior to *Orion*, embody an ambition comparable to that of the New York painting?

Our choice may well be criticized, but we did not come to our decision without due reflection. The gigantic huntsman Orion, once blinded by the King Œnopion for attempting to rape his wife and (or) his daughter, was advised by an oracle that only the rays of the sun could restore his sight and heal him.

Here we see him, led by Cedalion perched on his shoulders, striding toward the sun, the source of life hidden from him by some clouds—Diana, Orion's enemy, rests her elbow on one of them. A hymn to nature, to its fecundity and its perpetual resurgence, *Orion* is a haunting image but also one of the most moving and touching in Western painting.

Nicolas Poussin,
The Death of Germanicus,
Minneapolis, The Minneapolis
Institute of Arts

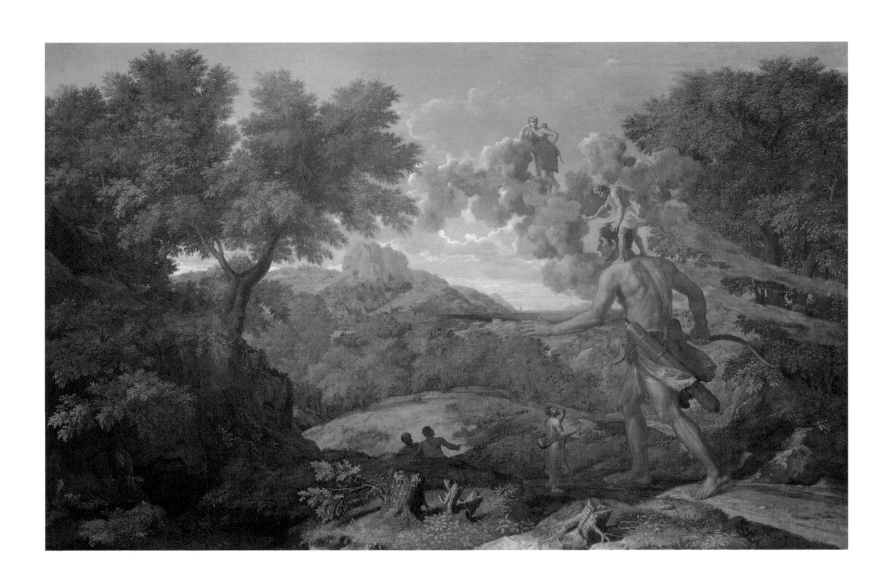

Guido Cagnacci

Sant' Arcangelo di Romagna, 1601 – Vienna, 1663

Martha Rebukes her Sister Mary for her Vanity,

or

The conversion of Mary-Magdalene

Canvas
H. 229.4; W. 265.4
Signed lower right: *GVIDVS CAGNACCIVS*
C. 1660

Pasadena, Norton Simon Museum
(inv. M. 1982.5.P)
[See Provenance and Reference p. 228]

Martha led a chaste life whereas her sister Mary-Magdalene, the sinner, led a life of pleasure. In the Pasadena picture we see Martha, kneeling on a cushion, attempting to persuade the partly nude Magdalene to renounce worldly material possessions, her jewels and her precious clothes. On the left, an angel drives away the devil while on the right two women symbolizing contrition and vanity enter the room.

Among the seventeenth-century Emilian artists, of course Cagnacci cannot presume to be ranked first, he is neither Annibale Carracci nor Guido Reni. However, his *Conversion of Mary-Magdalene*, his masterpiece, at once sensual and strange, refined in its use of light and its chromatic inventions, entitles him to the honors of our book.

It is not known whether the picture was painted in Venice c. 1660 or shortly after that date in Vienna, where the painter was called by the Emperor Leopold.

Guido Cagnacci,
Cleopatra, Vienna,
Kunsthisorisches Museum

Jan de Bray

Haarlem, c. 1627 – Haarlem, 1697

The Banquet of Antony and Cleopatra

Canvas
H. 249; W. 190
Signed and dated on the left on the dish:
JDB [those three letters entwined] *aij 1669*

Manchester, New Hampshire, Currier Museum of Art
(inv. 1969.8)
[See Provenance and Reference p. 229]

Salomon de Bray,
Jael, Deborah, and Barak,
Puerto Rico, Ponce, Museo
de Arte Fundación Luis A. Ferré

Jan de Bray, *The Banquet of
Antony and Cleopatra,* Hampton
Court, collection of her Majesty
the Queen of England

When we drew up our list of a hundred pictures, we hesitated between the *Jael, Deborah, and Barak* by Salomon de Bray (1597–1664) in the Ponce museum in Puerto Rico and the *Banquet of Antony and Cleopatra* by his son Jan, at Manchester. The two pictures have something in common that contradicts the concept of our book: they are not unique. In fact, for the Ponce picture there is another version at the Catharijneconvent Museum in Utrecht. As for the Manchester painting, it was preceded by a first, smaller (H. 170.2; W. 166.4) and older composition (1652), presently held in the Queen's collections at Hampton Court.

A first version, though, which is indeed appreciably different, as Ben Broos and Jeroen Giltaij compellingly demonstrated in the catalogs mentioned on p. 229.

According to Pliny, Cleopatra, Queen of Egypt, claimed she would offer Antony, her lover, a banquet that would cost not less than ten million sesterces. Antony challenged her. She served a very ordinary meal. At the end of the banquet she removed from her ear one of her pearls, the biggest known at the time, and dissolved it in vinegar, winning her wager.

The large Manchester canvas is at once a historical painting such as very few Dutch artists (*pace* Rembrandt) painted, a portrait of the different members of the Bray family (we recognize, on Cleopatra's right, the very young Maria van Hees whom Jan married in 1668 and who died the following year, as well as the painter's parents in the guise of Antony and Cleopatra), and an allegory of the vanity of worldly possessions to which alludes the peacock's long tail on the left of the composition.

Between 1892 and 1966 the Manchester picture belonged to the Germanisches National Museum in Nuremberg. Purchased by the great German museum at auction in 1892 for 1.750 marks, the canvas was sold, for reasons unknown to us, at Christie's in London, 1 July 1966 (n. 88) for 5.880 dollars...

Johannes Vermeer

Delft, 1632 – Delft, 1675

Allegory of the Faith

Canvas
H. 114.3; W. 88.9
C. 1670

New York, The Metropolitan Museum of Art
(Bequest of Michael Friedsam, 1931, inv. 32.100.18)
[See Provenance and Reference p. 236]

Vermeer was converted to Catholicism before his marriage in 1654 and this picture, the only one of its kind in the artist's oeuvre, probably painted c. 1670, alludes beyond doubt to his religious convictions. To depict the Faith Vermeer more or less directly took his source in Cesare Ripa's *Iconologia*. Faith has her foot on the globe. The glass sphere hanging from the ceiling refers to the divine world. The apple on the floor is that of Original Sin.

Admire the fine piece of painting of the crushed serpent and the stone: the latter symbolized the cornerstone of Christianity, victorious over the serpent, temptor and corruptor.

We know moreover that the ebony crucifix, the embossed leather panel, the *Crucifixion* by Jordaens seen in the background, were in Vermeer's residence in Delft.

By grouping in a room of his home this allegory of the Faith and these familiar items and drawing for us the curtain—an admirable historiated hanging—preserving his intimacy, Vermeer introduces us to his private life and his belief.

Of all of Vermeer's canvases, of all the Vermeers in the United States, 13 out of the 36 known ones, the *Allegory of the Faith* is outstanding by its solemnity as well as its personal tone.

Johannes Vermeer, *Young Woman with a Water Pitcher*, New York, The Metropolitan Museum of Art

Giuseppe Maria Crespi

Bologna, 1665 – Bologna, 1747

Young Woman Tuning her Lute

Canvas
H. 121; W. 152.5
C. 1695–1705

Boston, Museum of Fine Arts
(Charles Porter Kling Fund, inv. 69.958)
[See Provenance and Reference p. 229]

A portrait but also a genre scene or even an allegory of music, the *Young Woman Tuning her Lute* counts among Crespi's most attractive secular achievements. While its provenance and its date (between 1695 and 1705) are still disputed, the quality of the work—its gorgeous brown and white impasto textures and the clever choice of lighting that immerses in shadow the face of the young, bare-shouldered artist—is exceptional. Notice that the lute-player's hand and ear are brightly lit as though to clearly signal the indispensable harmony between the sense of hearing and touch.

The Boston picture can be compared to the *Lute-Player* by Orazio Gentileschi at the National Gallery in Washington (p. 77).

Noël-Nicolas Coypel

Paris, 1690 – Paris, 1734

The Rape of Europa

Canvas
H. 127; W. 193
Signed (the date is erased) lower right
1726

Philadelphia, Philadelphia Museum of Art
(Gift of John Cadwalader, inv. 1978-160-1)
[See Provenance and Reference p. 229]

In 1727 a competition opposed the best living French painters. It was won by Jean-François de Troy and François Lemoine who shared the prize. Yet by common consent the *connoisseurs* and critics of the time, and rightly so, acknowledged that the finest painting shown was *The Rape of Europa* by Noël-Nicolas Coypel, today the least famous of the four painters bearing that name, and his masterwork. You will admire the sumptuous coloring ranging "from flesh-tone pink to lavendar blue", in this chatoyant and sensual mythological composition, the energetic, lively arrangement of the figures, faces, and bodies, their beauty, the treatment of the seemingly iridescent light.

The Rape of Europa is one of the first eighteenth-century French canvases to land on American soil. In 1815, Joseph Bonaparte, Napoleon's older brother, former King of Spain in exile, settled with his collections at Point Breeze near Bordentown in New Jersey (for another picture of his collection, today in San Diego, see p. 75).

Nicolas de Largillierre

Paris, 1656 – Paris, 1746

Portrait of Elizabeth Throckmorton

Canvas
H. 81.5; W. 65.7
Signed and dated on the reverse: *Peint par N. de Largilliere 1729*

Washington, National Gallery of Art
(Ailsa Mellon Bruce Fund, inv. 1964.20.1)
[See Provenance and Reference p. 232]

The Throckmorton family was Catholic. Several of its members sought refuge in France. In 1729 Sir Robert Throckmorton went to Paris, had Largillierre paint him (Coughton Court, National Trust) and commissioned from the artist the portraits of his aunt Ann Throckmorton (1664–1734), a religious of the Augustinian order (Coughton Court, National Trust), his cousin Frances Wollascot (1708–1751), she as well an Augustinian nun (Adelaide, Art Gallery of South Australia), and last his sister Elizabeth (1694–1760). Like her aunt and her cousin, the latter entered the convent of the blue-robed Augustinians. She pronounced her vows in 1714 and was twice lady superior of the order, from 1736 to 1744 and from 1752 until her death. A whole scale of whites softened with highlights in pink, beige, and gold miraculously tone in with the black veil of the Augustinian sister and the colored note of her breviary. There is nothing severe in the handsome face, tender and appealing, not without sensuality, of this nun who is looking at us, musing, smiling…

Nicolas de Largillierre,
Portrait of Frances Wollascot,
Adelaide, Art Gallery of South
Australia

ELIZABETH DAUGHTER OF Sʳ ROᵇᵗ THROCKMORTON BARᵗ.

Pompeo Girolamo Batoni

Lucca, 1708 – Rome, 1787

The Triumph of Venice

Canvas
H. 174.3; W. 286.1
Signed lower right on the basket of fruit: *P. Batoni*
1737

Raleigh, North Carolina Museum of Art
(Gift of the Samuel H. Kress Foundation, inv. GW. 60.17.60)
[See Provenance and Reference p. 228]

Batoni was not merely the portraitist of English lords on their way through Rome on the occasion of their *Grand Tour*. He was also an excellent painter of religious, historical, or allegorical compositions, the most important one, along with Subleyras (1699–1749), in eighteenth-century Rome.

In 1737 for the ambassador of the Venetian Republic in Rome, Marco Foscarini (he was elected Doge, the hundred-seventeenth, in 1762, a year before his death), Batoni painted this superb allegory of his city, then sunk into a political decline, but at the same time uplifted by a wonderful artistic rebirth (Canaletto, Bellotto, the Tiepolo father and son, the Guardi brothers…).

The United States preserves two historical-allegorical masterpieces by Batoni: the Raleigh picture and the one in Minneapolis (1757), *Pope Benedict XIV presenting in 1756 the Encyclical* Ex Omnibus *to the Comte de Stainville, ambassador of France*. We picked the first, unmatched in Europe, partly because of Venice (the Ducal Palace, the *Piazzetta*, the gondolas in the middle distance) and partly because of its provenance.

In fact the picture reached the United States in 1857 and stayed there until at least 1916 (sale New York, New Galleries, 3 April 1916, n. 147). Sold in Paris, 4 May 1955, n. 126, it was purchased the following year by the Samuel H. Kress Foundation. Samuel H. Kress (1863–1955), to whom America owes an impressive list of capital works (see herein, Grünewald, Van der Hamen y León, Tanzio da Varallo, and Louis-Joseph Le Lorrain) and a considerable number of rare canvases often purchased against the ruling trend, had just died.

Pompeo Girolamo Batoni, *Pope Benedict XIV presenting in 1756 the Encyclical* Ex Omnibus *to the Comte de Stainville, ambassador of France*, Minneapolis, The Minneapolis Institute of Arts

Giovanni Antonio Canal, known as Canaletto

Venice, 1697 – Venice, 1768

Bacino di San Marco

Canvas
H. 124.5; W. 204.5
1738

Boston, Museum of Fine Arts
(Abbott Lawrence Fund, Seth K. Sweetser Fund,
and Charles Edward French Fund, inv. 39.290)
[See Provenance and Reference p. 228–29]

Certainly one of the most beautiful portrayals of the Bacino di San Marco (and one of the largest), seen approximately from the Custom-house (Dogana di mare) with San Giorgio Maggiore in the background and, on the left, the Palace of the Doges and the campanile of Piazza San Marco. There has been much hesitation over the date of the picture: that of 1738 advanced by Alessandro Bettagno for topographical reasons (indeed the bell-tower of St. Antonin, seen at center covered with scaffolding, was under construction at that date) appears convincing. Two centuries later, in 1939 to be precise, the picture left Castle Howard in Northumberland, where it had been held since the eighteenth century (England still possesses today over half of Canaletto's painted work), and was purchased by Boston on the advice of its new English curator William George Constable (1887–1976), an eminent scholar of the artist. The most beautiful Canaletto in the United States, here it immortalizes one of the magical sites of old Europe.

Maurice Quentin de La Tour

Saint-Quentin, 1704 – Saint-Quentin, 1788

Portrait of the Président Gabriel-Bernard de Rieux

Pastel and gouache
Assemblage of several sheets of paper mounted on canvas
H. 200; W. 150 (H. 317.5; L; 203 with its frame)
1739–41

Los Angeles, The J. Paul Getty Museum
(inv. 94.PC.39)
[See Provenance and Reference p. 232]

Maurice Quentin de La Tour,
*Portrait of Madame la Présidente
de Rieux in a Ballgown*,
Paris, Musée Cognacq-Jay

Gabriel-Bernard de Rieux (1687–1745) was the son of the lavish and very rich financier Samuel Bernard. In the pastel by Maurice Quentin de La Tour, his masterwork with the *Portrait of the Marquise de Pompadour* in the Louvre and a masterpiece in the art of pastel, he wears the attire of the president of the second chamber of the court of enquiry of the High Judicial court of Paris (black cassock with wide belt, gray bands, red robe). He is seated in his study in front of a screen and a map of the world; on a table, books and an inkstand, on the floor, a magnificent rug.

Presented at the Salon of 1741, the *Portrait of the Président de Rieux* was unanimously acclaimed, insuring La Tour's success. The following year the artist showed a *Portrait of Madame la Présidente de Rieux in a Ballgown*, smaller but equally beautiful, held today at the Musée Cognacq-Jay in Paris.

Maurice Quentin de La Tour,
*Portrait the Président Gabriel-
Bernard de Rieux*,
with frame

Jean-Baptiste Oudry

Paris, 1686 – Paris, 1755

Flowerbed of Tulips and Vase of Flowers

Canvas
H. 129; W. 162
Signed and dated lower left, on the stone pedestal
upon which the vase is set: *J.B. Oudry 1744*

Detroit, The Detroit Institute of Arts
(The Founders Society, The John N. and Rhoda
Lord Family and General Endowment Fund, inv. 67.78)
[See Provenance and Reference p. 233]

Despite the old or more recent alterations affecting the canvas, Oudry's picture is possessed of great charm. It shows us flowers that all came from the garden of M. de La Bruyère, the commissioner of the painting: tulips, naturally in different varieties, but also, in the vase, hyacinths, primulas, an iris, poppies, peonies, immortelles. Two butterflies enliven the composition, a common emperor-moth ogled by a parrot, and an *atlas atticus*, a butterfly from Southern Asia that is said to be the biggest butterfly in the world.

It is hard to say what we admire most in the Detroit canvas: the imagination of the artist who, to bring this botany illustration to life, added to it a parrot and two moths, or the originality of the composition with its subtle play of straight lines drawn on the ground, or the gorgeousness of its colors.

The booklet of the Salon of 1745 precised that the "King [Louis XV] had [had] sent from Holland" the "hyacinths" gracing the bouquet of flowers in the garden of M. de La Bruyère.

Louis-Joseph Le Lorrain

Paris, 1715 – Saint-Petersburg, 1759

Before the Masked Ball

Canvas
H. 166; W. 127
C. 1750?

Washington, National Gallery of Art
(Samuel H. Kress Collection, inv. 1961.9.92)
[See Provenance and Reference p. 232]

If the quality of the picture is not under discussion, the attribution to Louis-Joseph Le Lorrain, for which we take full responsibility, is still uncertain. The canvas has been given all sorts of names, usually Italian (Pietro Longhi, Amigoni, Bacciarelli, G.D. Ferretti, Fontebasso…), but also Austrian, Polish, or even Swedish. It shows us two men and a woman attending a masked ball, but we have not been able to identify the origin of their lavish costumes (some claimed them "Polish" or characteristic of Venetian mascarades), nor of the impressive architecture of the palace.

Le Lorrain spent his time between Rome, Paris, and Saint-Petersburg. During his brief career he was considered one of the most promising among the young French painters. Judging by the Washington picture these promises were fulfilled, and here you will admire the stunning execution and the scale of cold, glittering colors. A detail supports our proposal: the shell design on the armchair, at the center of the composition, is comparable to similar motifs adorning the few ascertained works by Le Lorrain.

Gaspare Traversi

Naples, c. 1722 – Rome, 1770

Saint Margaret of Cortona

Canvas
H. 172.1; W. 122.6
C. 1758

New York, The Metropolitan Museum of Art
(Gwynne W. Andres Fund, inv. 68.182)
[See Provenance and Reference p. 236]

For a long time the attribution of this picture to the Neapolitan painter Gaspare Traversi was challenged. It does not entirely satisfy us, and the recent showing of the work at the *Traversi* exhibition in Naples did not dissipate our reservations.

Here Margaret of Cortona, a thirteenth-century saint canonized in 1728, wears the habit of the Franciscan Tertiary order. Grasping a crucifix, she looks at an angel holding a crown of thorns. Satan, who sought to persuade her to return to her former life of sin, flees into the flames of Hell. The dog, a handsome spaniel, is the saint's attribute, and the child, bent over him, her illegitimate son.

Traversi had not accustomed us to such technical mastery, such refinements of color (the angel's wings), this superb metallic, burnished shimmering (in the hair of the angel and the child). Notwithstanding, whoever the author may be, this is one of the most beautiful works in eighteenth-century Italian religious painting, a masterpiece of narrative poetry.

William Hogarth

London, 1697 – London, 1764

The Lady's Last Stake

Canvas
H. 91.5; W. 105.5
1758–60

Buffalo, Albright-Knox Art Gallery
(Gift of Seymour H. Knox, inv. 1945:2.1)
[See Provenance and Reference p. 232]

The picture, one of the the artist's last genre scenes if not the last, was commissioned in 1758 from Hogarth by an Irish nobleman, a friend of the painter, Lord Charlemont, who left him free to choose its subject.

The young woman gambled and lost all she had, her money, her jewelry, her watch: the handsome officer offers to cancel her debt at the expense of her virtue and fidelity to her husband. Aside from the rather labored description of the rich interior where the scene unfolds, aside from the many details alluding to the awkward dilemma facing the hesitant young woman, in this very last of Hogarth's masterpieces, we find the exceptional combination of realism and morality, the fondness for satire and literary narrative, and above all the unmitigated biting, pitiless irony that rank the painter among the greatest artists of his century.

George Stubbs

Liverpool, 1724 – London, 1806

A Zebra

Canvas
H. 103; W. 127.5
1762–63

New Haven, Yale Center for British Art
(Paul Mellon Collection)
[See Provenance and Reference p. 233]

This is the first zebra, a female, to arrive in England. The animal came from the Cape of Good Hope and was offered in 1762 to Queen Charlotte, wife of George III, by Sir Thomas Adams. Visible at the menagerie of Buckingham House, the animal, that died in 1773, was widely commented.

We should not be surprised at Stubbs' interest in it: weary of "sporting life" scenes and horses, the zebra appealed to his taste for exoticism. Of course he painted it with his usual naturalistic, almost hyperrealistic care, his usual coolness, but the weird design of its hide, so very "painterly" and astonishingly modern, could not be a matter of indifference to such an immensely curious artist.

Stubbs did not depict his zebra in its South African environment, but in front of a typical English countryside landscape. It can be compared to the zebra by the Swiss painter Agasse (1767–1849) which we could not put in our book, owing to our limited space.

Jacques-Laurent Agasse,
Zebra, New Haven,
Yale Center for British Art

140

Thomas Gainsborough

Sudbury, 1727 – London, 1788

Portrait of Jonathan Buttall: the "Blue Boy"

Canvas
H. 179.5; W. 124
1770

San Marino, The Huntington Library and Art Collections
(inv. HEH 21.01)
[See Provenance and Reference p. 230]

At the Royal Academy exhibition in 1770 the work was titled *Portrait of a Gentleman*, but the sitter's identity has long been known: Jonathan Buttall (1752–1805). At the time he was eighteen years old. Buttall was among those who, at Gainsborough's explicit request, attended the artist's funeral in 1788, which did not prevent him from selling his portrait a few years later, in 1796. We now know that at an early stage Gainsborough had portrayed his model in the company of his dog, a spaniel.

This icon of English painting, owing its title to the color of Buttall's satin outfit, is directly inspired by Van Dyck's portraits of adolescents. Before the picture permanently left England in 1921, it was shown at the National Gallery, drawing some 90.000 visitors (see p. 230). Recently the work's extraordinary popularity somewhat harmed it in the opinion of the most discriminating *connoisseurs*. They criticize it for its sentimentality, its meretricious virtuosity, and "chic" handling. The picture deserves to be judged with more subtlety.

Jean-Bernard Restout

Paris, 1732 – Paris, 1796

Morpheus, or *Sleep*

Canvas
H. 97. 6; W. 130
1771 at the latest

Cleveland, The Cleveland Museum of Art
(Leonard C. Hanna Jr. Fund, inv. 1963-502)
[See Provenance and Reference p. 234]

In Classical mythology Morpheus personifies Sleep, his large wings enabling him to move about in a flash. Poppy flowers, which he holds in the Cleveland picture, provide quiet nights and pleasant dreams.

It took a long time for the picture to find its proper attribution (see p. 234). Jean-Bernard Restout, son of the great Restout (1692–1768), a neglected painter (we await the monograph that Nicole Willk-Brocard has promised), played quite a significant role in the new artistic institutions founded under the Revolution.

If the subject of the work is certainly Morpheus, whom we recognize with his eyes closed and sound asleep, it can also be seen as an anatomy study, one of those male "academies" executed from life and that young eighteenth-century French painters had to draw, and then paint, in learning their craft. But this handsome piece of painting, energetically executed, forceful and sculptural, is already the work of a confirmed artist.

Jean-Étienne Liotard

Geneva, 1702 – Geneva, 1789

Trompe-l'œil

Oil on silk, mounted on canvas
H. 23.3; W. 32.3
Signed and dated above upper leftward: *par J.E. Liotard 1771*

New York, The Frick Collection
(Bequeathed by Lore Heinemann in memory of her husband,
Dr. Rudolf J. Heinemann, inv. 97.1.182)
[See Provenance and Reference p. 232]

Quite a few American museums, the Metropolitan Museum, the Pierpont Morgan Library, the National Gallery in Washington benefited by the generosity of Lore Heinemann who, with her husband the art dealer Rudolf J. Heinemann, formed an important collection of paintings and drawings, mainly Venetian.

Liotard's *Trompe-l'œil*, painted (on silk) in Paris in 1771, is unique. In the lower register, Liotard copied two women's heads borrowed from his own works, a "coeffure turque" (Turkish hairstyle) and a "coeffure de Ulm" (Ulm hairstyle) which allude to the artist's constant travels, as far as Turkey. Also on a wooden panel where we make out the veins, not attached with wax seals like the two drawings but with iron screws, two plaster casts reproduce prints representing Venus and Eros, more or less directly derived from Boucher.

The United States (Cleveland, Kansas City, Washington…) hold several capital works by Liotard. The admirable pastel portraying *John Mountstuart, future first Marquis of Bute*, recently purchased by the Getty, is particularly appealing.

Jean-Etienne Liotard,
Portrait of François Tronchin,
Cleveland, The Cleveland
Museum of Art

Jean-Etienne Liotard,
*John Mountstuart, future first
Marquis of Bute*, Los Angeles,
The J. Paul Getty Museum

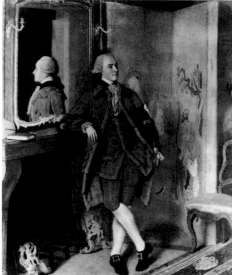

Jean-Honoré Fragonard

Grasse, 1732 – Paris, 1806

The Pursuit

Canvas
H. 318; W. 215.5
Signed lower right, on the pedestal: *fragonard*
1771–73

New York, The Frick Collection
(inv. 15.1.45)
[See Provenance and Reference p. 230]

The Comtesse du Barry, mistress of Louis XV, had Claude-Nicolas Ledoux (1736–1806) build her an extremely modern country seat at Louveciennes, inaugurated in 1771. She commissioned from Fragonard an important decoration which she then refused (for reasons unknown to us). This décor, after belonging to J. Pierpont Morgan, was purchased in 1915 by H. Clay Frick. It is Fragonard's absolute masterwork and one of the summits of eighteenth-century French painting.

The ensemble consists of four principal compositions, *The Pursuit, The Meeting, Love Letters, The Lover Crowned*, and ten secondary panels.

The Pursuit shows us an attractive youth offering a rose to a young girl who appears to wish to take flight. The work, a dazzling fireworks of colors, aquamarine blues, an entire range of greens and pinks amidst lush vegetation, is stunning, with its dash, its ardent vitality. It is the triumph of *en plein-air* painting.

For a century now art historians have been studying the sequence of the tale and its progression (we wish to affectionately quote among them Donald Posner, recently passed away). *The Pursuit* and the three other compositions of the series seek to share with the beholder the visible pleasure Fragonard had in painting them. We partake in his happiness and in turn feel it, as though we ourselves were the enamoured models of these works.

The Musée des Beaux-Arts in Angers recently purchased the sketch for *The Pursuit*.

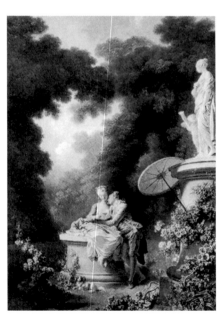

Jean-Honoré Fragonard,
Love-Letters, New York,
The Frick Collection

Jean-Honoré Fragonard,
The Pursuit, Angers,
Musée des Beaux-Arts

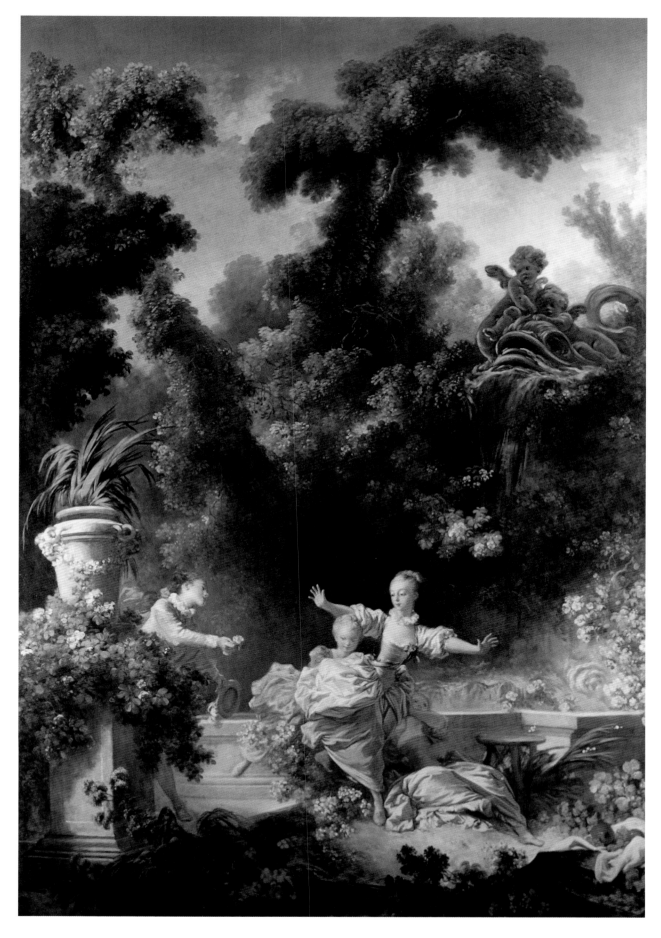

Joshua Reynolds

Plympton (Devonshire), 1723 – London, 1792

A Young Black

Canvas
H. 78.7; W. 63.7
C. 1770

Houston, The Menil Collection
[See Provenance and Reference p. 234]

The sitter's identity is not ascertained: not a single one of the many proposals advanced in the past few years seems perfectly satisfying. Conversely, the date generally proposed, c. 1770, as well as the presence of the work in Reynolds' studio up to 1796, date of its dispersion after the artist's death, appear certain.

Scholars concur in seeing in the painting an unfinished work rather than a preparatory study for some composition presently lost. We should recall that Reynolds painted Blacks on more than one occasion. He had in his service a "black servant," but experts of the artist hesitate to identify in the Houston picture a portrait in the strict sense of the word.

We recall the extremely varied, multiple interests of Mme de Menil, one of the great figures of twentieth-century American art patronage. They comprised Max Ernst and Rothko, the cause of religious œcumenism, as well as that of Blacks, to which she was actively committed. So we should not be at all surprised at her wishing to acquire this portrait of a young Black, with his noble demeanor, subsequently entered in the Houston museum which she had commissioned Renzo Piano to build.

151

Joseph Wright of Derby

Derby, 1734 – Derby, 1797

The Old Man and Death

Canvas
H. 102; W. 127
1774

Hartford, The Wadsworth Atheneum Museum of Art
(The Ella Gallup Sumner and Mary Catlin Sumner Collection Fund,
inv. 1953.15)
[See Provenance and Reference p. 236]

The subject is drawn from the fables by Aesop and La Fontaine: a poor woodcutter crushed under the weight of his load and old age calls on Death to free him, but when she appears to him, aghast, he repulses her. The scene is set in a lovely verdant landscape, on the banks of a tranquil river. On the left the ruins of a Gothic abbey. The skeleton of Death, right at the center of the composition, opens its arms to the woodcutter who, with a determined gesture, drives it from his sight. Admire the accurate rendering of the details, the "crystalline exactness of the Pre-Raphaelite vision of nature" to quote Robert Rosenblum, and the innovative aspect of the work, both as regards subject and handling. Thanks to Paul Mellon (1907–1991), Yale preserves an outstanding ensemble of Wright's canvases, views of the Roman countryside, of the Vesuvius, portraits, pictures featuring scientific subjects… Nonetheless, we believe the Hartford *Old Man and Death* is the only one to be truly unmatched in England.

Joseph Wright of Derby,
The Blacksmith's Shop,
New Haven, Yale Center
for British Art

Francesco Guardi

Venice, 1712 – Venice, 1793

The Garden of the Palazzo Contarini dal Zaffo in Venice

Canvas
H. 48; W. 78
Shortly after 1780

Chicago, The Art Institute
(Marion and Max Ascoli Fund, inv. 1991.112)
[See Provenance and Reference p. 231]

The canvas belongs to a group of four compositions: the three other pictures of the series (James Fairfax and Jayne Wrightsman collections and private collection) depict villas in the vicinity of Venice. Commissioned by the English resident in Venice John Strange, they likely date to shortly after 1780.

Why select this work among Guardi's huge production (over a thousand pictures)? Simply because it is a unique representation of a unique place in Venice (now difficult to visit). On the left toward the lagoon, across from Murano, the "Sacca della Misericordia" (a basin of the lagoon) and the "Casino degli Spiriti," so called because of its isolation or its echo (or perhaps because it once belonged to a family named Spirito), renowned in the eighteenth century for its literary and artistic gatherings. Then on the right the back of the Contarini palace and, in the background, the "Scuola vecchia" of the Misericordia.

But above all what captivates our eye is the Contarini garden, particularly well-kept in the eighteenth century (it survived but is now divided). Guardi depicts it from above, insists on its vastness, brings it to life with passers-by busy chatting: a realistic image, an ideal image of a city that has entirely preserved its fascination…

Francesco Guardi,
Villa Loredan at Paese,
New York, Wrightsman
Collection

Jacques-Louis David

Paris, 1748 – Brussels, 1825

Portrait of Antoine-Laurent Lavoisier and his Wife

Canvas
H. 259.7; W. 194.6
Signed and dated lower left: *W. David parisiis anno 1788*

New York, The Metropolitan Museum of Art
(Purchase, Mr. and Mrs. Charles Wrightsman
Gift in honor of Everett Fahy, inv. 1977.10)
[See Provenance and Reference p. 229]

Lavoisier (1743–1794), one of the inventors of modern chemistry, was also a farmer general, which was to cost him his head under the Terror. In 1771 he married Marie-Anne-Pierrette Paulze (1758–1836) who became his collaborator.

David portrays the couple at work. The scientific instruments (several of them can be seen at the Conservatoire national des Arts et Métiers in Paris), placed on the table and on the floor, allude to Lavoisier's works on gas, the composition of air, the formation of water from its constituents…

Shall we win approval for our choice? Or should we have selected, by David as well and in the same Metropolitan Museum, the *Death of Socrates*, dated to a year earlier than the portrait of the Lavoisier couple? This one is unique, David's most ambitious portrait and most perfect achievement in the genre. And the *Sabines* or the *Horatii* can be preferred to the *Socrates*.

David displays his supreme skill in rendering the reflections on the large balloon-flask in the foreground, on the gasometer and the hydrometer, and adds a subtle touch to the solemnity of his composition with a fond note of conjugal understanding.

Jacques-Louis David,
The Death of Socrates,
New York, The Metropolitan
Museum of Art

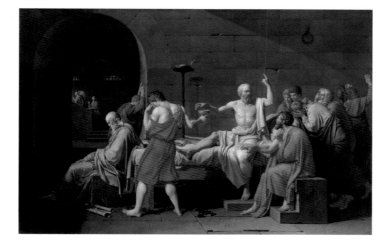

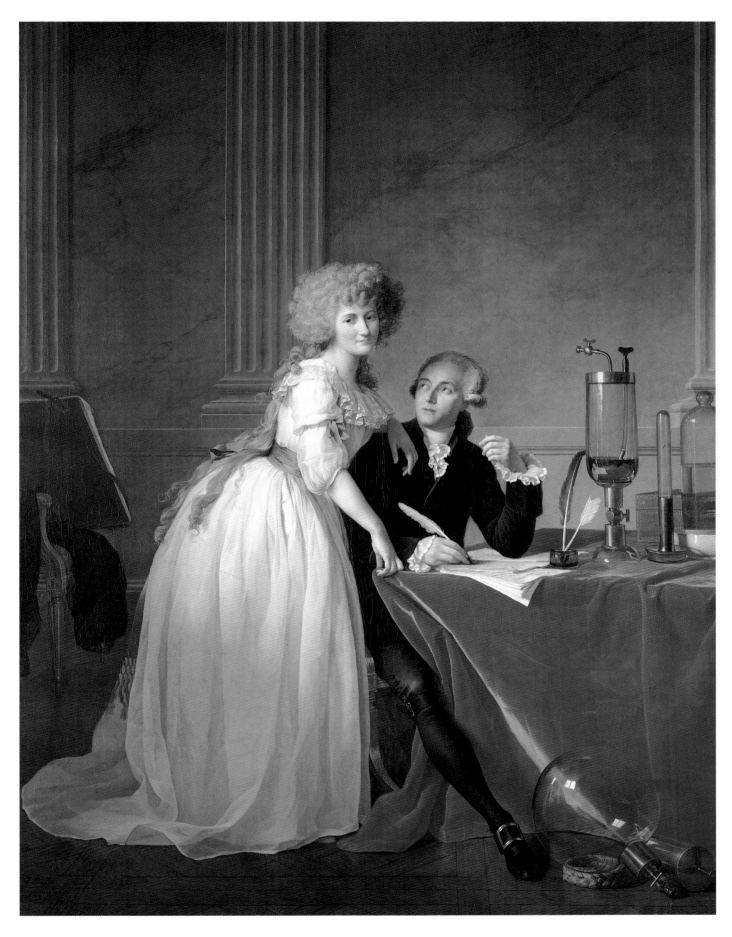

Thomas Lawrence

Bristol, 1769 – London, 1830

Portrait of Sarah Goodin Barrett Moulton: "Pinkie"

Canvas
H. 148; W. 102.2
1794

San Marino, The Huntington Library and Art Collections
(inv. HEH 27.61)
[See Provenance and Reference p. 232]

Right after his election to the Royal Academy at the minimum required age of twenty-five, Lawrence was given the commission for the portrait of Sarah Goodin Barrett Moulton. She had just turned eleven and arrived from Jamaica. The adolescent looks like she is about to perform a dance step in the wind, a wind ruffling her hair and blowing about the ribbons on her hat. She comes toward us, in front of a vast cloudy sky, looking at us with a candid expression (and an innocent ambiguity). The color of her dress explains the nickname *Pinkie* which at a very early date, as soon as it was painted, was given to the picture (and of course in contrast with Gainsborough's *Blue Boy*, p. 143).

Nothing in this portrait foreshadowed the story's sad end: Pinkie died at the age of twelve, a week before Lawrence showed her portrait at the Royal Academy (at the time the work failed to win the huge popularity it still enjoys today).

Francisco de Goya y Lucientes

Fuendetodos, 1746 – Bordeaux, 1828

Portrait of the Duchess of Alba

Canvas
H. 210; W. 149
Inscribed and dated, across from the sitter's feet: *Solo Goya 1797*

New York, The Hispanic Society of America
(inv. A 102)
[See Provenance and Reference p. 231]

Francisco de Goya y Lucientes,
Portrait of the Artist and his Physician,
Minneapolis, The Minneapolis
Institute of Art

Francisco de Goya y Lucientes,
Portrait of the Duchess of Alba,
Madrid, private collection

Among the many often magnificent paintings by Goya in American museums, it is not an easy task to choose one that is unrivaled in Europe, especially at the Prado. Of course we are aware there is another version of the *Portrait of the Duchess of Alba,* smaller and earlier (1795), but we felt the duchess' gesture, imperiously pointing her finger at the ground where Goya's name appears in large letters, gave a unique, exceptional flavor to the Hispanic Society's work.

The importance of the gesture is further emphasized by the attitude of the duchess, staring straight at us, as though determined to take us to witness. What does she wish us to understand? Or what does Goya want to tell us, and what can be the meaning of this trialogue between the duchess, Goya, and ourselves?

We should add that the portrait of the duchess is the very first after her husband's death, which explains her mourning clothes, and we point out that the two rings she is wearing are incised, one with the name *Alba* and the other with *Goya.*

Did Goya paint his desires and were his desires fulfilled? Shall we ever find out?

Louis Gauffier

Poitiers, 1762 – Livorno, 1801

Portrait of Thomas Penrose

Canvas
H. 68.5; W. 52.5
Signed and dated lower right: *W. Gauffier, Flor., 1798*

Minneapolis, The Minneapolis Institute of Arts
(The John R. van Derlip Fund, inv. 66.20)
[See Provenance and Reference p. 230]

Thomas Penrose (1769–1851), between 1794 and 1800, was private secretary to William Wyndham, British envoy to the court of the Grand Duchy of Tuscany before the occupation of Florence by the French troops. Gauffier portrayed for us his sitter outdoors, seated on a wall of one of the terraces of the Boboli Gardens in front of an admirable view of Florence. You will easily recognize the famous Cathedral dome, the tower of Palazzo Vecchio, and the hills of Fiesole. Young Penrose is holding a sketchbook on his lap and looks at us with a smile.

Gauffier left us the unforgettable view of a sunny Florence beneath a fleecy sky, and the image of a young amateur artist about to draw it to take home a souvenir.

Lisbon holds the preparatory drawing for this enchanting picture.

Louis Gauffier, *Portrait of Thomas Penrose* (drawing), Lisbon, Museu Nacional de Arte Antiga

162

Anne-Louis Girodet de Roucy Trioson

Montargis, 1767 – Paris, 1824

Portrait of Mademoiselle Lange as Danae

Canvas
H. 64.5; W. 54 (oval)
1799

Minneapolis, The Minneapolis Institute of Arts
(The William Hood Dunwoody Fund, inv. 69.22)
[See Provenance and Reference p. 231]

The picture caused a scandal: the actress Anne-Françoise-Elisabeth Lange (1772–1825) commissioned her portrait from Girodet. She was renowned for her beauty, her talent as an actress, and her dissolute mores. She refused her portrait she considered a poor likeness. Galled, Girodet destroyed his work and sought to get even with her. In just a few weeks (ninety days!) he painted the picture in Minneapolis today. It was shown but a few days at the Salon of 1799 before it closed.

We easily recognize Mlle Lange as Danae, entirely nude, wearing vanity's headdress of peacock feathers. The actress is preening in a mirror and amassing gold coins, Jupiter's gold, the gold given her by her lovers. The turkey is reportedly the portrait of the actress' bankrupt husband, Michel-Jean Simons. The actress's contemporaries perfectly understood the numerous allusions to her (hardly private) life. They also could interpret the four medallions gracing the original frame: the lower right corner, for instance, shows us La Fontaine's frog that wished to be as big as an ox, an allusion to the actress' pretense to glory.

The work's lunar light, its affectation, its enameled colors are surprising, but essentially what makes it memorable is its rousing eroticism.

Anne-Louis Girodet,
*Portrait of Mademoiselle Lange
as Danae*, with its original frame

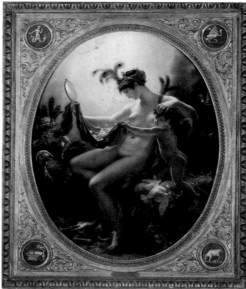

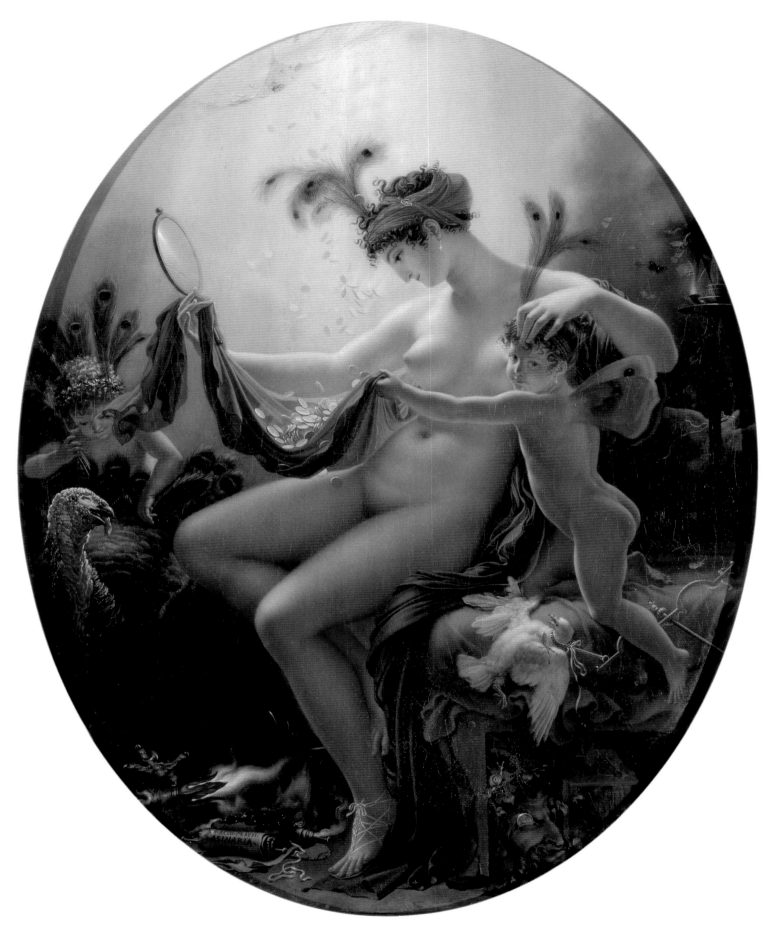

Théodore Géricault

Rouen, 1791 – Paris, 1824

The Lovers

Canvas
H. 22.5; W. 29.8
1817–20

Los Angeles, The J. Paul Getty Museum
(inv. 95.PA 72)
[See Provenance and Reference p. 230]

In speaking of Géricault we instantly think of the *Raft of the Medusa*. But that means we are forgetting he painted several erotic pictures which to date have not been rediscovered, if we except the one purchased—courageously on behalf of a public American institution—by the Getty in 1995.

A nude young woman lying on a bed is engrossed in watching the lovemaking of a young couple embracing and kissing. The brunette's head is resting on a blue-green pillow while the blonde woman, seen from the rear, is bent over her lover she is intent on embracing. She kept on only her chemise and one white stocking. A source of light coming from the left shines upon the blonde's chignon, her chemise, and her muscular thigh, as well as the wide-hipped, voluptuously offered body of the brunette. A scene of voyeurism with an innuendo: are we not, just like the brunette, the voyeurs of this amorous play?

Whereas the date of the work, after 1817 and Géricault's return from Italy, appears convincing, the identity of the models (but are they really models?) is still under discussion. Among the fine Géricaults purchased in recent years by the Getty (compare the *Portrait Study for the Head of a Black* with Reynolds' painting on the same subject, see p. 151), the *Lovers* is outstanding. The antique is a mere pretext (the bed, the statue, the drapery) and does not veil the realism of a scene that seems to be taken from life. Its frankness and bluntness are unheard of in the history of painting.

Théodore Géricault,
Portrait Study, Los Angeles,
The J. Paul Getty Museum

Théodore Géricault,
Monomania of Child Kidnapping, Springfield,
Museum of Fine Arts

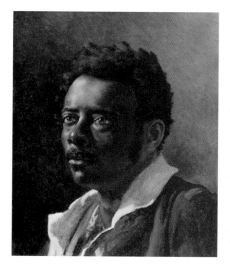

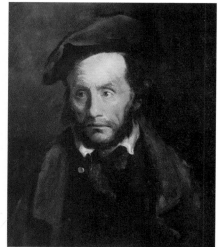

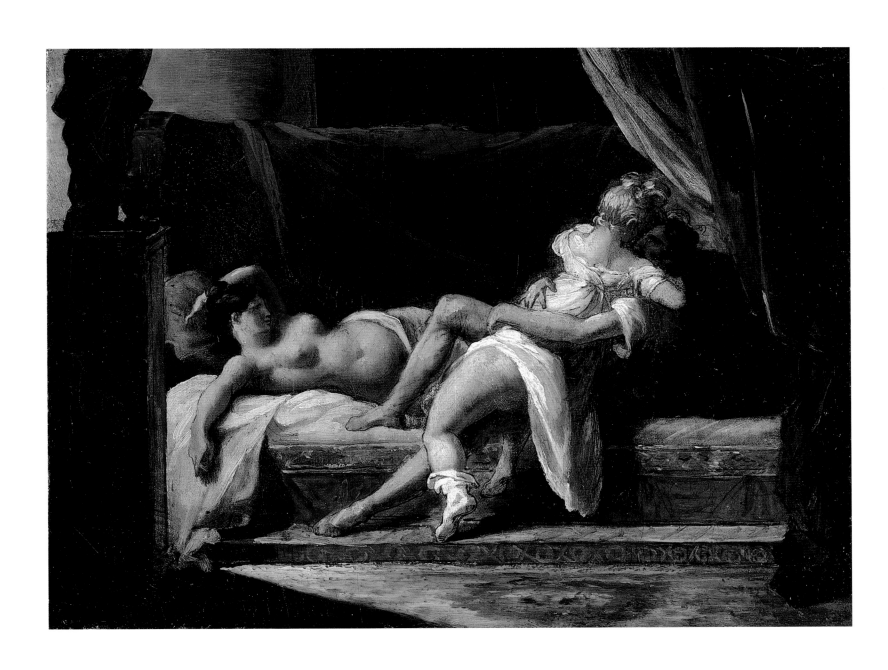

Joseph Mallord William Turner

London, 1775 – London, 1851

Slave Ship

Canvas
H. 91; W. 123
1840

Boston, Museum of Fine Arts
(Henry Lillie Pierce Fund, inv. 99.22)
[See Provenance and Reference p. 236]

We hesitated at length on the choice of this picture rather than one of the two "American" versions (Philadelphia [fig. 12] and Cleveland reproduced below) of *The Burning of the Houses of Lords and Commons, 16 October 1834*. We finally selected the Boston canvas, not only because it belonged to Ruskin (who unreservedly admired it but parted with it because "the throwing overboard of the dead and dying [...] had become too painful to live with"), but also because of John Shearman (1931–2003). In fact the great English scholar, an Italian Renaissance specialist, when asked advice for the present book, wrote us: "If I am allowed 'out of my field': some years ago the Museum of Fine Arts in Boston was under renovation and had to put its best pictures in one room. I thought (to my surprise) that the outstanding picture was Turner's *Slave Ship*" (letter dated 7 April 2003).

The work frightened the critics by the fascinating freedom of its handling as much as by its violently abolitionist subject. The sharks are attacking the black slaves cast overboard by the captain of the ship caught in a typhoon.

Joseph Mallord William Turner, *The Burning of the Houses of Lords and Commons, 16 October 1834*, Cleveland, The Cleveland Museum of Art

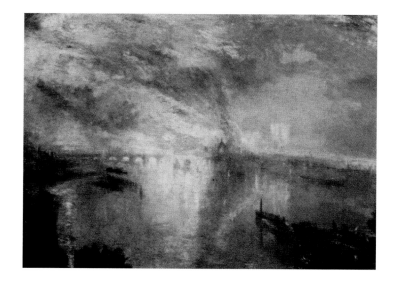

Jean-Auguste-Dominique Ingres

Montauban, 1780 – Paris, 1867

Portrait of the Vicomtesse Othenin d'Haussonville,
née Louise-Albertine de Broglie

Canvas
H. 132; W. 92
Signed and dated lower left: *Ingres.1845*

New York, The Frick Collection
(inv. 27.1.81)
[See Provenance and Reference p. 232]

The United States has a bounty of portraits by Ingres, especially of women. And several of the most beautiful. We selected the one of the Comtesse d'Haussonville (1818–1882), painted in Paris in 1845 when Ingres was sixty-five years old. The sitter was the granddaughter of Madame de Staël. The picture was exhibited at the castle of Coppet in Switzerland, once the residence of the author of *De l'Allemagne* and *Corinne* until 1925.

"M. Ingres must have been in love with you to paint you like that," Adolphe Thiers is said to have cried on seeing the canvas. As for Charles Blanc, he wrote in 1870: "The entire portrait appears to be seen through a light gauze, gray verging on lilac," dwelling on "the life of the sitter" and her "bemused expression." And to quote Baudelaire (1846), whose love for Delacroix was not exclusive: "M. Ingres is never so gifted nor so forceful as when his genius tackles the charms of a young beauty. The muscles, the folds of the flesh, the shadows of dimples, the hilly undulations of the skin, nothing is missing." Last, let us quote the great art historian Antoine Schnapper, recently passed away: "The Frick Collection *Portrait of the Comtesse d'Haussonville* is perhaps the picture I love the most" (interview published in the *Gazette de l'Hôtel Drouot*, 17 September 2004).

We linger on the opulence of several items furnishing the mantelpiece, lovingly detailed and depicted (most of them are now in the Frick museum), the work's chromatic distinction, and above all on the "play in the mirror reflecting Madame d'Haussonville," in keeping with one of Ingres' favorite practices.

Gustave Courbet

Ornans, 1819 – La Tour de Peilz, Switzerland, 1877

The Preparation of the Dead Girl

Canvas
H. 188; W. 251.5
C. 1850–60

Northampton, Smith College Museum of Art
(Drayton Hillyer Fund, inv. 1929.1)
[See Provenance and Reference p. 229]

The picture may well not be the artist's most important work, if we just think of the *The Painter's Studio* or *A Burial at Ornans*, or again of the recent fame of the *Origin of the World*. Nor is it the most outstanding picture by Courbet in American collections (*Young Women from the Village*, 1851, New York, The Metropolitan Museum of Art, *Hunting Dogs with Dead Hare*, 1857, Boston, Museum of Fine Arts, *The Treillis*, 1863, Toledo, Museum of Art, or else *The Greyhounds of the Comte de Choiseul*, 1866, Saint Louis, Art Museum). But it is unique. Until 1977, the Smith College canvas supposedly represented *The Preparation of the Bride*. But, as Hélène Toussaint and Linda Nochlin believe, its subject is far more macabre, the preparation of a dead girl before her parents and relatives come to pay her their last respects. It appears likely that the dead girl, initially nude, was then dressed and the position of her left arm altered, as confirmed by the X-Rays, to make the work easier to sell.

As it came down to us—unfinished and partly repainted—it is striking by the provocative boldness of its subject and in parts its dazzling execution.

The work is usually dated to between 1850 and 1860.

Gustave Courbet,
The Treillis, Toledo, Toledo
Museum of Art

Paris, 1833 – Sèvres, 1914

Self Portrait as an aquafortist

Pastel
H. 92.9; W. 68.2
Signed and dated upper left: *F. BRACQUEMOND.*
pictor chalcographus/ anno/ act 20/ 1853 dicipulus Jos Guichard
(for the various inscriptions on the pastel, see the exhib. cat. p. 228)

Cambridge, Harvard University Art Museums, Fogg Art Museum
(Grenville W. Winthrop Collection, inv. 1943.836)
[See Provenance and Reference p. 228]

Today Bracquemond is essentially known for his etchings, a genre to which he applied himself and that he revived. His pastel self portrait, one of the rare pastels in our book, shows him at the age of twenty surrounded by his working instruments. He holds in one hand a bottle containing a blue liquid "obtained by the reaction of copper dissolved in an eau-forte solution." In front of him on the table, a copper plate and a burin.

When the work was auctioned in London at Christie's, 7 July1939 (n. 29), it roused the enthusiasm of Martin Birnbaum, the customary buyer for Grenville Winthrop (1864–1943). He had to pay out ninety pounds and six shillings to purchase it.

Selecting this pastel meant choosing the unique work of a lesser artist. It also meant honoring the memory of Grenville Winthrop, to whom the United States owes an outstanding ensemble of nineteenth-century English and French drawings and paintings, insufficiently known because on the one hand they are mostly on paper and as a result rarely displayed, and on the other hand, by their donor's wish, they are prohibited from loan.

The recent exhibition in Lyon, London, and New York revealed to a wide public a few pieces from this fascinating, fabulous collection.

Jean-Auguste-Dominique Ingres, *Odalisque with a Slave*, Cambridge, Fogg Art Museum (formerly in the Winthrop Collection)

Ford Madox Brown, *Self Portrait*, Cambridge, Fogg Art Museum (formerly in the Winthrop Collection)

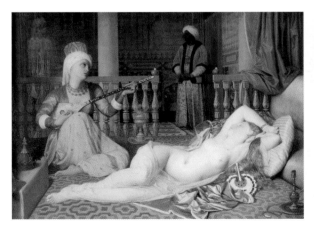

Edouard Manet

Paris, 1832 – Paris, 1883

Christ with Angels

Canvas
H. 179; W. 150
Signed lower left: *Manet* and inscribed on a stone:
évang[ile]. sel[on]. St Jean chap. XX v.XII
1863–64

New York, The Metropolitan Museum of Art
(inv. 29.100.51)
[See Provenance and Reference p. 233]

The presentation of the painting at the Salon of 1864 caused a public outcry. Critics berated Manet for his "dirty black shadows," for the wings of the two angels with their shrill blues, the wound of Christ on the left instead of on the right... But Baudelaire, Degas, Zola defended the work: "It is a brightly lit cadaver painted with honesty and vigor. And I even like the angels in the background, those children with big blue wings whose strangeness is so sweet and elegant" (Émile Zola, *Écrits sur l'art*, ed. 1991, Paris, p. 159).

Rarely do we associate Impressionism (in the broadest sense of the word) with religious painting. Manet, whose Italian (Mantegna, Andrea del Sarto, Veronese...) and Spanish (Velázquez, Ribalta) visual sources are familiar to us, boldly renewed a theme that had contributed several masterpieces to the history of painting.

When Manet painted the *Christ with Angels*, shortly after *Olympia* and the *Déjeuner sur l'herbe*, at a time when he was trying his hand at the most varied genres, had the artist truly given up painting "what we see," to borrow his own words?

The United States holds a second "religious" masterpiece by Manet, *The Mocking of Christ* at the Chicago Art Institute.

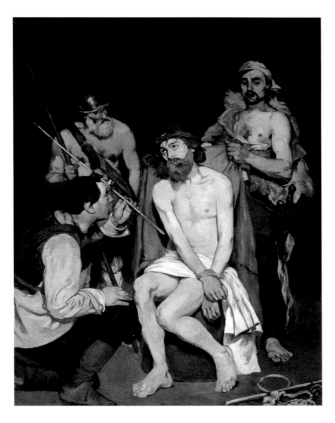

Edouard Manet,
The Mocking of Christ,
Chicago, The Art Institute

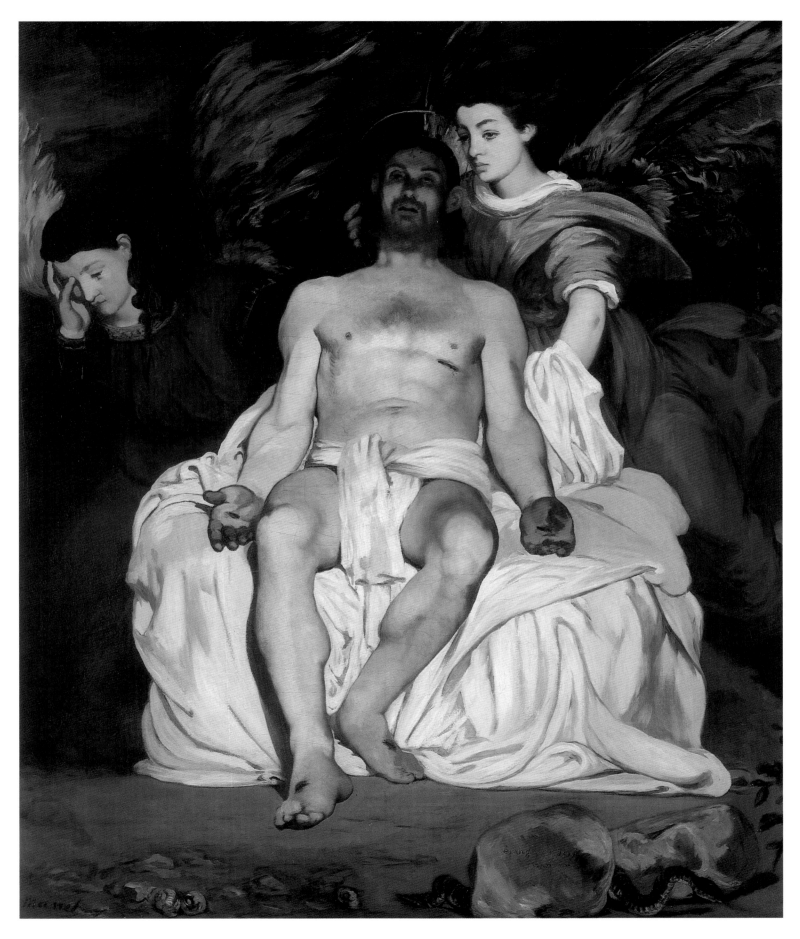

Claude Monet

Paris, 1840 – Giverny, 1926

Garden at Sainte-Adresse

Canvas
H. 98; W. 130
Signed lower right: *Claude Monet*
1867

New York, The Metropolitan Museum of Art
(Purchase, special contributions and funds given and bequeathed
by friends of the Museum, inv. 1967.241)
[See Provenance and Reference p. 233]

Monet painted this picture, his masterwork, during the summer of 1867, on a terrace at Sainte-Adresse near Le Havre. We make out Honfleur in the distance and some have recognized the artist's father donning a white Panama hat and several relatives of the Monet family seated or standing on the terrace.

The composition is divided horizontally in three sections, the flowering garden, the sea, the sky. Monet shows them from an elevated vantage point, a first-floor window.

Note the two vanishing points, the terrace balustrade and the horizon and above all the vertical masts with their flags waving. Later Monet claimed, referring to his picture: "At the time the composition was considered daring." It still is today, by its feeling of the open air wrought with wind, sun, sea, cloudy sky, flowers, dazzling light, luxuriant color, and its lyrical observation of nature.

Not a single museum in the world, except the Musée d'Orsay, owns as many Monets as the Chicago Art Institute (respectively 34 and 88).

Claude Monet,
The Gare Saint-Lazare,
Chicago, The Art Institute

Edgar Degas

Paris, 1834 – Paris, 1917

Mademoiselle Fiocre in the Ballet of "La Source"

Canvas
H. 130; W. 145
1867–68

Brooklyn, The Brooklyn Museum
(Gift of A. Augustus Healy, James H. Post, and John T. Underwood,
inv. 21.111)
[See Provenance and Reference p. 230]

The many admirers of Degas, who know how rich American museums are in Degas' works, may be taken aback by our choice. Why *Mlle Fiocre* instead of the *Interior*, known as *The Rape*, in Philadelphia (1868–69), or *At the Milliner's* at the Metropolitan Museum, or still the admirable *Portrait of the duchesse de Montejasi and her Two Daughters* (1876) recently acquired by Boston, or again this or that late pastel by the artist?

The work shows us a break during a rehearsal of the ballet *La Source*, libretto by Charles Nuitter and Saint-Léon, music by Ludwig Minkus and Léo Delibes, created in Paris, 12 November 1866. Eugénie Fiocre (1845–1908), a famous dancer of the time, was the prima ballerina.

Not a portrait, nor an Orientalist picture, nor actually a ballet scene, nor a history painting, the canvas belongs to all those different genres which Degas ambitiously sought to refresh. Skillfully blending realism and theatrical magic, for the first time the artist approached the world of dance of which he would become the incomparable illustrator. He created a poetic, captivating image, abounding in delectable notations, and added an appealing, somewhat provocative novelty: we are not seeing a performance of the ballet. Degas took us into the wings and painted a break, a moment of rest for the troupe.

Edgar Degas, *Interior*, or *The Rape*, Philadelphia, Philadelphia Museum of Art

Jean-François Millet

Gruchy, near Cherbourg, 1814 – Barbizon, 1875

The Bird Nesters

Canvas
H. 73.5; W. 92.5
Signed lower right: *J.F. Millet*
1874

Philadelphia, Philadelphia Museum of Art
(William W. Elkins Collection, inv. E 24-3-14)
[See Provenance and Reference p. 233]

Every devotee of Millet knows he must go to the United States to admire several of his masterpieces, notably to Boston (thanks to the Quincy Adams Shaw and Martin Brimmer gifts).

However we selected a work in the Philadelphia museum, a night scene, his last painting, which expresses all the cruelty of life. In 1873–74, Millet declared to a young American painter, Will H. Low (1853–1932): "When I was a boy, there were great flights of wild pigeons which settled in the trees at night, when we used to go with torches and the birds, blinded by the light, could be killed by the hundreds with clubs." Merciless, those who took part in this massacre fell upon their victims, knocking them down and choking them. The hallucinated, visionary violence of the scene is shattering.

Jean-François Millet,
Harvesters Resting, Boston,
Museum of Fine Arts

Pierre-Auguste Renoir
Limoges, 1841 – Cagnes-sur-Mer, 1919

Luncheon of the Boating Party

Canvas
H. 130; W. 175.5
Signed and dated lower right : *Renoir/ 1881*

Washington, The Phillips Collection
[See Provenance and Reference p. 234]

We are on the terrace of the Maison Fournaise, an open-air café still in business today, on an island of the Seine at Chatou, a few kilometers from Paris. The weather is wonderful, a superb sunny summer day, some friends (in the foreground on the right, we recognize the painter Gustave Caillebotte) gather around a bountiful table near the water. Begun during the summer of 1880, the picture was completed that winter in the studio.

In this ambitious work, the chromatic beauty of which has always been admired and rightly so, Renoir sought to paint a scene of modern life, while energetically refusing to turn it into an anecdote. Renoir is not telling a story, and if his models appear to be posing, it is all the better to perpetuate and substract from time this hymn to friendship and *joie de vivre*. When he purchased the painting in 1923, Duncan Phillips wrote with great foresight to a friend: "Its fame is immense and people will come thousands of miles to our house to see it."

Pierre-Auguste Renoir,
*Madame Charpentier
and her children,*
New York, The Metropolitan
Museum of Art

Gustave Caillebotte

Paris, 1848 – Gennevilliers, 1894

Nude on a Couch

Canvas
H. 129.5; W. 194.6
Signed lower right: *G. Caillebotte*
C. 1882

Minneapolis, The Minneapolis Institute of Arts
(The John R. van Derlip Fund, inv. 67.67)
[See Provenance and Reference p. 228]

The reader, aware of the wealth of American collections in Impressionist paintings, is likely be surprised to see this nude reproduced in our book rather than the so famous *Paris Street: Rainy Day* (1873) by the same Caillebotte, owned by the Chicago Art Institute. We feel that with its raw, provocative truth, the Minneapolis canvas is far bolder and, as has already been observed, ranks outstandingly next to Manet's *Olympia* (1863) and Gervex's *Rolla* (1878). The woman's insistent nudity, to quote Kirk Varnedoe, recently departed and who did so much to give Caillebotte the place he deserves among the Impressionist painters, is disturbing, makes us uncomfortable. A pitiless, uncompromising image of modern life, the *Nude on a Couch*, painted c. 1882, takes your breath away. Notice the ankle-boots on the floor and the model's clothing, as well as the hair on the pubes and the armpits.

The picture was purchased in 1967 for the Minneapolis museum by its director Anthony Clark (1923–1976) whose name is familiar to all scholars of eighteenth-century Roman art, notably of Pompeo Batoni. At that date, Caillebotte was underrated in France as in the United States, so we can but admire the courage and shrewdness of this acquisition.

Gustave Caillebotte,
Paris Street: Rainy Day,
Chicago, The Art Institute

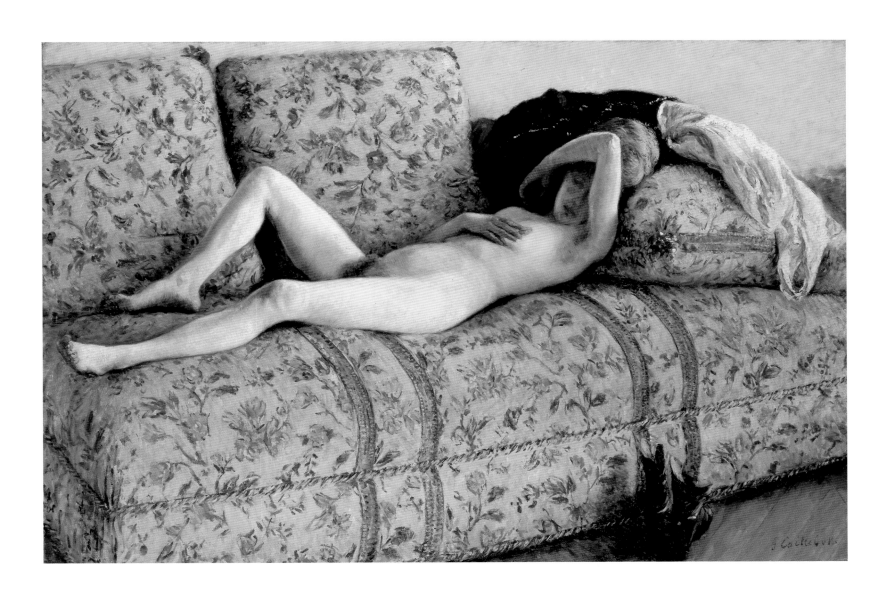

187

Walter Goodman

London, 1838 – England, c. 1906

The Printseller's Window

Canvas
Signed lower right: *Walter Goodman*
H. 132; W. 113.5
c. 1882

Rochester, Memorial Art Gallery of The University of Rochester
(Marion Stratton Gould Fund, inv. 98-75)
[See Provenance and Reference p. 231]

Why choose this trompe-l'œil by a mysterious English painter, by whom we know only three other paintings? American museums abound in masterpieces, but they equally hold in store amazing surprises, astonishing works by underrated artists or "minor masters," especially from the nineteenth century.

Goodman's canvas, a recent acquisition of the Rochester museum, offers a good example of that kind of work. Our information about it comes from the catalog of an exhibition devoted to the trompe-l'œil held in Washington, curated by Sybille Ebert-Schifferer, and from a letter Nancy Norwood, curator in Rochester, sent us. The author of the catalog entry, Franklin Kelly, identifies a good number of the prints (after Rubens, Reynolds, Van Dyck, Carlo Dolci…) and the models of the photographs we see in it (such as Gustave Doré, Millais, Rosa Bonheur, Frederick Lord Leighton, Lawrence Alma Tadema). Still according to Franklin Kelly, the picture must be later than 1882, since that is the date of the framed photograph of John Ruskin we see on the shelf (1819–1900).

The painting is certainly a rarity: but it is a great deal more. A highly skilled trompe-l'œil, a tribute to photography and the art of reproduction, it intrigues, seeks to hold your attention and inspire curiosity. Who will be the one to succeed in perfectly deciphering it?

Paris, 1859 – Paris, 1891

La Grande Jatte

Canvas
H. 207.5; W. 308
1884–86

Chicago, The Art Institute
(Helen Birch Bartlett Memorial Collection, inv. 1926.224)
[See Provenance and Reference p. 235]

Beyond all doubt the most important, most irreplacable French painting held in the United States. By Seurat, America possesses several masterpieces (*The Models* at the Barnes Foundation, as well as the Metropolitan Museum sketch for *La Grande Jatte*) and an impressive number of drawings, the famous "blacks", and we have to admit we cannot do full justice to the artist's genius without going there and visiting one after another New York (Metropolitan, but also Guggenheim and MoMA), Washington, Cambridge, Chicago, Buffalo, Saint Louis, Detroit, Indianapolis, Minneapolis, Kansas City, San Francisco (its wonderful *Eiffel Tower*, fig. 2)…

Painted in 1884–86, carefully prepared, shown at the eighth Impressionist exhibition in 1886, *La Grande Jatte* or, to be precise, *Sunday Afernoon on the Island of La Grande Jatte 1884*, owes its title to the island thus named on the Seine in the vicinity of Paris between Courbevoie and Neuilly. Forty-eight figures of every age, three dogs, a swarm of parasols and top hats, a handsome orange butterfly, eight boats, and a monkey compose this icon of neo-Impressionist painting, but even moreso, of modern painting.

On a sun-drenched Sunday, Parisians stroll, rest, and enjoy themselves on the banks of the Seine. Movement is ruled out. Fishermen, yachtsmen, strollers, musicians, children, and lovers silently mingle. Over and above Seurat's elect color theory, known as *pointillism*, over and above the mixing of social classes and of generations assembled in an already citified countryside, Seurat succeeded in creating the definitive, timeless image of a scene of modern life.

Georges Seurat,
The Models, Merion,
The Barnes Foundation

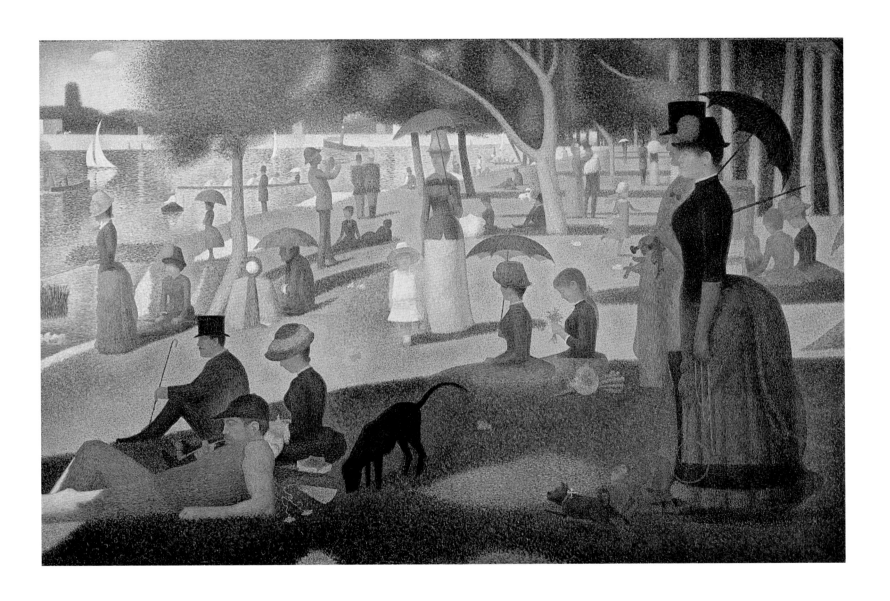

Fernand Khnopff

Grembergen-lez-Termonde, 1858 – Brussels, 1921

Portrait of Jeanne Kéfer

Canvas
H. 80; W. 80
Signed and dated lower center: *FERNAND KHNOPFF 1885*

Los Angeles, The J. Paul Getty Museum
(inv. 97.PA.35)
[See Provenance and Reference p. 232]

Jeanne Kéfer was the daughter of the Belgian composer and pianist Gustave Kéfer. Khnopff exhibited the portrait in 1886 at the "XX" of which he had been one of the founding members in 1884.

The excellence of the work is determined as much by its charm as by its daring color and exacting composition. The little girl—she was five years old in 1885—, stylishly attired, standing, leaning against a door that is far too big for her—a door for adults—stares at us, unmoving, alone, shy, enthralled.

At a glance, the canvas strives to be realistic and preeminently descriptive. But Khnopff did not let himself be trapped in such a reductive formula. The dreamlike stance, the silence, a cool, elegant poetry, a note of tenderness and restrained emotion, a delicate intimism, the absence of gestures, contribute to create a melancholy, accomplished, geometrically designed work, an image indeed, but haunting and unusual in the European painting of the last years of the nineteenth century.

James Ensor

Ostend, 1860 – Ostend, 1949

Christ's Entry into Brussels in 1889

Canvas
H. 252.5; W. 430.5
Signed and dated lower right: *J. ENSOR/ 1888*

Los Angeles, The J. Paul Getty Museum
(inv. 87.PA.96)
[See Provenance and Reference p. 230]

The great Belgian master's absolute masterpiece, probably painted in 1889 and not 1888, marks the artist's break with the different trends of Impressionism and his determination to turn toward a virulent, satirical art, looking back to Bosch and Brueghel. Carnival masks, symbols of the hypocrisy of contemporary society, take up the entire foreground of the scene. Christ, tiny and forgotten, is lost amidst the milling crowd. The awkward inscriptions, the shrill, clashing color, the intentionally disturbing character of the composition, everything is upsetting in this outsize work, whose fortune—expressionism, surrealism—was immense. Did Ensor want to contrast Seurat, whose *Grande Jatte* (p. 191) had just been shown in Brussels in 1887? Their subject, their execution, their inspiration, their artistic ideal, everything opposes the two masterpieces.

Vincent van Gogh

Groot Zunder, 1853 – Auvers-sur-Oise, 1890

Rain

Canvas
H. 73.5; W. 92.5
1889

Philadelphia, Philadelphia Museum of Art
(The Henry P. McIlhenny Collection,
in memory of Frances P. McIlhenny, inv. 1986-26-36)
[See Provenance and Reference p. 236]

The picture was probably painted on 2 November 1889, at a time when Van Gogh had requested to be admitted in the Saint-Paul de Mausole asylum at Saint-Rémy de Provence. He may have painted it from a window in his room (he alludes to the picture in one of his letters).

Every period of Van Gogh is superbly represented in museums, whether large or small, in the United States, and yet there is something unique about this landscape in the rain. Van Gogh had already painted this walled field, with the Alpilles in the background, but here what absorbed him was the rain, its drops rolling down the front of his canvas, its long vertical streaks giving the work at once its vigor and hemmed-in, rather despondent tone. The scale of colors—olive greens, light blues, and delicate purples—is particularly subtle.

The picture once belonged to Henry P. McIlhenny, one of the most distinguished *connoisseurs* in America, whose entire collection entered the Philadelphia museum in 1986.

Vincent van Gogh,
The Starry Night, New York,
The Museum of Modern Art

Paul Signac

Paris, 1863 – Paris, 1935

Portrait of Félix Fénéon

Canvas
H. 73.5; W. 92.5
Signed and dated lower left: *P. Signac 90*
inscription lower right *Op. 217*

New York, The Museum of Modern Art
(Fractional Gift of Mr. and Mrs. David Rockefeller)
[See Provenance and Reference p. 235]

At the Salon des Indépendants of 1891, the title of the work was *Op. 127. On the Enamel of a Rhythmic Background with Beats and Angles, Tones, and Tints, Portrait of M. Félix Fénéon in 1890.* Félix Fénéon was one of the most sophisticated figures of his time, prime mover of literary magazines, art critic, and dealer in avant-garde paintings. His friendship with Signac, with whom he shares his anarchizing political ideals and admiration for Seurat, goes back to 1884. His portrait reflects that friendship and the two men's interest in Japanese art, Japanese prints, and the theories of Charles Henry on rhythms and lines.

This authentic kaleidoscope of colors is equally a manifesto of the new Neo-Impressionist school. In this painting we are struck by the sitter seen in profile with his odd Yankee-style goatee, grasping his top hat and stick in one hand, and the flower—a cyclamen or an orchid?—in the other, delicately held with his fingertips.

Henri de Toulouse-Lautrec

Albi, 1864 – château de Malromé, in the Gironde, 1901

At the Moulin Rouge

Canvas
H. 123; W. 141
Monogram-stamp lower left
1892

Chicago, The Art Institute
(Helen Birch Bartlett Memorial Collection, inv. 1928.610)
[See Provenance and Reference p. 235]

Hesitation is out of the question: Toulouse-Lautrec's masterpiece in the United States, and one of his most perfect, is beyond all doubt the Chicago *Moulin Rouge*. And yet it is among the artist's most enigmatic works.

If we easily recognize Toulouse-Lautrec and his cousin Gabriel Tapié de Celeyran, as well as La Goulue arranging her hairdo in the middle distance of the canvas, scholars disagree over the other protagonists of the composition. In this way, they are undecided between Nelly C. and Mary Milton for the woman, on the far right of the canvas, whose heavily made-up face is violently lit from below with what is sometimes described as deep-sea light.

Nor do we know when and why Toulouse-Lautrec decided to enlarge his canvas in its lower section and on the right, nor the stages of its transformation. However the date of 1892 is widely accepted.

The audacity of the composition, with the oblique balustrade in the left foreground, is equalled by the boldness of the subject which associates men of high society and women from the world of entertainment and the demi-monde in the famous Montmartre cabaret.

Described without indulgence, with a cruel, disenchanted irony, the *Moulin Rouge* offers a lasting image of real life, far removed from the tourist clichés still prevailing today.

Henri de Toulouse-Lautrec,
At the Moulin Rouge:
The Dance, Philadelphia,
Philadelphia Museum of Art

Henri Rousseau, known as Douanier Rousseau

Laval, 1844 – Paris, 1910

The Sleeping Gypsy

Canvas
H. 129.5; W. 200.7
Signed and dated lower right: *Henri Rousseau 1897*

New York, The Museum of Modern Art
(inv. 646.39)
[See Provenance and Reference p. 234]

In a letter dated 10 July 1898 addressed to the mayor of Laval, Rousseau commented on his painting: "A wandering negress, playing a mandoline, with her water jug at her side, is sound asleep overwhelmed with fatigue. A lion chances by, smells her, and does not devour her. It is a moonlight effect, extremely poetic. The scene takes place in a completely arid desert. The Gypsy is dressed in the Oriental style."

The attorney John Quinn (1870–1924), the "most intense collecter there ever was or will ever be," to quote Henri-Pierre Roché, bought the picture in February 1924 but had only a short time to enjoy it. We should recall he gave the Louvre Seurat's *Circus*.

In his preface to the catalog of John Quinn's estate sale, Jean Cocteau (1889–1963) observed: "Besides, it is not without a reason if the painter who never forgot a single detail did not mark any footprints on the sand by the sleeping feet. The sleeping gypsy did not come here. She is simply here…" She is dreaming, Rousseau is dreaming and we are dreaming.

Paul Gauguin

Paris, 1848 – Atuona, Hiva Oa island, Marquesas islands, 1903

Where do we come from? What are we? Where are we going?

Canvas
H. 139; W. 374.5
1897–98

Boston, Museum of Fine Arts
(Tompkins Collection, inv. 36.270)
[See Provenance and Reference p. 230]

Painted in 1897–98 at Tahiti, *Where do we come from? What are we? Where are we going?* is—no one ever questioned it—Gauguin's masterwork. The artist himself, and his many letters about the huge canvas confirm it, felt certain: "I cannot stop looking at it and, well (I confess), I admire it," he wrote to Daniel de Monfreid in February 1898.

On the right (*Where do we come from?*), women, a child, a leaping dog symbolize Spring, the first steps in life; at center (*What are we?*) a man raises his arms to pick the fruit of the tree of knowledge, then on the left (*Where are we going?*) an old woman wearing a veil alludes to the brevity of life. Last, the bird is the symbol of "the futility of words."

Using Gauguin's writing, scholars of the artist's oeuvre examined each motif of the picture, its literary or visual sources (Puvis de Chavannes), their symbolic signification. Over and above the artist's declared ambition to merge drawing and color, to paint the total work of art, at once primitive and civilized, *Where do we come from...* closed the nineteenth century with a page both monumental and decorative, in the highest sense of the word, a lesson which in the twentieth century inspired the Nabis as well as Matisse or even several German Expressionist painters.

André Derain

Chatou, 1880 – Chambourcy, 1954

The Ball in Suresnes

Canvas
H. 180; W. 145
Signed and dated lower right: *a derain/ 1903*

Saint Louis, The Saint Louis Art Museum
(inv. 172:1944)
[See Provenance and Reference p. 230]

In 1903, Derain was twenty-three and doing his military service at Commercy in the Vosges. Although he had met Vlaminck and, in his studio at Chatou, tried out the delights of pure color, he had not yet made up his mind to devote himself exclusively to painting.

In the *Ball in Suresnes*, three artillerymen in dress uniform—one is supposedly Derain himself—impassively observe an ill-assorted, unusual pair of dancers: a tall angular dark-haired woman wearing a long dress, and a soldier. Notice the outsize white glove on the lady's hip, the bright, clear colors, and above all the ruthless, biting irony with which Derain describes the scene, clearly antimilitarist in character.

A young artist's experimental work, unique in his vast, extremely varied production, the *Ball in Suresnes* introduced a great painter.

Balthus,
Portrait of Derain, New York,
The Museum of Modern Art

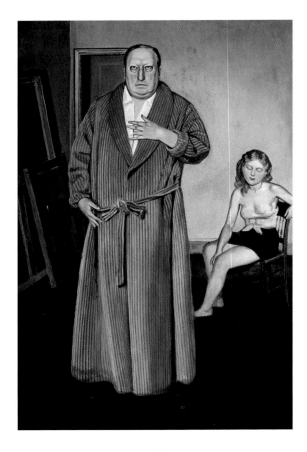

Paul Cézanne

Aix-en-Provence, 1839–1906

The Large Bathers

Canvas
H. 208.3; W. 251.5
1906

Philadelphia, Philadelphia Museum of Art
(The W.P. Wilstach Collection, inv. W37-1-1)
[See Provenance and Reference p. 229]

Which Cézanne should we choose among the artist's many masterpieces held in the United States? We long hesitated, wavering also between the Philadelphia *Large Bathers* and those at the nearby Barnes Foundation, one of the fifty-one Cézanne paintings (including the incomparable *Card Players*) owned by the famous institution.

One of the artist's very last works, one of the largest and most ambitious on which Cézanne was still working the year he died, the *Large Bathers* are the culmination of the painter's reflection on the theme of male and female bathers that absorbed him all his life.

The color scale is confined to the essentials: blue, green, ochre, a few touches of vermilion. There has been much comment on the grandiose character of this monumental human architecture, the triumph of the nude and *en plein air* painting.

A German visitor, Karl Ernst Osthaus, who traveled to Aix in April 1906 with the sole purpose of meeting Cézanne and admiring his "immortal works," wrote about the *Large Bathers*: "The tall trunks of the trees formed an arched cathedral perspective over the bathing scene." In turn, admiring the *Large Bathers* at Auguste Pellerin's in 1921, the English sculptor Henry Moore exclaimed: "For me this was like seeing Chartres cathedral…"

Paul Cézanne,
The Large Bathers, Merion,
The Barnes Foundation

Henri Matisse

Le Cateau-Cambrésis, 1869 – Nice, 1954

Joy of Life [*Happiness of Life*]

Canvas
H. 175; W. 241
Signed lower left: *Henri Matisse*
1905–06

Merion, The Barnes Foundation (inv. 719)
[See Provenance and Reference p. 233]

It was quite a challenge to choose among the countless masterpieces by Matisse dispersed among the greatest American museums (Chicago, Saint Louis [fig. 1], Baltimore Museum of Art...). Which paintings out of the extraordinary collection assembled by Dr. Barnes (Cézanne [p. 208], Seurat [p. 190], Renoir, without forgetting the *Seated Rifain* by the same Matisse...)? *Happiness of Life*, more commonly called *Joy of Life*, was painted in 1905–06 on Matisse's return from a trip to Collioure. Presented at the Salon des Indépendants of 1906, the painting afforded Matisse "the greatest hilarity success in his entire career." That very year Picasso had the opportunity to admire it in the Stein's apartment in the rue de Fleurus. He probably planned his *Demoiselles d'Avignon* to counter the large canvas by Matisse, a hymn to color and beauty. He sought to retort to Matisse's "rather innocent erotic reverie" (Flam), all curves, with an angular, harsh canvas inspired by the reality of a brothel.

Merging dance, music, and love in a sort of paradise on Earth, a Virgilian pastoral poem, Matisse renewed the myth of a golden age which Ingres glorified before him.

Henri Matisse, *Seated Rifain,* Merion, The Barnes Foundation

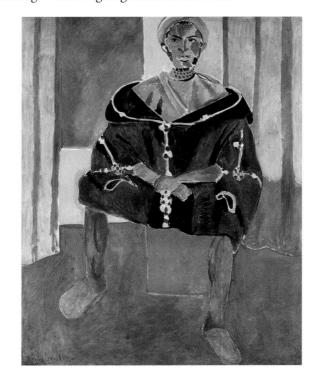

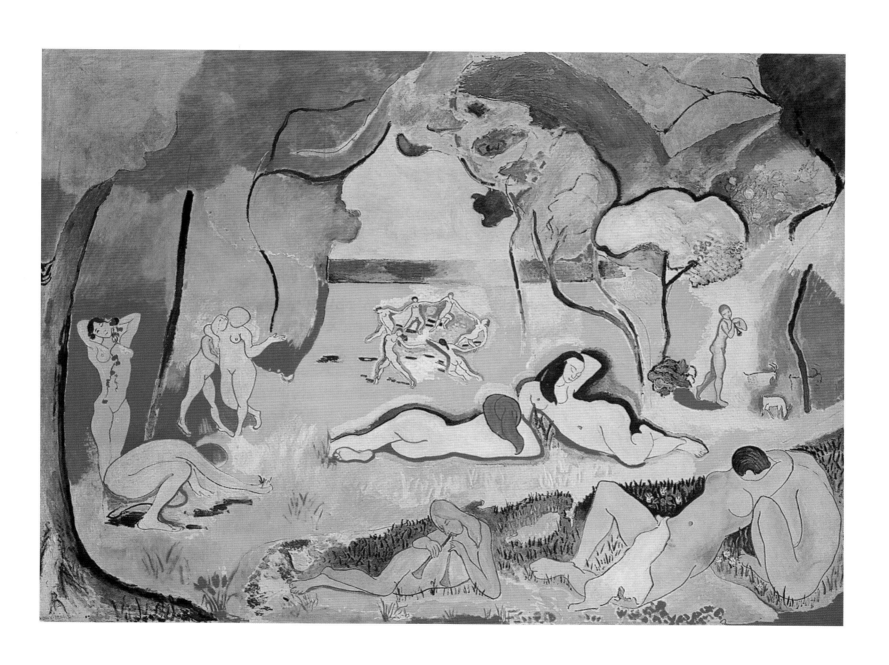

Pablo Picasso

Malaga, 1881 – Mougins, 1973

Les Demoiselles d'Avignon

Canvas
H. 243.3; W. 233.7
1907

New York, The Museum of Modern Art
(Lillie P. Bliss Bequest, inv. 333.39)
[See Provenance and Reference p. 233]

Everything has already been said about the *Demoiselles d'Avignon*, painted by Picasso at his Bâteau-Lavoir studio in Paris in June-July 1907: about the origin of its title, a brothel in Barcelona on Avignon Street ("Carrer d'Avinyó"), about the influences on it, at times acknowledged by the artist at others denied, Assyrian art, Egyptian art, African masks, Iberian statuary, El Greco, his determination to surpass Cézanne and his *Large Bathers* (p. 209), his rivalry with Matisse whose *Joy of Life* (p. 211) caused a sensation at the Salon des Indépendants of 1906. Much has been made of Picasso's rejection of color, of his wish to fracture forms and recompose them, which would make the *Demoiselles d'Avignon* the first Cubist picture. Yet it is the vitality of the work, its intense eroticism, the abundance of its experiments, its complexity that are arresting in this icon of twentieth-century art.

In 1912 the fashion designer Jacques Doucet sold his admirable collection of eighteenth-century paintings and drawings, prevailingly French. He undertook a new, equally admirable, collection of contemporary works, paintings but furniture and *objets d'art* as well.

Why reproduce here Degas' *Racecourse*? Because to purchase the *Demoiselles d'Avignon* the MoMA had to sell that painting.

Edgar Degas, *Racecourse*,
Private collection

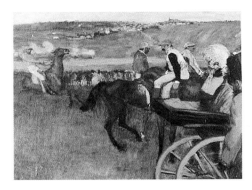

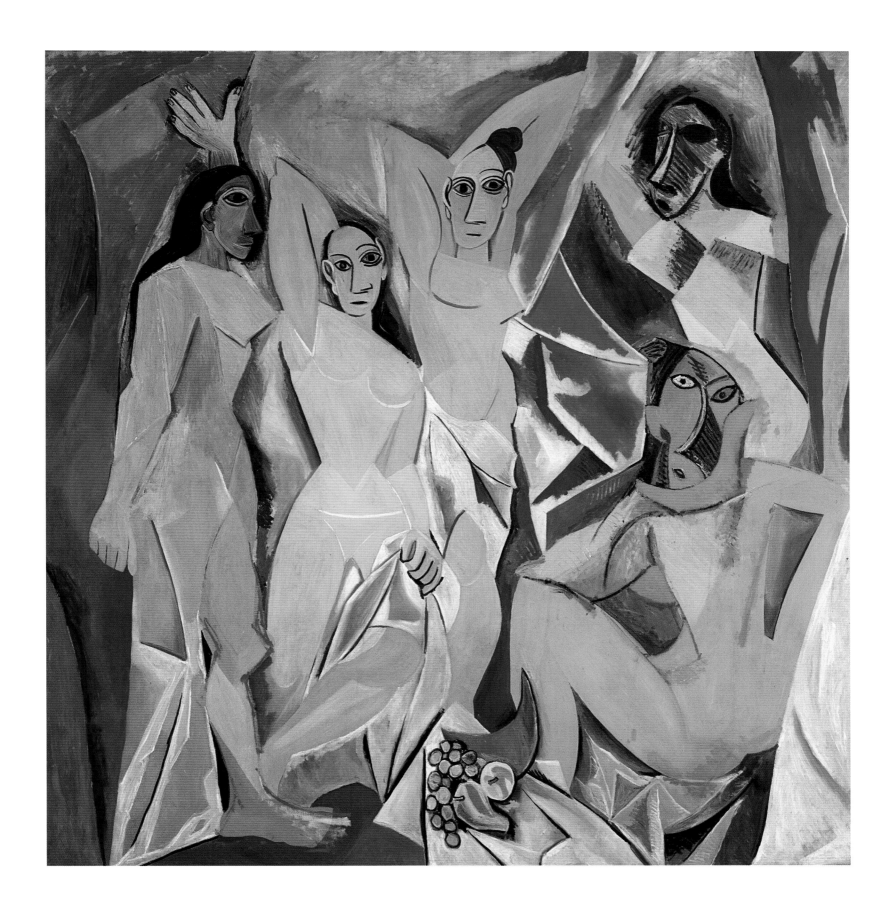

Oskar Kokoschka

Pöchlarn, 1886 – Montreux, 1980

Portrait of Hans Tietze and Erica Tietze Conrat

Canvas
H. 76.5; W. 136.2
Monogrammed lower right: *OK*
1909

New York, The Museum of Modern Art
(Abby Aldrich Rockefeller Fund, inv. 651.39)
[See Provenance and Reference p. 232]

The painting to a certain extent exemplifies the tragedies of the twentieth century. Austrian by birth, Kokoschka worked in Vienna and then in Prague, became a Czech citizen, then English, and died in Switzerland. A large part of his work was confiscated by the Nazis in 1937. The Tietzes (Hans, born in Prague in 1880, died in New York in 1954, and Erica 1883–1958) married in 1905, left Austria after the Anschluss—they were Jewish—and settled in New York where they devoted their lives to art history. Among their many writings on Venetian drawing, on Dürer, on Altdorfer, we are dutybound to mention their *Master European Drawings in the United States*, first published in German in 1935 (in English in 1939), whose subject in a way is very close to ours.

The young couple, the picture dates to 1909, are not looking at each other. Kokoschka insists on their hands and their long fingers. If the work unmistakably recalls Vienna before 1914, and if the influence of Klimt (figg. 3 and 4) and Schiele can still be felt, this double portrait already displays that anguished violence the artist will but rarely relinquish.

Umberto Boccioni

Reggio di Calabria, 1882 – Verona, 1916

The City Rises

Canvas
H. 199; W. 301
Signed lower right: *U. Boccioni*
1910–11

New York, The Museum of Modern Art
(Mrs. Simon Guggenheim Fund, inv. 507.51)
[See Provenance and Reference p. 228]

The City Rises—at first the picture was titled *Work*—dates to 1910–11: in 1910, Boccioni, very close to Balla, Carrà, Russolo, and the poet Marinetti, wrote the *Manifesto of the Futurist Painters*. In his theoretic writings the painter proved to be the leading champion of Futurist esthetics and poetics.

When it was shown in Paris in 1912, Georges Michel wrote: "And here we have an interesting picture. Oh! Cubists, you trivial *pompiers*, Cézanne, you old fossil, Van Gogh or Van Dongen, you shamefaced old dotards, Monet, Renoir, Manet, you ghosts of the past… away with you! Even your fieriness, oh de Groux [the Belgian painter Henri de Groux 1867–1930] is gloomy compared to this horse, as red as an inferno, dragged by serpent-men dressed like construction workers, and that raises palaces with a mere snort."

The work, still akin to the esthetics of the Ferrarese painter Previati and to Morbelli, with its daring color and its ambition to combine and blend symbolism and realism, proves the will to introduce motion and dynamism in the construction of forms.

Giacomo Balla

Turin, 1871 – Rome, 1958

Dynamism of a Dog on a Leash

Canvas
H. 90; W. 110
Signed and dated lower right: *Balla 1912*

Buffalo, Albright-Knox Art Gallery
(Bequest of A. Conger Goodyear and Gift of George F. Goodyear,
inv. AKAG 1964:16)
[See Provenance and Reference p. 228]

Balla was one of the signatories of the *Manifesto of the Futurist Painters* published in 1910, a movement founded by the Italian writer Marinetti and advocating a program celebrating the modern world, the machine, speed... Two years later at the Countess Nerazzini's at Montepulciano he painted his *Dynamism of a Dog on a Leash*, a work displaying the artist's interest in the study of the decomposition of motion, a concern which proved lasting.

What is appealing in the Buffalo painting, more than the application of an artistic ideology—the basset's paws, tail, and leash seen in several positions—, more than a composition that seeks to astonish, is Balla's sense of humor in handling his subject. But where in the world is she rushing with such a determined step, that woman of whom all we see is her shoes and the bottom of her dress?

Otto Dix

Untermhaus, 1891 – Hemmenhofen, 1969

Self Portrait

Oil and tempera on wood
H 73.7; W. 49.5
Signed and dated upper left: *DIX/ 1912*

Detroit, The Detroit Institute of Arts
(Gift of Robert H. Tannahill, inv. 51.65)
[See Provenance and Reference p. 230]

In reaction to the *Brücke* and the *Blaue Reiter* movements, predominant in Germany at the time, Otto Dix chose the path of tradition, realism, and objectivity, without seeking to disguise his admiration for the past masters, in this case the many "men with a pink" of old German and Netherlandish painting (School of Van Eyck in Berlin, Michael Ostendorfer at the Liechtenstein Museum of Vienna). He chose a support, wood, and a technique, primed panel and a mixture of oil and distemper, that prove his intent to revive the past.

The sitter's modern attire and his anxious, suspicious expression, however, lead us back to the art of the twentieth century of which Otto Dix was a major witness. The work was considered "degenerate" by the Nazis and sold in 1937.

Michael Ostendorfer,
Self Portrait, Vienna,
Liechtenstein Museum

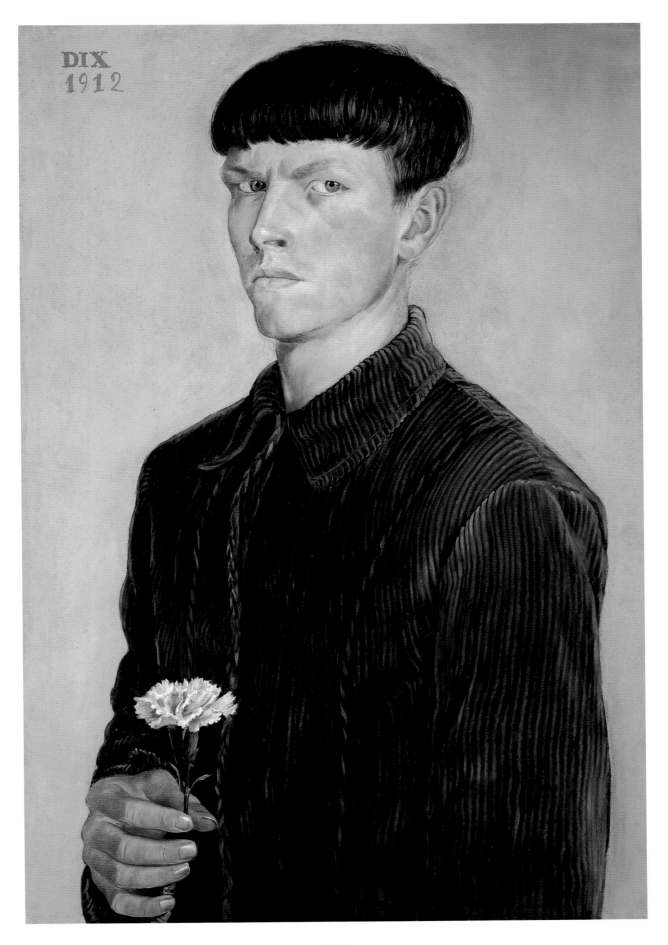

221

Kasimir Malevich

Kiev, 1878 – Leningrad [Saint-Petersburg], 1935

The Knife-Grinder (Principle of Glittering)

Canvas
H. 79.7; W. 79.5
Signed lower right: *K.M.*
1912–13

New Haven, Yale University Art Gallery
(inv. 1941.553)
[See Provenance and Reference p. 232]

The work dates to 1912, a crucial, decisive year in which a great many twentieth-century avant-garde movements were born, in France but as well in Italy, Germany, and Russia. In 1913 Malevich presented his *Knife-Grinder* in Moscow and, invited by Kandinsky, took part in the second *Blaue Reiter* exhibition. The *Knife-Grinder* is the most perfect of the works of Malevich's Cubo-Futurist "mechanical" period, prior to the rise in 1913 of the "cosmic" suprematist movement to which the artist's name remains permanently linked.

The inspiration of Léger's fractured Cubism was completed by a taste for the machine and for the decomposition of volumes and motion. The influence of the *Knife-Grinder* in the twentieth century proved considerable.

The painter (her 1918 *Portrait of Marcel Duchamp* belongs to the MoMA) and collecter Katherine Dreier, with Man Ray and Duchamp, founded in 1920 the Société Anonyme to promote contemporary art in the United States through traveling exhibitions and lectures, and by creating a permanent collection which in 1941 Katherine Dreier began to transfer to the Yale University Art Gallery.

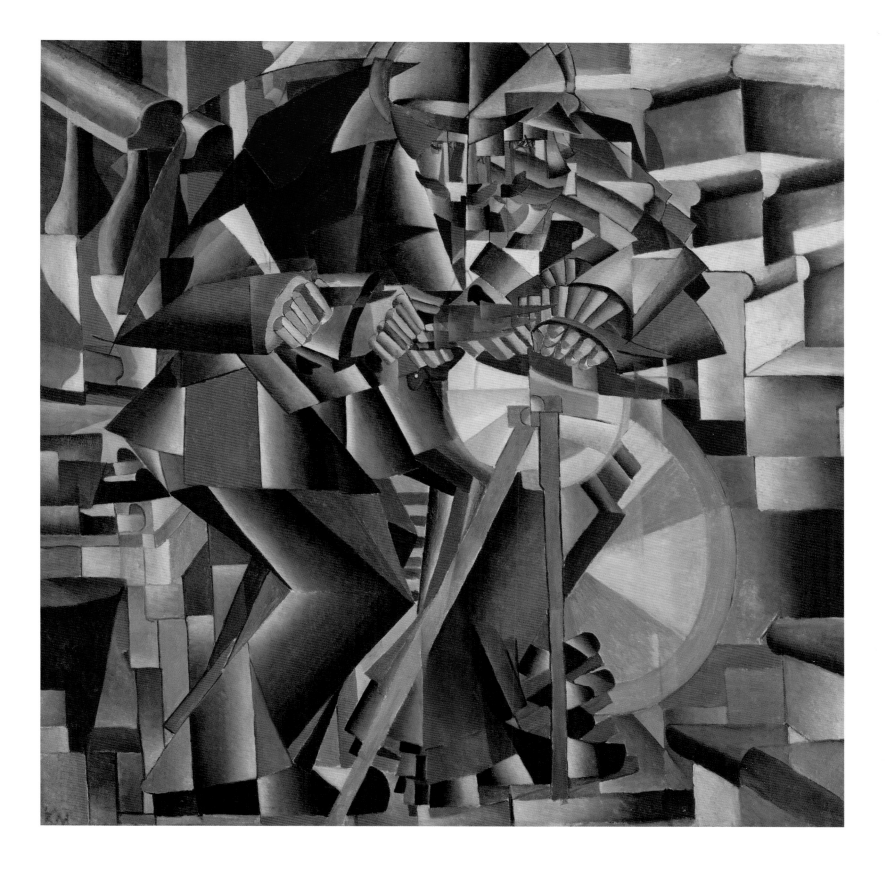

Marcel Duchamp
Blainville, 1887 – Neuilly-sur-Seine, 1968

Nude Descending a Staircase n. 2

Canvas
H. 146; W. 89.2
Signed and dated lower left: *MARCEL DUCHAMP 12*
and written lower left: *NU DESCENDANT UN ESCALIER*

Philadelphia, Philadelphia Museum of Art
(The Louise and Walter Arensberg Collection, inv. 1950-134-59)
[See Provenance and Reference p. 230]

There could be no better conclusion to this book than the *Nude Descending a Staircase* painted by Marcel Duchamp at Neuilly-sur-Seine in January 1912. In addition to the twofold scandal, the refusal of the organizers of the Salon des Indépendants in Paris in 1912 to exhibit it and the scandal arisen on showing the work at the Armory Show in New York the following year, there was the radical break, already latent in this painting and which will be further asserted, with the art of the past. Of course the work is still related to a form of Cubism into which motion was introduced (however not to be be mistaken with Futurism), of course chronophotography and the cinema are present, but Marcel Duchamp's ambition was more philosophical and intellectual, more experimental, more ironic (and more iconic), as well as more sarcastic.

"Painted in wood tones […], the *Nude* is outstanding by the fact that it does not exist or at least is not visible, since it is strapped inside a sort of sheath with extendible gussets that turns it into a machine for descending." (Robert Lebel, *Sur Marcel Duchamp*, Paris, 1959, p. 9)

Marcel Duchamp's choice to become an American citizen in 1955 fully confirmed the shift of the center of gravity of painting from Europe to America.

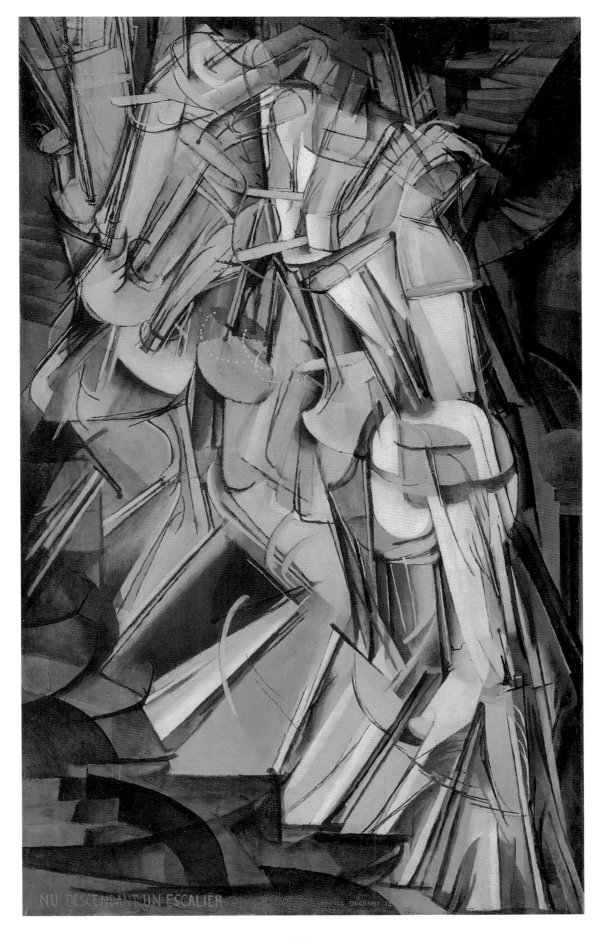

NU DESCENDANT UN ESCALIER

Provenance and Reference

Balla, Giacomo
Dynamism of a Dog on a Leash
[pp. 218–19]
Provenance: Purchased by the industrialist (he was also the first president of the MoMA) Anson Conger Goodyear (1877–1964) c. 1936.
Reference: Giovanni Lista, *Balla*, Modena, 1982, n. 241, repr.

Bartolomeo di Giovanni Corradini, known as Fra Carnevale
The Presentation of the Virgin at the Temple (?)
[pp. 38–39]
Provenance: From the oratory of Santa Maria della Bella at Urbino, then, after 1632, collection of cardinal Antonio Barberini (1607–1671). Barberini collection until 1934.
Reference: Exhib. cat. *From Filippo Lippi to Piero della Francesca: Fra Carnevale and the Making of a Renaissance Master*, Milan, Pinacoteca di Brera, and New York, The Metropolitan Museum of Art, 2004–05, n. 45b, repr. (entry by Keith Christiansen).

Bassano, Jacopo, Jacopo da Ponte, known as
The Flight into Egypt
[pp. 64–65]
Provenance: In England in the nineteenth century and specifically at Prinknash Abbey in Gloucestershire until 1969, date of its sale, 5 December, in London, Christie's, n. 112, repr., where it was purchased for 260.000 guineas (655.000 dollars) by Norton Simon (1907–1993).
Reference: Bernard Aikema, *Jacopo Bassano and his Public. Moralizing Picture in an Age of Reform, ca. 1535–1609*, Princeton, 1996, pp. 23–26, repr.

Batoni, Pompeo Girolamo
The Triumph of Venice
[pp. 126–27]
Provenance: Commissioned in 1737 by Marco Foscarini (1696–1763), ambassador of the Serenissima to the Holy See from 1736 to 1740. In the United States between c. 1857 and 1916 and again after 1956, date of its purchase by the Kress Foundation that gave it to the Raleigh museum in 1960.
Reference: Anthony Clark and Peter Bowron, *Pompeo Batoni*, Oxford, 1985, n. 13, repr.

Bellini, Giovanni
Saint Francis of Assisi in Ecstasy
[pp. 46–47]
Provenance: See the entry (as well as Rosella Lauber, "From Venice to New York, Bellini's epical saint Francis…," *Venezialtrove. Almanacco della presenza veneziana nel mondo*, n. 3, 2004, pp. 85–89).
Reference: Anchise Tempestini, *Giovanni Bellini*, Milan, 1997, pp. 112–114, n. 45, repr.; Willi Hirdt, *Il San Francesco di Giovanni Bellini. Un tentativo di interpretazione del dipinto della Frick Collection*, Florence, 1997; Helmut Wohl, "The Subject of Giovanni Bellini's St. Francis in the Frick Collection," dans *Mosaics of Friendship. Studies in Art and History For Eve Borsook*, Florence, 1999, pp. 187–198; Norman Hammond, "Bellini's ass: a note on the Frick 'St Francis'," *The Burlington Magazine*, vol. CXLIV, n. 1186, January 2002, pp. 24–26

Bermejo, Bartolomé
Santa Engracia
[pp. 44–45]
Provenance: See the entry p. 44–45. The Brussels sale was on 27 May 1904, n. 546. The painting belonged to Somzée's collection. He purchased the work before 1899 in Saragossa.
Reference: Exhib. cat. *La pintura gótica hispanoflamenca. Bartolomé Bermejo y su época*, Barcelona, Museu Nacional d'Art de Catalunya, and Bilbao, Museo de Bellas Artes, 2003, n. 7, repr. (entry by Ana Galilea Antón).

Boccioni, Umberto
The City Rises
[pp. 216–17]
Provenance: Shown in Milan in 1911, then in 1912 in Paris, London, Berlin, and Brussels. When in London, the work is purchased by the pianist and composer Ferruccio Busoni (1866–1924). His son Rafaello sells it in 1951 to the MoMA.
Reference: Maurizio Calvesi and Ester Coen, *Boccioni. L'opera completa*, Milan, 1983, n. 675, repr.

Bor, Paulus
Medea Betrayed
[pp. 102–03]
Provenance: After belonging to the Chigi and the Andrea Busiri Vici (1903–1989) collections, the picture was purchased by Ben Heller who gave it to the Metropolitan Museum in 1972.
Reference: Hélène E.C. Mazur-Contamine, "Twee 'tovenaressen' van Paulus Bor," *Bulletin van het Rijksmuseum*, 29, 1981, pp. 3–8; Jeroen Giltaij, in exhib. cat. *Dutch Classicism in Seventeenth Century Painting*, Rotterdam, Boijmans van Beuningen Museum, and Frankfurt, Städelsches Kunstinstitut, 1999–2000, pp. 144–47, repr.; cat. exp. *The Metropolitan Museum of Art New York Chefs-d'œuvre de la peinture européenne*, Martigny, 2006, n. 13, repr. (entry by Walter Liedtke).

Bracquemond, Félix-Auguste-Joseph
Self Portrait as an aquafortist
[pp. 174–75]
Provenance: Exhibited at the Salon of 1853. In England by the nineteenth century. Purchased for Grenville W. Winthrop (1864–1943) by Martin Birnbaum (1878–1970) in 1939.
Reference: Exhib. cat. *The Grenville W. Winthrop Collection*, Lyon, London, and New York, 2003–04, n. 4, repr. (entry by Marjorie B. Cohn).

Cagnacci, Guido
Martha Rebukes her Sister Mary for her Vanity, or *The conversion of Mary-Magdalene*
[pp. 114–15]
Provenance: In the collections of the Duke of Mantua in 1665. Purchased in 1711 for 800 (or 1.200) ducats by Henry Bentinck, future Duke of Portland, and in his family until Christie's sale in London, 11 December 1981, n. 52, repr. Acquired the following year by Norton Simon (1907–1993).
Reference: Exhib. cat. *Guido Cagnacci*, Rimini, Museo della città, 1993, n. 41 pp. 166–68, repr. (entry by Gabriello Milantoni).

Caillebotte, Gustave
Nude on a Couch
[pp. 186–87]
Provenance: Purchased by Minneapolis in 1967 from the Stephen Hahn gallery in New York.
Reference: Marie Berhaut, *Gustave Caillebotte. Catalogue raisonné des peintures et pastels*, Paris, 1994, n. 201, repr.; exhib. cat. *Gustave Caillebotte 1848–1894*, Paris, Grand Palais, and Chicago, The Art Institute, 1994–95, n. 82, repr. (entry by Gloria Groom).

Cairo, Francesco
Judith with the Head of Holophernes
[pp. 100–01]
Provenance: Discovered in Denmark in 1963, passed into the English art market. Purchased in 1966 by the Sarasota Museum.
Reference: Francesco Frangi, *Francesco Cairo*, Turin, 1998, p. 245, repr.

Campin, Robert, also known as Master of Flémalle
The Annunciation with Saint Joseph and Couple of Donors, or *The Mérode Triptych*
[pp. 26–27]
Provenance: Purchased in 1956 from the comtesse Jeanne de Grunne, descendant of the comte de Mérode (according to *Life* magazine, 7 April 1958, the Metropolitan Museum paid out over 750.000 dollars, approximately 5.000.000 dollars today).
Reference: Shirley Neilsen Blum, in *La peinture flamande dans les musées d'Amérique du Nord*, Antwerp, 1992, n. 1,

repr.; exhib. cat. *From Van Eyck to Bruegel. Early Netherlandish Painting in The Metropolitan Museum of Art*, New York, The Metropolitan Museum of Art, 1998, n. 2, repr. (entry by Maryan W. Ainsworth).

Canaletto, Giovanni Antonio Canal known as
Bacino di San Marco
[pp. 128–29]
Provenance: Purchased (and perhaps commissioned), apparently in 1738, by Charles Howard, third Earl Carlisle (d. 1738) or, more likely, by his son Henry, fourth Earl. Bought by Boston in 1939.
Reference: Exhib. cat. *Canaletto*, New York, The Metropolitan Museum of Art, 1989, n. 51, repr. (entry by Katharine Baetjer and Joseph Gluckstein Links).

Carpaccio, Vittore
The Cormorant Hunt, or *Hunting on the Lagoon* (reverse: *Trompe-l'œil with Letter Rack*)
[pp. 50–51]
Provenance: Collection of cardinal Fesch (1763–1839), uncle of Napoleon. Collection of the marquis Giovanni Pietro Campana (1808–1880). Purchased by Andrea Busiri Vici in Rome in 1944. Auctioned at Christie's in London, 30 November 1973, but did not sell. Bought by the Getty in 1979.
Reference: Yvonne Szafran, "Carpaccio's 'Hunting on the lagoon': a new perspective," *The Burlington Magazine*, vol. CXXXVII, n. 1104, March 1995, pp. 148–58; exhib. cat. *Il Rinascimento a Venezia e la pittura del Nord ai tempi di Bellini, Dürer, Tiziano*, Venice, Palazzo Grassi, 1999, n. 27, repr. (entry by Enrico Maria del Pozzolo).

Cecco del Caravaggio (Francesco Boneri)
The Resurrection
[pp. 78–79]
Provenance: Commissioned in 1619, with two canvases by Honthorst and Spadarino, by Piero Guicciardini, the

Medici's agent in Rome, for the Guicciardini chapel in the church of Santa Felicita in Florence, but refused by the commissioner. Probably Scipione Borghese collection. Entered the Chicago museum in 1934.
Reference: Gianni Papi, *Cecco del Caravaggio*, Soncino, 2001, pp. 132–35, repr.

Cézanne, Paul
The Large Bathers
[pp. 208–09]
Provenance: Ambroise Vollard (1866–1939) sold the canvas to Auguste Pellerin (1852–1929). His son Jean-Victor disposed of it in favor of the Wildenstein gallery. The Philadelphia Museum bought it in 1937 with the W.P. Wilstach Fund.
Reference: Exhib. cat. *Cézanne*, Paris, London, and Philadelphia, 1995–96, n. 219, repr. (entry by Joseph Rischel).

Christus, Petrus
A Goldsmith in his Shop, possibly Saint Eloi
[pp. 34–35]
Provenance: Probably painted for the goldsmiths' guild in Bruges. Philip Lehman (1861–1947) after 1920, then his son Robert (1891–1969), entered the collections of the Metropolitan Museum in 1975.
Reference: Exhib. cat. *Petrus Christus Renaissance Master of Bruges*, New York, The Metropolitan Museum of Art, 1994, n. 6, repr. (entry by Maryan W. Ainsworth); exhib. cat. *From Van Eyck to Bruegel. Early Netherlandish Painting in The Metropolitan Museum of Art*, New York, The Metropolitan Museum of Art, 1998, n. 22, repr. (entry by Della C. Sperling).

Courbet, Gustave
The Preparation of the Dead Girl
[pp. 172–73]
Provenance: The picture belonged to Juliette Courbet (1831–1915), the painter's sister. Courbet sale, 1919, n. 1. Jacques Zoubaloff collection.

Purchased in 1929 in New York.
Reference: Exhib. cat. *Gustave Courbet*, Paris, Grand Palais, 1977–78, n. 25, repr. (entry by Hélène Toussaint); exhib. cat. *Courbet reconsidered*, Brooklyn, Brooklyn Museum, 1998, n. 27, repr. (entry by Linda Nochlin).

Coypel, Noël-Nicolas
The Rape of Europa
[pp. 122–23]
Provenance: We know in detail every displacement of this picture ever since it was painted, in 1726, up to 1978 when John Cadwalader gave it to the Philadelphia Museum, passing through the collections of Blondel de Gagny, Calonne, Donjeux, without forgetting Joseph Bonaparte (1768–1844) who in 1839 offered it to General Thomas Cadwalader.
Reference: Exhib. cat. *The Loves of the Gods: Mythological Painting from Watteau to David*, Paris, Philadelphia, and Fort Worth, 1991–92, n. 30, repr. (entry by Colin B. Bailey); Jérôme Delaplanche, *Noël-Nicolas Coypel 1690–1734*, Paris, 2004, n. P. 35, repr.

Crespi, Giuseppe Maria
Young Woman Tuning her Lute
[pp. 120–21]
Provenance: If we are certain that by 1960 the picture belonged to the art dealer and historian Vitale Bloch (1900–1975), we know nothing about its earlier provenance or, in any case, none of the various propositions advanced are entirely convincing.
Reference: Mira Pajes Merriman, *Giuseppe Maria Crespi*, Milan, 1980, n. 213, repr.; exhib. cat. *G.M. Crespi 1665–1747*, Bologna, Pinacoteca nazionale, 1990, n. 58, repr. (entry by August Rave).

Crivelli, Carlo
Saint George and the Dragon
[pp. 40–41]
Provenance: Like the *ensemble* of the altarpiece, it comes from the church of San Giorgio at Porto San Giorgio near Fermo in the Marches, doubtless

commissioned by Giorgio Albanese, subsequently Salvadori. Sold in England by a descendant of the commissioner in 1835 (the purchaser paid 90 scudi to Luigi Salvadori, but also had to compensate the town of Porto San Giorgio by paying 300 scudi) Purchased in 1897 by Mrs. Gardner (1840–1940), through Bernard Berenson (1865–1959).
Reference: Pietro Zampetti, *Carlo Crivelli*, Florence, 1986, pp. 254–57, repr.; Ronald Lightbown, *Carlo Crivelli*, New Haven and London, 2004, pp. 109–18, pl. 26.

David, Jacques-Louis
Portrait of Antoine-Laurent Lavoisier and his Wife
[pp. 156–57]
Provenance: Paid to David the enormous amount of 7.000 pounds in 1788. Purchased from the Lavoisier family by John D. Rockefeller (1839–1937) in 1925. Bought from the Rockefeller Institute for Medical Research by the Metropolitan Museum in 1977 thanks to the generosity of Mr. and Mrs. Charles Wrightsman.
Reference: Exhib. cat. *Jacques-Louis David 1748–1825*, Paris, Musée du Louvre, and Versailles, Musée National du Château, 1989–90, n. 84, repr. (entry by Antoine Schnapper); Gary Tinterow and Asher Ethan Miller, in *The Wrightsman Pictures*, New York, 2005, n. 70, repr.

De Bray, Jan
The Banquet of Antony and Cleopatra
[pp. 116–17]
Provenance: See the entry p. 116–17. Acquired by Manchester in 1969.
Reference: Exhib. cat. *Great Dutch Paintings from America*, The Hague and San Francisco, 1990–91, n. 13, repr. (entry by Ben Broos); exhib. cat. *Dutch Classicism in Seventeenth Century Painting*, Rotterdam, Boijmans van Beuningen Museum, and Frankfort, Städelsches Kunstinstitut, 1999–2000, n. 58, repr. (entry by Jeroen Giltaij); exhib. cat.

Jan de Bray and the Classical Tradition, Washington, National Gallery of Art, 2005, n. 3, repr.

Degas, Edgar
Mademoiselle Fiocre in the Ballet of "La Source"
[pp. 180–81]
Provenance: Exhibited at the Salon of 1868, "retouched" by Degas c. 1892–95. First Degas studio sale, 6 May 1918, n. 8a (80.500 francs). Purchased in 1921 by A. Augustus Healey, James H. Post, and John T. Underwood who gave the picture to the Brooklyn Museum.
Reference: Exhib. cat. *Degas*, Paris, Ottawa, and New York, 1988–89, n. 77, repr. (entry by Henri Loyrette).

Derain, André
The Ball in Suresnes
[pp. 206–07]
Provenance: Belonged to Ambroise Vollard (1866–1939) who in 1905 bought the artist's entire production, then to Etienne Bignou and last to Joseph Brummer, all three art dealers. Purchased by Saint Louis in 1944.
Reference: Michel Kellermann, *André Derain. Catalogue raisonné de l'œuvre peint*, I, Paris, 1992, n. 351, repr.; exhib. cat. *André Derain. Le peintre du " trouble moderne "*, Paris, Musée d'Art moderne de la Ville de Paris, 1994–95, n. 5, repr. (entry by Miriam Simon).

Dix, Otto
Self Portrait
[pp. 220–21]
Provenance: Purchased by the Düsseldorf Kunstmuseum in 1925. Confiscated and sold in 1937 as "degenerate art," Bought by Robert H. Tannahill (1893–1969) in 1938 who offered it to the Detroit museum in 1951.
Reference: Fritz Löffler, *Otto Dix 1891–1969. Œuvre der Gemälde*, Recklinghausen, 1981, p. 9–11.

Duchamp, Marcel
Nude Descending a Staircase n. 2
[pp. 224–25]

Provenance: Listed in the catalog of the Salon des Indépendants of 1912, but was not shown there. Exhibited in 1913 at the Armory Show in New York. Purchased that same year by Frederic C. Torrey of San Francisco, then Louise and Walter Arensberg collection (1878–1954) in 1919.
Reference: Arturo Schwarz, *The Complete Works of Marcel Duchamp*, New York, ed. 1997, n. 242, repr.

Ensor, James
Christ's Entry into Brussels in 1889
[pp. 194–95]
Provenance: Remained at the painter's until his death. At the casino in Knokke-le-Zout between 1951 and 1957, date of its purchase by Louis Franck, who lent it to the Fine Arts museum in Antwerp, then to the Kunsthaus in Zurich. The picture was bought by the Getty in 1987.
Reference: Xavier Tricot, *James Ensor. Catalogue raisonné des peintures (1875–1902)*, I, Paris, 1992, n. 280, repr.; Patricia G. Berman, *Christ's Entry into Brussels in 1889*, Los Angeles, 2002.

Fragonard, Jean-Honoré
The Pursuit
[pp. 148–49]
Provenance: Painted, with the other compositions of the series, for the château of Louveciennes at the request of the comtesse du Barry (1743–1793), but refused by her and returned to Fragonard. At Grasse between 1791 and 1898 (sold for 1.250.000 francs). Collections of John Pierpont Morgan (1837–1913) and then Henry Clay Frick (1849–1919) in 1915 (bought for 1.425.000 dollars).
Reference: Exhib. cat. *Fragonard*, Paris, Grand Palais, and New York, The Metropolitan Museum of Art, 1987–88, pp. 319–25 (entry by Pierre Rosenberg).

Furini, Francesco
Cephalus and Aurora
[pp. 92–93]

Provenance: The date of the picture, doubtless c. 1628, and the name of its commissioner (Alessandro del Nero?) remain uncertain. The *Death of Adonis* at the Budapest Fine Arts Museum, commissioned by Giovambattista Baccelli, might be the *pendant* of the Ponce painting. On the English market in the late 1950s and acquired by Ponce in 1958.
Reference: Exhib. cat. *Il Seicento fiorentino. Arte a Firenze da Ferdinando I a Cosimo III. Pittura*, Florence, Palazzo Strozzi, 1986–87, vol. I, n. 130, repr. (entry by Giuseppe Cantelli).

Gainsborough, Thomas
Portrait of Jonathan Buttall: the "Blue Boy"
[pp. 142–43]
Provenance: Shown at the Royal Academy in 1770. Sold by the sitter in 1796. Purchased in 1802 by the painter John Hoppner (1758–1810) who sold it to Robert, second Earl of Grosvenor and future first marquis of Westminster. Acquired by the art dealer Joseph Duveen (1869–1939) in 1921 and sold to Henry Edwards Huntington (1850–1927) for the sum of 182.000 pounds considered astronomical at the time (728.000 dollars, about ten million dollars today).
Reference: Robyn Asleson, *British Paintings at the Huntington*, San Marino, 2001, n. 17, repr. (in the same catalog, essay on H.E. Huntington, the collector, by Shelley M. Bennett); exhib. cat. *Great Paintings from American Collections. Holbein to Hockney*, New Haven, Yale Center for British Art, and San Marino, Huntington Library, 2001–02, n. 17, repr. (exhibited only at San Marino; entry by Robyn Asleson).

Gauffier, Louis
Portrait of Thomas Penrose
[pp. 162–63]
Provenance: English private collection until its sale in London, Sotheby's, 4 April

1962, n. 56. Purchased four years later by Minneapolis.
Reference: Philippe Bordes, "Louis Gauffier and Thomas Penrose in Florence", *The Minneapolis Institute of Arts Bulletin 1972–1973*, 1974, pp. 73–75, repr.; exhib. cat. *French Painting 1774–1830. The Age of Revolution*, Paris, Detroit, and New York, 1974–75, n. 66, repr. (entry by Jean-François Méjanès); John Ingamells, *A Dictionary of British and Irish Travellers in Italy 1701–1800*, London, 1997, p. 756.

Gauguin, Paul
Where do we come from? What are we? Where are we going?
[pp. 204–05]
Provenance: Shown in 1898 at the art dealer Ambroise Vollard's (1866–1939) who in 1901 sold the work to Dr. Gabriel Frizeau (1870–1938) from Bordeaux. Purchased by Boston in 1936 from Marie Harriman's gallery for 80.000 dollars.
Reference: Exhib. cat. *Gauguin Tahiti*, Paris, Grand Palais, and Boston, Museum of Fine Arts, 2003–04, p. 219–51 (essay by George T.M. Shackelford).

Gentileschi, Orazio
The Lute Player
[pp. 76–77]
Provenance: In 1697 the picture already belonged to the Liechtenstein collection, in Vienna then in Liechtenstein, until 1962 when it entered the National Gallery collections.
Reference: Exhib. cat. *Orazio and Artemisia Gentileschi*, Rome, New York, and Saint Louis, 2001–02, n. 22, repr. (entry by Keith Christiansen).

Géricault, Théodore
The Lovers
[pp. 162–63]
Provenance: Cited by Charles Clément, Géricault's biographer, in the third edition of his book devoted to the artist (1879, p. 309 n. 131). The work belonged to the sculptor Jean-Pierre Dantan Jeune (1800–1869). Auctioned in Paris in 1992 (3.500.000

francs) and purchased by the Getty three years later.
Reference: Philippe Grunchec, entry in the sale catalog, Paris, Hôtel Drouot, 26 June 1992, n. 48, repr.; cat. *Fifty Paintings 1535–1825,* Matthiesen Fine Art & Stair Sainty Matthiesen, New York and London, 1993, n. 49, repr. (entry by Lorenz Eitner); exhib. cat. *Géricault. La folie d'un monde,* Lyon, 2006, n. 71, repr.

Giovanni di Paolo
The Creation and the Expulsion of Adam and Eve from Paradise
[pp. 32–33]
Provenance: Section of the predella of the Guelfi altarpiece painted in 1445 by Giovanni di Paolo for the homonymous family at San Domenico of Siena. Albin Chalandon collection, then Camille Benoît in Paris. Purchased by Philip Lehman (1861–1947) in 1917 from the art dealer F. Kleinberger, then collection of his son Robert Lehman (1891–1969), entered the Metropolitan Museum in 1975 (the altarpiece belongs to the Uffizi Galleries in Florence; another section of the predella, *Paradise,* is also at the Metropolitan Museum).
Reference: Exhib. cat. *Painting in Renaissance Siena 1420–1500,* New York, The Metropolitan Museum of Art, 1988–89, n. 32a, repr. (entry by Carl Brandon Strehlke).

Girodet, Anne-Louis Girodet de Roucy Trioson
Portrait of Mademoiselle Lange as Danae
[pp. 164–65]
Provenance: Exhibited during the final days of the Salon of 1799. Collection of Henri-Guillaume Chatillon, Girodet's pupil. Purchased by Minneapolis in 1969 from the Wildenstein gallery.
Reference: Mario Praz, "Girodet's *Mlle Lange as Danaë*", *The Minneapolis Institute of Arts Bulletin 1969,* 1970, pp. 64–68, repr; George Levitine, "Girodet's *New Danaë:* The Iconography of a Scandal", *ibidem,* pp. 69–77,

repr.; exhib. cat. *Girodet 1767–1824,* Paris, Chicago, New York, and Montreal, 2005–2006, n. 41, repr. (entry by Sylvain Bellenger).

Goltzius, Hendrick
"Sine Cerere et Libero friget Venus" / Without Bacchus and Ceres, Venus Would Freeze
[pp. 72–73]
Provenance: Like the *Hare* by Hans Hoffmann (p. 68), it belonged to the emperor Rudolph II (1552–1612), then the collections of Queen Christina of Sweden and Charles II of England. Purchased by Philadelphia in 1990.
Reference: Lawrence W. Nichols, *The "Pen Works" of Hendrick Goltzius,* Philadelphia, 1992 (*Philadelphia Museum of Art Bulletin,* vol. 88, nn. 373–74).

Goodman, Walter
The Print-Seller's Window
[pp. 188–89]
Provenance: Purchased at the sale of the Masco Corporation collection, New York, Sotheby's, 3 December 1998, n. 9, repr. (415.000 dollars).
Reference: Exhib. cat. *Deceptions and Illusions. Five Centuries of Trompe l'Œil Painting,* Washington, The National Gallery, 2002–03, n. 77, repr. (entry by Franklin Kelly).

Goya, Francisco de Goya y Lucientes
Portrait of the Duchess of Alba
[pp. 160–61]
Provenance: Collection of the Duchess of Alba (1762–1802) until her death in 1802; probably returned to Goya by her heirs. Sold in 1836 by Javier Goya to Baron Taylor for the collection of Louis-Philippe, King of France; Louis-Philippe sale, London, 21 May 1853, n. 444, knocked down for the paltry sum of six pounds. Péreire sale, Paris, 30–31 January 1868 (2.500 francs). Purchased in 1906 by Archer Milton Huntington (1870–1955) from the art dealers Gimpel and

Wildenstein for the sum of 35.000 dollars and offered two years later to the Hispanic Society of America.
Reference: Exhib. cat. *El retrato español del Greco a Picasso,* Madrid, Museo Nacional del Prado, 2004–05, n. 62, repr. (entry by Nigel Glendinning).

Greco, Dhomenikos Theotokópoulos, known as El
View of Toledo
[pp. 70–71]
Provenance: Remained in Spain until 1907. Purchased in 1909 by Mrs. Lousine W. Havemeyer (1855–1929) from the Parisian art dealer Paul Durand-Ruel (1831–1922) for 70.000 francs and at her death bequeathed to the Metropolitan Museum.
Reference: Exhib. cat. *El Greco,* New York, The Metropolitan Museum of Art, and London, The National Gallery, 2003–04, n. 66, repr. (entry by Keith Christiansen).

Grünewald, Matthias, Matthias Gothardt Nithardt, known as
The Small Crucifixion
[pp. 52–53]
Provenance: Supposedly from the estate (1528) of the canon Heinrich Reitzmann at Aschaffenbourg. Collection of the duke William V of Bavaria in 1605, then of Maximilian I (1573–1651). Collection of Franz W. Koenigs (1881–1941) in Haarlem by 1927, sold by his heirs in 1953 to Samuel H. Kress (1863–1955) and entered the National Gallery in 1961.
Reference: Colin Eisler, *Paintings from the Samuel H. Kress Collection. European Schools Excluding Italian,* Oxford, 1977, pp.19–23, repr.; exhib. cat. *Circa 1492. Art in the Age of Exploration,* Washington, National Gallery of Art, 1991–92, n. 152, repr. (entry by Martin Kemp); Horst Ziermann, *Matthias Grünewald,* Munich, London, and New York, 2001, pp. 165–66, repr.

Guardi, Francesco
The Garden of the Palazzo Contarini dal Zaffo in Venice
[pp. 154–55]
Provenance: Commissioned from Guardi by John Strange (1732–1799), an English resident in Venice. Purchased by Chicago in 1991.
Reference: Antonio Morassi, *Guardi. I dipinti,* Milan, 1973 (2nd ed., 1984), I, n. 680, repr.; Richard Beresford and Peter Raissis, *The James Fairfax Collection,* Sydney, 2003, under n. 25; Everett Fahy, in *The Wrightsman Pictures,* New York, 2005, under n. 24, repr.

Guercino, Giovanni Battista Barbieri, known as
Portrait of a Dog
[pp. 84–85]
Provenance: Probably commissioned by the count Filippo Aldrovandi. Arrived in England at an unknown date, but before 1837. Rediscovered and published in *Country Life,* 20 June 1957. Purchased in 1984 by Norton Simon (1907–1993).
Reference: Luigi Salerno, *I dipinti del Guercino,* Rome, 1988, n. 104, repr.

Hoffmann, Hans
A Hare in the Forest
[pp. 68–69]
Provenance: Delivered in 1585 by the artist to the Emperor Rudolph II of Habsburg (1552–1612) in Prague for the price of 200 guilders. Arrived in Sweden at the time of the sack of Prague in 1648, then in England. Sale in London, Sotheby's, 4 July 1990, n. 14, but did not sell. Finally acquired by the Getty at Sotheby's, New York, 25 January 2001, n. 91 (inaccurate dimensions), repr., for the sum of 2.400.000 dollars.
Reference: Entry in the catalog of the sale, 4 July 1990.

Hogarth, William
The Lady's Last Stake
[pp. 138–39]
Provenance: Commissioned in 1758, apparently by Lord Charlemont, an Irish

nobleman, future president of the Royal Irish Academy. He paid out 100 pounds sterling for the work (in 1760). In 1874 it was knocked down at 1.585 pounds at auction in London. John Pierpont Morgan (1837–1913), who purchased it at the end of the nineteenth century, sold it in 1911 to Seymour Knox who gave it to the Albright-Knox Art Gallery in 1945.
Reference: Ronald Paulson, *Hogarth, His Life, Art and Times*, New Haven, 1971, n. 210, repr.; exhib. cat. *Great British Paintings from American Collections. Holbein to Hockney*, New Haven, Yale Center for British Art, and San Marino, Huntington Library, 2001–02, n. 9, repr. (entry by Brian Allen).

Ingres, Jean-Auguste-Dominique
Portrait of the vicomtesse Othenin d'Haussonville, née Louise-Albertine de Broglie
[pp. 170–71]
Provenance: Commissioned by the vicomte d'Haussonville in 1842. Château de Coppet in Switzerland until 1925. Purchased by the trustees of the Frick Collection, 13 January 1927.
Reference: Edgar Munhall, *Ingres and the Comtesse d'Haussonville*, New York, 1985; exhib. cat. *Portraits by Ingres. Image of an Epoch*, London, Washington, and New York, 1999–2000, n. 125, repr. (entry by Gary Tinterow); exhib. cat. *Ingres*, Paris, Musée du Louvre, 2006, n. 158, repr. (entry by Stéphane Guégan)

Khnopff, Fernand
Portrait of Jeanne Kéfer
[pp. 192–93]
Provenance: In the collection of the sitter's father. Purchased by the Getty in 1997.
Reference: Exhib. cat. *Fernand Khnopff 1858–1921*, Brussels, Salzburg, and Boston, 2004, n. 79, repr. (entry by Inga Rossi-Schrimpf); Michel Draguet, *Portrait of Jeanne Kéfer*, Los Angeles, 2004.

Kokoschka, Oskar
Portrait of Hans Tietze and Erica Tietze Conrat
[pp. 214–15]
Provenance: The picture belonged to the sitters until 1938, date of the couple's departure for New York. Purchased the following year by the MoMA.
Reference: Exhib. cat. *Oskar Kokoschka: Early Portraits from Vienna and Berlin, 1909–1914*, New York and Hamburg, 2002, pp. 122–123, repr. (entry by Tobias G. Natter).

La Hyre, Laurent de
Panthea, Cyrus, and Araspes
[pp. 94–95]
Provenance: Purchased by the Art Institute in 1976. The localization of the picture in the seventeenth century is unknown.
Reference: Exhib. cat. *France in the Golden Age. Seventeenth-century French Paintings in American Collections*, Paris, New York, and Chicago, 1982, n. 31, repr. (entry by Pierre Rosenberg); exhib. cat. *Laurent de La Hyre 1606–1656. L'homme et l'œuvre*, Grenoble, Rennes, and Bordeaux, 1989–90, n. 104, repr. (entry by Pierre Rosenberg and Jacques Thuillier); Susan Wise, in *French and British Paintings from 1600 to 1800 in The Art Institute of Chicago*, Chicago, 1996, pp. 82–86, repr.

Largillierre, Nicolas de
Portrait of Elizabeth Throckmorton
[pp. 124–25]
Provenance: Commissioned in 1729 by the brother of the sitter Sir Robert Throckmorton. Stayed in the family until 1964 (sale in London, Christie's, 26 June 1964, n. 68, repr., 62.000 guineas). Purchased that same year by the National Gallery.
Reference: Exhib. cat. *Largillierre*, Montreal, Musée des Beaux-Arts, under n. 56, repr. (entry by Mira N. Rosenfeld).

La Tour, Georges de
The Fortune-Teller
[pp. 98–99]

Provenance: In the Sarthe in 1879. Exported in 1949 and purchased in 1960 by the Metropolitan Museum, apparently for 800.000 dollars, a considerable figure for the time (for details on the scandal caused by that exportation, see exhib. cat. *La Tour*, Paris, 1999).
Reference: Exhib. cat. *Georges de La Tour*, Paris, Grand Palais, 1999, n. 27, repr. (entry by Jean-Pierre Cuzin).

La Tour, Maurice Quentin de
Portrait of the Président Gabriel-Bernard de Rieux
[pp. 130–31]
Provenance: Commissioned by the sitter (paid 8.000 pounds) and remained in his family at the château of Glisolles in the Eure until 1919, the date of its purchase by Georges Wildenstein (1892–1963). He sold it c. 1930 to Edmond de Rothschild (1845–1934); bought from his descendants by the Getty in 1994.
Reference: Georges Wildenstein, *Un pastel de La Tour. Le Président de Rieux*, Paris, 1919, repr.; Christine Debrie, in *Maurice Quentin de La Tour prince des pastellistes*, Paris, 2000, pp. 111–19.

Lawrence, Thomas
Portrait of Sarah Goodin Barrett Moulton: "Pinkie"
[pp. 158–59]
Provenance: Presented at the Royal Academy in 1795. In 1857 the property of Edward Moulton-Barrett, the sitter's brother and father of the poetess Elizabeth Barrett Browning. Purchased by the art dealer Joseph Duveen (1869–1939) in 1926 for almost 80.000 pounds, the highest price obtained at auction for an English painting to that date. Bought the same year by Henry Edwards Huntington (1850–1927) much to the dismay of Andrew W. Mellon.
Reference: Robyn Asleson, *British Paintings at the Huntington*, San Marino, 2001, n. 50, repr. (in that same catalog, essay on H.E.

Huntington, the collector, by Shelley M. Bennett); exhib. cat. *Great Paintings from American Collections. Holbein to Hockney*, New Haven, Yale Center for British Art, and San Marino, Huntington Library, 2001–2002, n. 39, repr. (exhibited at San Marino only; entry by Robyn Asleson).

Le Lorrain, Louis-Joseph
Before the Masked Ball
[pp. 134–35]
Provenance: The picture belonged to Camille Groult (1837–1908), the great connoisseur of English painting and of Watteau. Passed in the Groult sale, Paris, 21 March 1952, n. 84, repr. (as attributed to Pietro Longhi) and was purchased the following year by Samuel H. Kress (1863–1955). His heirs gave it to the National Gallery in 1961.
Reference: Pierre Rosenberg, "Louis-Joseph Le Lorrain (1715–1759)", *Revue de l'Art*, 1978, n. 40/41, pp. 196–98, repr.

Liotard, Jean-Étienne
Trompe-l'œil
[pp. 146–47]
Provenance: Auctioned in London, 15 April 1774, n. 74, where it was bought for 10 pounds and 10 shillings by the second Earl of Bessborough. In England until it was sold in London, Sotheby's, 6 March 1957 (1.550 pounds). Collection of the art dealer and historian Vitale Bloch (1900–1975). Gift in 1997 by Lore Heinemann in memory of her husband, Rudolf J. Heinemann.
Reference: The Frick Collection. An Illustrated Catalog. IX. Drawings, Prints, and Later Acquisitions, New York, 2003, pp. 378–81 (entry by Edgar Munhall).

Lotto, Lorenzo
Venus and Eros
[pp. 56–57]
Provenance: Purchased in 1986.
Reference: Keith Christiansen, "Lorenzo Lotto and the Tradition of Epithalamic

Painting", *Apollo*, vol. 124, 1986, pp. 166–173; exhib. cat. *Le siècle de Titien. L'âge d'or de la peinture à Venise*, Paris, Grand Palais, 1993, n. 154, repr. (entry by Sylvie Béguin); Everett Fahy, in *The Wrightsman Pictures*, New York, 2005, n. 2, repr.

Malevich, Kasimir
The Knife-Grinder (Principle of Glittering)
[pp. 222–23]
Provenance: Shown in 1913 in Moscow and Saint-Petersburg. Purchased by the Société Anonyme in 1922 for 41 dollars. Given by Katherine Dreier (1877–1952) in 1941.
Reference: The Société Anonyme and the Dreier Bequest at Yale University. A Catalogue Raisonné, New Haven and London, 1984, n. 443, repr. (catalog by Robert W. Herbert, Eleanor S. Apter, and Elise K. Kenney)

Manet, Edouard
Christ with Angels
[pp. 176–77]
Provenance: Shown at the Salon of 1864, n. 1281 ("Les Anges au tombeau du Christ"). Purchased by the art dealer Paul Durand-Ruel (1831–1922) in 1872 for 3.000 francs. Sold by Durand-Ruel in 1903 to Mr. and Mrs. Henry O. Havemeyer (1847–1907 and 1855–1929) for 17.000 dollars and bequeathed by Mrs. Havemeyer to the Metropolitan Museum in 1929.
Reference: Exhib. cat. *Manet*, Paris, Grand Palais, and New York, The Metropolitan Museum of Art, 1983, n. 74, repr. (entry by Charles S. Moffett); exhib. cat. *Origins of Impressionism*, Paris, Grand Palais, and New York, The Metropolitan Museum of Art, 1994–95, n. 96, repr. (entry by Henri Loyrette); exhib. cat. *Manet Velázquez. The French Taste for Spanish Painting*, Paris, Musée d'Orsay, and New York, The Metropolitan Museum of Art, 2002–03, n. 85, repr. (entry by Juliet Wilson-Bareau).

Martorell, Bernat
Saint George Killing the Dragon
[pp. 28–29]
Provenance: Gift of Mrs. Richard E. Danielson and Mr. Chauncey McCormick in 1933.
Reference: Exhib. cat. *Bernat Martorell, el Mestre de Sant Jordi*, Barcelona, Museu Nacional d'Art de Catalunya, 2002, pp. 36–39 and 129 (Catalan), pp. 148–49 (English), repr. p. 40 (catalog by Francesc Ruiz i Quesada).

Matisse, Henri
Joy of Life [*Happiness of Life*]
[pp. 210–11]
Provenance: Purchased in 1906 by Leo Stein (1872–1947) and hung in the apartment of Gertrude (1874–1946) and Leo Stein, 27 rue de Fleurus in Paris. Acquired by Dr. Alfred Barnes (1872–1951) in 1922 from the Danish collector Christian Tetzen Lund (1852–1936) for 45.000 francs.
Reference: Pierre Schneider, *Matisse*, Paris, 1992 (2nd ed.), pp. 241–248, repr.; exhib. cat. *De Cézanne à Matisse Chefs-d'œuvre de la fondation Barnes*, Paris, Musée d'Orsay, 1993–94, pp. 226–35, repr. (entry by Jack Flam).

Millet, Jean-François
The Bird Nesters
[pp. 182–83]
Provenance: Jean-François Millet sale, 10–11 May 1875, n. 53. Purchased in 1896 by William W. Elkins (1832–1903) who offered it that same year to the Philadelphia museum.
Reference: Exhib. cat. *Millet*, Paris, Grand Palais, and London, Hayward Gallery, 1975–76, n. 243, repr. (entry by Robert W. Herbert).

Monet, Claude
Garden at Sainte-Adresse
[pp. 178–79]
Provenance: The picture was bought in 1926 at Durand-Ruel's in New York by the Reverend Theodore Pitcairn for the sum of 11.500 dollars. It was purchased at the Pitcairn

sale, 1 December 1967, Christie's, in London, by the Metropolitan Museum for the price of 588.000 pounds, causing a sensation at the time.
Reference: Daniel Wildenstein, *Claude Monet. Biographie et catalogue raisonné*, Lausanne and Paris, I, 1974, n. 95, repr.; exhib. cat. *Origins of Impressionism,* Paris, Grand Palais, and New York, The Metropolitan Museum of Art, 1994–95, n. 137, repr. (entry by Gary Tinterow).

Murillo, Bartolomé Esteban
Two Women at a Window
[pp. 108–09]
Provenance: The picture was in England in the early eighteenth century before being purchased in 1894 by Peter A.B. Widener (1834–1915) and given in 1942 to the National Gallery by his son Joseph Widener (1860–1943).
Reference: Exhib. cat. *Bartolomé Esteban Murillo (1617–1682): Paintings from American Collections*, Fort Worth, Kimbell Art Museum, and Los Angeles, County Museum of Art, 2002, n. 32, repr. (entry by Suzanne W. Stratton-Pruitt); exhib. cat. *Deceptions and Illusions. Five Centuries of Trompe l'Œil Painting*, Washington, National Gallery of Art, 2002–03, n. 70, repr. (entry by Peter Cherry).

Neroccio de' Landi
Portrait of a Young Girl
[pp. 48–49]
Provenance: Purchased in London by Peter A.B. Widener (1834–1915) in 1912, the picture was offered to the National Gallery in 1942 by his son Joseph E. Widener (1893–1943).
Reference: Miklós Boskovits, in *National Gallery of Art. Italian Paintings of the Fifteenth Century*, Washington, 2003, pp. 531–35, repr.

Nicola di Maestro Antonio d'Ancona
Madonna and Child Enthroned with Saints Leonard, Jerome, John the Baptist, and Francis
[pp. 42–43]

Provenance: In all likelihood the painting comes from the church of San Francesco alle Scale in Ancona. In England in the nineteenth century. Christie's sale, London, 23 June 1967, n. 31, repr., sold for 58.000 guineas (170.520 dollars). Entered the Pittsburgh collections in 1971.
Reference: Federico Zeri, *Diario marchigiano, 1948–1988*, Turin, 2000, pp. 254–56, repr.; Romina Vitali, in *Le Marche disperse. Repertorio di opere d'arte dalle Marche al Mondo*, Milan, 2005, n. 10, pl. 4.

Oudry, Jean-Baptiste
Flowerbed of Tulips and Vase of Flowers
[pp. 132–33]
Provenance: Commissioned by M. de La Bruyère. Exhibited at the Salon of 1745. Purchased from the art dealer François Heim by Detroit in 1967.
Reference: Exhib. cat. *J.-B. Oudry 1686–1755*, Paris, Grand Palais, 1982–1983, n. 147, repr. (entry by Hal N. Opperman).

Picasso, Pablo
Les Demoiselles d'Avignon
[pp. 212–13]
Provenance: Purchased from Picasso by Jacques Doucet (1853–1929) in 1924 for 25.000 francs (the *couturier* also owned the *Portrait of a Black* by Reynolds in the present book, p. 151). The fashion designer's widow sold the picture in 1937 to the Galerie Seligmann for 150.000 francs. Purchased in 1939 (actually in 1937) for 28.000 dollars (in order to gather the sum, the museum had to sell for 18.000 dollars a canvas by Degas, *The Racecourse*, from the bequest of Lillie P. Bliss [1864–1931], one of the founders and principal patrons of the MoMA).
Reference: Exhib. cat. *Les demoiselles d'Avignon*, Paris, Musée Picasso, 1988, 2 vols.; special issue of *Studies in Modern Art*, n. 3, 1994 (catalog by William Rubin, Hélène Seckel, and Judith Cousins).

Piero di Cosimo, Pietro di Lorenzo, known as
The Building of a Palace
[pp. 54–55]
Provenance: In Russia, then the Emile Gavet collection († 1907?), then Alva Erskine Smith Vanderbilt Belmont at Marble House in Newport until 1928, date of its purchase by John Ringling (1866–1936; on the extravagant personality of that king of the circus, see herein Cairo, p. 101, and Patricia Ringling Buck, *The John and Mable Ringling Museum of Art*, Santa Barbara, 1988, in particular pp. 41–47).
Reference: Peter Tomory, *The John and Mable Ringling Museum of Art. Catalog of the Italian Paintings*, Sarasota, 1976, n. 8, repr; exhib. cat. *Da Brunelleschi a Michelangelo: la rappresentazione dell'architettura,* Venice, Palazzo Grassi, 1994, n. 86, repr. (entry by Daniela Lamberini) and in the same cat., pp. 86–98 (essay by Kathleen Weil-Garris Brandt); Anna Forlani Tempesti and Elena Capretti, *Piero di Cosimo*, Florence, 1996, n. 39, repr.; Deborah Krohn, in exhib. cat. *John Ringling Dreamer Builder Collector*, Sarasota, The John and Mable Ringling Museum of Art, 1997, pp. 139–48.

Pontormo, Jacopo Carucci, known as
Portrait of a Halberdier
[pp. 58–59]
Provenance: In Florence in 1612. Removed from Italy to Paris by the art dealer and expert Jean-Baptiste-Pierre Lebrun who put it on auction, 20 March 1810, n. 108 (under the name of Gianfrancesco Penni) where it was purchased for 1.055 francs by cardinal Fesch (1763–1839), uncle of Napoleon. At the Fesch sale in Rome in 1845 (17 March, n. 129), it was bought by Jean-Jacques-Joseph Leroy d'Etoilles (1798–1860). Then passed into the collection of Princesse Mathilde (1820–1904), Napoleon's niece, then that of James Stillman (1850–1918), president of the First National

City Bank, c. 1914. Remained with his heirs until its sale in New York, Christie's, 31 May 1989, n. 72, repr. where it was purchased by the Getty for 35.200.000 dollars.
Reference: Elizabeth Cropper, *Pontormo Portrait of a Halberdier*, Los Angeles, 1997; exhib. cat. *Pontormo, Bronzino, and the Medici. The Transformation of the Renaissance Portrait in Florence,* Philadelphia, Philadelphia Museum of Art, 2005, n. 18, repr. (entry by Carl Brandon Strehkle).

Poussin, Nicolas
Blind Orion Searching for the Rising Sun
[pp. 112–13]
Provenance: Painted for Michel Passart (1612–1692) in 1658. Certainly in England between 1745 and 1924, date of its purchase by the Metropolitan Museum.
Reference: Exhib. cat. *Nicolas Poussin*, Paris, Grand Palais, 1994–95, n. 234, repr. (entry by Pierre Rosenberg).

The Pseudo-Félix Chrestien, also known as the Master of the Dinteville Allegory
Moses and Aaron before Pharaoh
[pp. 62–63]
Provenance: Château de Dinteville at Polisy in the Aube. Arrived in Scotland in the nineteenth century. Purchased by the Metropolitan Museum in 1950.
Reference: Exhib. cat. *From Van Eyck to Bruegel. Early Netherlandish Painting in The Metropolitan Museum of Art,* New York, The Metropolitan Museum of Art, 1998, n. 43, repr. (entry by Mary Sprinson de Jesus); Elizabeth A.R. Brown, "The Dinteville Family and the Allegory of Moses and Aaron before Pharaoh", *Metropolitan Museum Journal*, vol. 34, 1999, pp. 73–100.

Rembrandt Harmenszoon van Rijn
Self Portrait
[pp. 110–11]
Provenance: The Earls of Ilchester collection in the

nineteenth century. Purchased by Henry Clay Frick (1849–1919) in 1906 from the art dealer Knoedler.
Reference: Exhib. cat. *Rembrandt by himself*, London, The National Gallery, and The Hague, Mauritshuis, 1999–2000, n. 71, repr. (entry by Edwin Buijsen).

Renoir, Pierre-Auguste
Luncheon of the Boating Party
[pp. 184–85]
Provenance: Purchased from Renoir by Paul Durand-Ruel (1831–1922), 14 February 1881 and sold by the Durand-Ruel gallery in 1923 to Duncan Phillips (1886–1966) for the considerable amount of 125.000 dollars.
Reference: Exhib. cat. *Renoir*, London, Paris, and Boston, 1985–1986, n. 51, repr.; exhib. cat. *Impressionists on the Seine: A Celebration of Renoir's "Luncheon of the Boating Party"*, Washington, The Phillips Collection, 1996

Restout, Jean-Bernard
Morpheus, or *Sleep*
[pp. 144–45]
Provenance: Salon of 1771, n. 137. Auctioned several times under attributions to Fragonard and Boucher. Purchased from the Cailleux gallery by Cleveland in 1967.
Reference: Exhib. cat. *A painting in Focus: Jean-Bernard Restout's Sleep – Figure Study and the French Royal Academy of Painting and Sculpture,* Cleveland, The Cleveland Museum of Art, 1999, n. 1, repr. (entry by Carter E. Foster).

Reynolds, Joshua
A Young Black
[pp. 150–51]
Provenance: Supposedly from the estate sale of Reynolds' studio, Greenwood, 15 April 1796. In several English and French collections (including that of the famous fashion designer Jacques Doucet [1853–1929]) during the nineteenth and twentieth centuries, until 1983, date of its purchase at auction in Paris by Mme de Ménil (1908–1997).

Reference: Exhib. cat. *Sir Joshua Reynolds 1723–1792*, Paris, Grand Palais, and London, Royal Academy of Arts, 1985–86, n. 35 in the French edition and n. 77 in the English edition, repr. (entry by Nicholas Penny).

Rosso Fiorentino, Giovanni Battista di Jacopo, known as
Allegory of Salvation with the Virgin and the Christ Child, Saint Elizabeth (?), the Young Saint John the Baptist, and Two Angels
[pp. 60–61]
Provenance: Discovered in Rome in 1931 by Roberto Longhi (or by Frederick Antal) and first cited by Kurt Kusenberg, the painting belonged to the Berlin art dealer Ernst Remak; his cousin, Herbert T. Kadmus offered it to the Los Angeles Museum in 1954.
Reference: David Franklin, *Rosso in Italy. The Italian Career of Rosso Fiorentino,* New Haven and London, 1994, pp. 76–80, repr.

Rousseau, Henri known as Douanier Rousseau
The Sleeping Gypsy
[pp. 202–03]
Provenance: Offered for sale in 1898 by Rousseau to the mayor of his home town, Laval. Lost until 1923 and pointed out by Picasso to Henri-Pierre Roché (1879–1959), who sold it for 175.000 francs in 1924 to John Quinn (1870–1924). Quinn sale in Paris, Hôtel Drouot, 28 October 1926, knocked down at 580.000 francs (exclusive of expenses) and bought by Henri Bing. Gift of Mrs. Simon Guggenheim to MoMA in 1939.
Reference: Exhib. cat. *Douanier Rousseau*, Paris, Grand Palais, and New York, The Metropolitan Museum of Art, 1984–85, n. 19, repr. (entry by Michel Hoog).

Sánchez Cotán, Juan
Still Life with Quince, Cabbage, Melon, and Cucumber
[pp. 74–75]

Provenance: Mentioned in the inventory of the artist's possessions drawn up in 1603 when he entered the Carthusian order. Doubtless collection of Philip III (1576–1621), King of Spain, then of Joseph Bonaparte (1768–1844) who settled in the United States in 1815.
Reference : Exhib. cat. *Spanish Still Life in the Golden Age 1600–1650*, Fort Worth, Kimbell Art Museum, 1985, n. 3, repr. (entry by William B. Jordan).

Scheggia, Giovanni di Ser Giovanni di Simone, known as the
The Triumph of Fame
[pp. 36–37]
Provenance: Commissioned by Piero de' Medici (1416–1469). Gift, in 1867, of Thomas Jefferson Bryan to the New York Historical Society that put it on sale 12 January 1995, n. 69, repr. It was purchased there by the Metropolitan Museum for 2.202.500 dollars.
Reference : Anonymous entry in the auction catalog of the New York Historical Society, New York, Sotheby's, 12 January 1995, n. 69, repr.

School of the Van Eyck brothers Jan and Hubert
The Annunciation
[pp. 30–31]
Provenance: J.J. van Hal estate sale, Antwerp, 23 August 1836, n. 80 (as Jan van Eyck), 2.800 francs. Sold for 65.000 dollars in 1926 by the art dealer F. Kleinberger to Michael Friedsam, who at his death bequeathed it to the Metropolitan Museum.
Reference : Exhib. cat. *Petrus Christus Renaissance Master of Bruges*, New York, The Metropolitan Museum of Art, 1994, n. 10, repr. (entry by Maryan W. Ainsworth); exhib. cat. *From Van Eyck to Bruegel. Early Netherlandish Painting in The Metropolitan Museum of Art*, New York, The Metropolitan Museum of Art, 1998, n. 5, repr. (entry by Della C. Sperling).

Seurat, Georges
La Grande Jatte
[pp. 190–91]
Provenance: Given to the Art Institute in 1926 by Frederic Clay Bartlett (1873–1953) in memory of his wife, Helen Birch, deceased the year before. The Bartletts purchased the work in 1924, reportedly for 20.000 dollars, from some descendants of Seurat (c. 1930, the French government apparently sought to buy back the picture for 400.000 dollars).
Reference : Exhib. cat. *Seurat and the Making of "La Grande Jatte"*, Chicago, The Art Institute, 2004 (catalog by Robert W. Herbert).

Signac, Paul
Portrait of Félix Fénéon
[pp. 198–99]
Provenance: Belonged to Félix Fénéon (1861–1944) who kept it throughout his lifetime, then to Emil Bührle in Zurich, the movie director Joshua Logan, and last the great Swiss collector of Nabi painting, Paul Josefowitz. Sale, New York, Parke-Bernet, 20 November 1968, n. 52, repr. (110.000 dollars). Purchased at that sale by Mr. and Mrs. David Rockefeller.
Reference : Françoise Cachin, *Signac: catalogue raisonné de l'œuvre peint*, Paris, 2000, n. 211, repr.; exhib. cat. *Signac 1863–1935*, Paris, Amsterdam, and New York, 2001, n. 51, repr. (entry by Marina Ferretti-Bocquillon).

Stanzione, Massimo
Woman in Neapolitan Costume
[pp. 106–07]
Provenance: It belonged to the former viceroy of Spain Gaspar de Haro y Guzmán, marquis del Carpio in Madrid in 1687. Passed into England. Archer M. Huntington bought the picture in 1908 and gave it to the Hispanic Society of America, which in 1941 lent it to the Museum of Fine Arts of San Francisco. The museum finally purchased it in 1997.
Reference : Thomas C. Willette, in Sebastian Schütze and

Thomas C. Willette, *Massimo Stanzione*, Naples, 1992, A 41, fig. 166 and pl. XVII.

Stubbs, George
A Zebra
[pp. 140–41]
Provenance: Shown by the artist at the Society of Artists in 1763. Estate sale of Stubbs' studio in 1807 (n. 88, 138 pounds). In several English and then American private collections before being purchased, 19 October 1960, at a sale at Harrod's (20.000 pounds) by Paul Mellon (1907–1991). Given in 1981 to the Yale Center for British Art.
Reference : Exhib. cat. *George Stubbs 1724–1806*, London, The Tate Gallery, and New Haven, Yale Center for British Art, 1984–1985, n. 77, repr. (entry by Judy Egerton); exhib. cat. *Great British Paintings from American Collections. Holbein to Hockney*, New Haven, Yale Center for British Art, and San Marino, Huntington Library, 2001–02, n. 22, repr. (entry by Malcolm Warner).

Susi, Lodewijk (Ludovico de Susio)
Still Life with Three Mice
[pp. 80–81]
Provenance: Probably painted for Charles-Emmanuel (1562–1630), duke of Savoy, in Turin. Purchased in 1949.
Reference : An unpublished PhD. dissertation, owed to Marie Louise Kane, defended in August 1981 before the Washington University of Saint Louis, was devoted to the picture.

Sweerts, Michael
The Plague
[pp. 104–05]
Provenance: The picture has been known only since the very early nineteenth century. It was attributed to Poussin until 1934, at which date Roberto Longhi gave it back to Sweerts. From the Cook collection (London, Christie's sale, 6 July 1984, n. 116, 1.215.000 dollars), it passed into the Saul

Steinberg collection. It was purchased at auction by Los Angeles (New York, Sotheby's sale, 30 January 1997, n. 34, 3.800.000 dollars).
Reference : Rolf Kultzen, *Michael Sweerts Brussels 1618–Goa 1664*, Doornspijk, 1996, n. 63, repr.; exhib. cat. *Michael Sweerts*, Amsterdam, San Francisco, and Hartford, 2002, n. XIII, repr. (entry by Guido Jansen and Peter C. Sutton).

Tanzio da Varallo, Antonio d'Errico (Enrico), known as
Saint John the Baptist in the Wilderness
[pp. 88–89]
Provenance: Attributed to Velázquez in the collection of the great art dealer Alessandro Contini Bonacossi (1878–1955), the painting was restituted to Tanzio da Varallo by Roberto Longhi at the time of its purchase by Samuel H. Kress (1863–1955) in 1939. Given by the Samuel H. Kress Foundation to Tulsa in 1944.
Reference : Exhib. cat. *Tanzio da Varallo*, Milan, Palazzo Reale, 2000, n. 29, repr. (entry by Richard P. Townsend).

Ter Brugghen, Hendrick
Saint Sebastian Tended by Irene and a Companion
[pp. 82–83]
Provenance: Cited in Amsterdam in 1668. Auction at Sarlat (Dordogne) in 1952.
Reference : Exhib. cat. *Masters of Light. Dutch Painters in Utrecht during the Golden Age*, San Francisco, Baltimore, and London, 1997–98, n. 10, repr. (entry by Leonard J. Slatkes).

Titian, Tiziano Vecellio, known as
Europa
[pp. 66–67]
Provenance: Painted in Venice between 1559 and 1562 for Philip II (1527–1598), King of Spain, and offered by Philip V (1683–1746), King of Spain and first Bourbon king, to the duc de Gramont. Orléans collection, arrived in England at the close of the eighteenth century. Purchased in 1896

from Earl Darnley by Bernard Berenson (1865–1959) for Isabella Stewart Gardner (1840–1924); read the enthusiastic letters from Isabella Stewart Gardner to Berenson in *The Isabella Stewart Gardner Museum*, Boston, 1995, pp. 118–119).
Reference : Exhib. cat. *Titian and Rubens. Power, Politics, and Style*, Boston, Isabella Stewart Gardner Museum, 1998, in particular pp. 12–19 (essay by Hilliard T. Goldfarb); Karinne Simonneau, "Une relecture politique de l'*Enlèvement d'Europe* de Titien: Philippe II et les Turcs", *Revue de l'Art*, n. 125, 1999, pp. 32–37.

Toulouse-Lautrec, Henri de
At the Moulin Rouge
[pp. 200–01]
Provenance: Jean Laroche collection. Purchased by Frederic Clay Bartlett (1873–1953) in 1928 and given that same year to the Art Institute.
Reference : Exhib. cat. *Toulouse-Lautrec*, London, Hayward Gallery, and Paris, Grand Palais, 1991–92, n. 75 (entry by Richard Thomson).

Traversi, Gaspare
Saint Margaret of Cortona
[pp. 136–37]
Provenance: Perhaps in a convent of Piacenza in the early nineteenth century. In the collection of the count Merenda at Forlì in the nineteenth century as "Flemish school". Purchased in 1968 on the Venetian art market as by "Pompeo Batoni".
Reference : Exhib. cat. *Gaspare Traversi: napoletani del '700 tra miseria e nobilità*, Naples, Castel Sant'Elmo, 2003–04, n. 90, repr. (entry by Francesco Barocelli).

Turner, Joseph Mallord William
Slave Ship
[pp. 168–69]
Provenance: Presented at the Royal Academy in 1840, the picture was purchased in 1844 for 250 guineas by John

Ruskin senior and offered to his son John Ruskin (1819–1900), who sold it in 1872. In Boston after 1880 and sold in 1899 by William Lothrop to the museum of that city.
Reference : Exhib. cat. *L'Amérique vue par l'Europe*, Paris, Grand Palais, 1976–77, n. 315, repr. (entry by Hugh Honour); Martin Butlin and Evelyn Joll, *The Paintings of J.M.W. Turner*, New Haven and London, 1984, n. 385, repr.

Van der Hamen y León, Juan
Still Life with Sweets and Pottery
[pp. 86–87]
Provenance: Comes from the collection of the marquis of Leganés in Madrid who, at his death in 1655, owned nine still lifes by Van der Hamen. Purchased by Samuel H. Kress (1863–1955) in 1955.
Reference : Exhib. cat. *Spanish Still Life in the Golden Age 1600–1650*, Fort Worth, Kimbell Art Museum, 1985, n. 17, repr. (entry by William B. Jordan); William B. Jordan, *Juan van der Hamen y León and the court of Madrid*, New Haven and London, 2005, p.34 repr.

Van Dyck, Antoon
Rinaldo and Armida
[pp. 90–91]
Provenance: Commissioned by Endymion Porter for Charles I of England and delivered in 1629. In England until the early twentieth century; purchased by Jacob Epstein in 1927 and bequeathed to the Baltimore museum in 1951.
Reference : Exhib. cat. *Anthony van Dyck*, Washington, National Gallery of Art, 1990–91, n. 54, repr. (entry by Arthur K. Wheelock Jr.).

Van Gogh, Vincent
Rain
[pp. 196–97]
Provenance: Collection of Hugo von Tschudi (1831–1911) in Munich. Purchased by the great collector Henry P. McIlheny

(1910–1986) in 1950 and at his death offered to the Philadelphia Museum.
Reference : Exhib. cat. *The Henry P. McIlhenny Collection: Nineteenth Century French and English Masterpieces*, Atlanta, High Museum of Art, 1984, n. 32, repr. (entry by Peter F. Blume); exhib. cat. *Van Gogh in Saint-Rémy and Auvers*, New York, The Metropolitan Museum of Art, 1986–87, n. 29, repr. (entry by Ronald Pickvance); Jan Hulsker, *The Complete Van Gogh*, Amsterdam, 1996, pp. 422 and 424, repr.

Vermeer, Johannes
Allegory of the Faith
[pp. 118–19]
Provenance: Hermann Stoffelsz van Swoll collection in Amsterdam before 1698, then in Austria and Russia. Purchased in 1899 by the Dutch art historian Abraham Bredius (1855–1946) for 700 Deutsche Marks. Acquired by Colonel Michael Friedsam in 1928 for 300.000 dollars. Entered the Metropolitan Museum in 1931.
Reference: Exhib. cat. *Johannes Vermeer*, Washington, National Gallery of Art, and The Hague, Mauritshuis, 1995–96, n. 20, repr. (entry by Arthur K. Wheelock Jr. and Ben Broos).

Wright of Derby, Joseph
The Old Man and Death
[pp. 152–53]
Provenance: Painted in 1774, shown that same year at the Society of Artists, but the work, for which the artist asked 80 guineas, did not sell. It remained in Wright's studio until his death and the dispersion of his studio in 1801 (51 pounds and 9 shillings). Purchased by Hartford in 1953.
Reference: Exhib. cat. *Joseph Wright of Derby*, Paris, Grand Palais, 1990, n. 42, repr. (entry by Judy Egerton); exhib. cat. *Great Paintings from American Collections. Holbein to Hockney*, New Haven, Yale Center for British Art, and San

Marino, Huntington Library, 2001–02, n. 28, repr. (entry by Julia Marciari Alexander).

Zurbarán, Francisco de
Lemons, oranges, and rose
[pp. 96–97]
Provenance: It comes, apparently, from an auction in Paris, Hôtel Drouot, 26 May 1922, n. 18. Collection of the art dealer Alessandro Contini Bonacossi (1878–1955). Purchased by Norton Simon (1907–1983) in 1973 for the sum of 3.000.000 dollars, considered exorbitant at the time.
Reference: Maria Luisa Caturla, *Francisco de Zurbarán*, Paris, 1994, pp. 100–01, 103, repr.

DATE DUE